Dedalus Europe 2006
General Editor: Mike Mitchell

Grand Solo for Anton

Herbert Rosendorfer

Grand Solo for Anton

Translated by Mike Mitchell

Dedalus

LOTTERY FUNDED

Published in the UK by Dedalus Ltd, Langford Lodge,
St Judith's Lane, Sawtry, Cambs, PE28 5XE
email: info@dedalusbooks.com
www.dedalusbooks.com

ISBN 1 903517 45 1
ISBN 978 1 903517 45 1

Dedalus is distributed in the United States by SCB Distributors,
15608 South New Century Drive, Gardena, California 90248
email: info@scbdistributors.com web site: www.scbdistributors.com

Dedalus is distributed in Australia & New Zealand by Peribo Pty Ltd,
58 Beaumont Road, Mount Kuring-gai N.S.W. 2080
email: peribo@bigpond.com

Dedalus is distributed in Canada by Disticor Direct-Book Division,
695 Westney Road South, Suite 14 Ajax, Ontario, LI6 6M9
web site: www.disticordirect.com

Publishing History
First published in Germany 1979
First Dedalus edition 2006

Großes Solo für Anton copyright © by Nymphenburger in F.A. Herbig Verlagsbuch-
handlung GmbH München, 1979
Translation copyright © Mike Mitchell 2006

The right of Herbert Rosendorfer to be indentified as the author and Mike Mitchell
to be identified as the translator of this work has been asserted by them in accordance
with the Copyright, Designs and Patent Act, 1988.

Printed in Finland by WS Bookwell
Typeset by RefineCatch Limited, Bungay, Suffolk

A C.I.P. listing for this book is available on request.

THE AUTHOR

Herbert Rosendorfer (born 1934) is a multi-talent. One of Germany's leading contemporary writers, he spent his working life as a judge. He has also published musical compostiions, from string quartets to lieder, and written the libretto of an opera performed at the Salzburg Festival.

His first novel *Der Ruinenbaumeister* (*The Architect of Ruins*, Dedalus 1992) is one of the masterpieces of post-war German fiction; *Briefe in die chinesische Vergangenheit* (*Letters Back to Ancient China*, Dedalus 1997) was a great critical and commercial success, having sold over two million copies. His other novels include *Stephanie* (Dedalus edition in 1995).

THE TRANSLATOR

Mike Mitchell is one of Dedalus's editorial directors and is responsible for the Dedalus translation programme. His translations been shortlisted for numerous prizes: Schlegel-Tieck 1993 and 1996; Weidenfeld 2000 and 2001; Kurt Wolff 2004; CWA 2005. His translation of Rosendorfer's *Letters Back to Ancient China* won the 1998 Schlegel-Tieck Translation Prize.

He has translated a wide variety of books from German including five novels by Gustav Meyrink, three novels by Grimmelshausen, three novels by Herbert Rosendorfer, two novels by Hermann Ungar, essays by Adolf Loos, plays and poems by Oskar Kokoschka, detective novels by Friedrich Glauser. From French he has translated for Dedalus two novels by Mercedes Deambrosis and *Bruges-la-Morte* by Georges Rodenbach.

He is currently working on the first English translation of *Le Carillonneur* by Georges Rodenbach.

'The ultimate aim of the world is a book.'
Stéphane Mallarmé

1

A swelling of the solar plexus

When, a few days later, Anton L. started to think the matter over – initially he had had no time for that, he had been too busy gawping in astonishment and organising his new life – he remembered that during the night of the 25th he had briefly woken up once. He had not looked at the clock. There had been a strikingly bright light coming in through the gap in the curtains, a pale, yellowish glare such as you get on snowy nights. He had only been awake for a brief moment, Anton L. recalled, not long enough to summon up the energy to look at the clock, but long enough to think: 'It's a snowstorm,' and to counter: 'No, not in June.' Then he must have gone back to sleep.

This bright, pale yellow glare was the only thing Anton L. had noticed during the night of the 25th that he could later take as a clue when he was looking for an explanation of what had happened. It didn't get him very far.

June 26 1973 was a Tuesday. Anton L. was woken, before his alarm clock rang at half past six, by the barking of the dogs on the veranda of the apartment diagonally opposite. The family that lived there had two dogs, a small one the colour of a frankfurter, with hair hanging down over its eyes, and a larger, spotted one with a pointed muzzle. From the fact that he woke up with his head ringing, Anton L. deduced that the dogs had been barking for some time. He got up and drew the curtains.

The window of his bedsitter did not open directly onto the outside, but onto a veranda similar to the one where the dogs were barking. Since he had been living there, the veranda outside Anton L.'s window had been full of useless objects,

old, dusty household appliances and other junk. Sometimes, when his landlord, Herr Hommer, had given her another of his lectures about keeping the house clean and tidy, Frau Hommer would spend a day or two desperately trying to clear up the mess on the veranda. Since, however, she was too afraid of Herr Hommer to throw anything away, even the most useless object, her efforts were more or less vain. More recently – since Herr Hommer had retired the previous autumn to be precise – Frau Hommer's task had been rendered even more difficult by the fact that Herr Hommer kept an iguana in a terrarium on the veranda. It was hard to say which Frau Hommer was more afraid of, her husband or the iguana.

The veranda windows were uncleaned and covered in grime. Through a pane that was slightly less dirty Anton L. could see the veranda opposite. The bigger dog was standing at the window, its front paws on the window-ledge. Immediately it disappeared and the barking modulated to a whimper.

Now his alarm clock went off. Anton L. took his toilet bag and towel and went to the bathroom. There were no washing facilities in his room, but Anton L. had the right to use the bathroom according to a precisely drawn-up timetable, a written copy of which Herr Hommer, at that time still working as a civil servant, had handed him when they signed the tenancy agreement.

The arrangement was pedantic, but not ungenerous. Anton L. did not even make use of all the available time his landlord had allocated him, although one has to take into account the fact that he had a very individual attitude to cleanliness. Anton L. was what one might call an intermittent cleanaholic. At irregular intervals, which could be as long as six months but were never shorter than four weeks, he was seized with the need to cleanse himself. He would spend whole weekends, or several days holiday, in the public baths (the facilities offered by the Hommers were naturally inadequate to satisfy the demands of such excessive periods of self-ablution), taking hot baths, cold baths, steam baths, shower baths, bubble baths, saltwater baths, mineral baths; he had massages, manicures, pedicures, went to the sauna, used scrubbing brushes, sea

cucumbers, aloe wraps, lay back in the bath studying sodden brochures on new medicinal cleansing products, underwent scalp massage and face packs and sometimes even colonic irrigation. Once this period of excessive cleansing was over, Anton L. restricted himself for, as we said, up to six months, to a minimal daily routine of a brief brushing of his teeth, shaving and washing his finger tips. During such times Anton L. did not change his underwear either, with the result that he gradually started, not to put too fine a point on it, to smell, especially since he also used to sleep in his underwear.

Anton L. had been fired from both a job in a bank (four years ago) and a job with a travel agency (two years ago) because of his smell. (He had left a position with a publisher for other reasons which we will go into later.) He wasn't sorry about the bank, but he would have liked to stay with the travel agent's. He had therefore blushingly tried to explain to his boss how pleasant, even comforting it was to keep to the same unwashed underwear. With time, Anton L. had said, your underwear reached a degree of softness impossible for clean underwear. It became part of you. You became part of it. You had a feeling of invulnerability, Anton L. said. His boss was unimpressed.

For two years now Anton L. had been working at the Tax Office. The Tax Office's clients would still be reluctant to come even if the civil servant in charge of their case smelt of all the perfumes of Arabia. The head of the Tax Office hardly ever saw Anton L. so was never confronted with his smell. Now and then a colleague who shared an office with him would complain; if he complained loudly enough and persistently enough, either he or Anton L. would be moved to another room. That did not bother Anton L. He was not interested in social contact with his colleagues, whom he regarded – with a certain justification, it must be said – as his intellectual inferiors.

Later, on the Friday or Saturday, when Anton L. had had time to think about the matter, he said to himself, 'Who knows, my smell might have protected me from the catastrophe. Who knows . . .'

All was quiet in the apartment. That was not a cause for

concern, but it was unusual at that early hour. Normally Frau Hommer got up before Anton L. and would scurry round the apartment (with the exception of his bedsitter, of course), going about her mysterious business. He often wondered whether this constant scurrying – which meant that the image people had of her in their minds was always fuzzy, slightly out of focus, so to speak – whether this constant scurrying was congenital. Or did she scurry around to provide a less clear, moving target for her husband's anger? If that was the case, then it was wasted effort; the sound waves of Herr Hommer's commands were powerful enough to reach a woman even if she was scurrying. Since his retirement Herr Hommer had got into the habit of having a long lie-in every morning, but even from his bed he was well able to keep his wife on the move. Her scurrying became a wasp-like buzz, bringing the woman back into sharper focus, when the retired civil servant left his bed in order to celebrate – there is no other word for it – the completion of the digestive cycle. That took place with precise regularity every morning shortly before half past seven, when Anton L., on working days, was about to leave for the office. Herr Hommer would emerge from the conjugal bedroom, attired in a Turkish dressing-gown with a gold cord, swing the tassel and say in an astonished tone – every morning – as if the encounter were a great coincidence, "Ah, Herr L.!" and – every morning – "A very good morning to you," adding – every morning – in an urbane baritone, "I'm off to plant some *cack*tuses."

Naturally the details of precisely what went on behind the lavatory door were unknown to Anton L. The planting of the *cack*tuses lasted a long time. From his days off he knew that Herr Hommer, who weighed himself before and after planting his *cack*tuses, returned to his bed with the newspaper and a reflective look on his face, and that beforehand, while he was still in the lavatory, a bowl of warm soda water had to be handed in to him.

'Where can the old woman be today?' Anton L. wondered. He could not imagine that she had overslept. She had never overslept. Could she be ill? He tried to imagine Frau Hommer

dying. There was no other way it could be: one day she would scurry out and down the three flights of stairs, scurry along like a puff of air to the cemetery, past two nonplussed coffin bearers and into an open coffin, that happened to be lying around, and close it over her, like a mussel closing its shell. That was the only way she could protect herself from the anger that could reach beyond the grave with which her husband would be seized. Who would warm up his soda water for him now?

When, shortly after a quarter to seven, Anton L. vacated the bathroom and once more crossed the corridor to return to his room, there was still no sight nor sound of Frau Hommer.

Anton L. got dressed. According to his written tenancy agreement, he had the right to a kettle of hot water between seven and half past eight. In this, too, Anton L. waived a large part of his entitlement. He put two teaspoons of instant coffee in a tumbler and took it into the kitchen. Still not a sound in the apartment. He put the kettle, a very old inhabitant of the Hommers' kitchen, sixteen-sided (that is, almost round but not quite), whose metal had long since gone dull, on the gas stove. Anton L. knew his way around, even when Frau Hommer was not there.

While the water was heating, Anton L. went out onto the veranda, which was accessible from the kitchen. The whimpering of the dogs on the veranda of the house diagonally opposite had grown even more pitiful. It was a clear, sunny day. The line of sight along which the iguana was looking was at a precise tangent to Anton L.'s head. It was a large iguana, a beautiful animal. Only a superficial observer could have called it "green". As the first bubbles appeared in the sixteen-sided kettle, Anton L. watched the animal in the clear rays of the morning sun. Its body shimmered with all possible shades of green, just like a broad-leaved forest damp with the dew of a summer morning, from almost yellow to almost blue. The iguana's name was Sonja. It had originally been Ernst, until an iguana specialist had pointed out to Herr Hommer that it was a female.

'Can the Hommers have gone away? On holiday?' Anton

L. wondered. All the time he had lived there the Hommers had never gone away. They couldn't, they always said, because of their daughter. And if they had, who was going to feed Sonja? Surely they'd have left a note for Anton L. But yesterday evening the Hommers had gone to bed *before* Anton L. That they would get up again, into order to sneak out of the house and go away, was highly unlikely. One can, of course, leave very early in the morning, at five o'clock, for example, but that will inevitably, especially with people like the Hommers, who were not accustomed to travelling, cause some noise. Anton L. would have heard it.

The water boiled. Anton L. poured the boiling water onto the coffee in the tumbler. It broke. The hot water – or was it already coffee? – spilt over Anton L.'s left knee and down his shin. His hot, wet trousers were wrapped round his leg. He took them off – in the kitchen! Standing there in his yellowing underpants, he thought, 'How fortunate the Hommers aren't here.' Herr Hommer was, as he often emphasised, a freethinker, but he was also a stickler for morality. He would never have allowed his wife to see him, Hommer himself that is, her husband, in his underpants, much less their lodger. It might even have led to his immediate separation from wife and lodger.

Anton L. ran to the bathroom, dried himself (according to his subtenancy agreement he was entitled to one hook in the bathroom hanging space; towels he had to provide himself), then went to his room and put on another pair of trousers. If he insisted on having a cup of coffee he would be late for work.

'There's no way I'm going without my coffee,' he told himself. This was the point at which the thought first flashed through his mind that he might possibly be ill.

It had been the last tumbler Anton L. possessed.

He went back into the kitchen. Still no sound from the rest of the apartment. They really have gone away, thought Anton L. He grew bold. He took one of the Hommers' cups out of the cupboard, spooned some more instant coffee (from his own jar) into it and put more water on.

While he was waiting for it to boil he cleaned up the floor.

Then he made his coffee and – taking another liberty, this was not part of his contractual entitlement – sat down at the kitchen table.

'They *did* go to bed before me,' he thought. He had spent the previous evening with the Hommers in their living room. Of course that was not part of his entitlement either. He had been invited. The ex-civil servant liked to have company when he was watching television. It was his habit to explain what was going on on the screen; not to comment on it, to explain it, as if the others could not see it. It was a habit that quickly got on one's nerves, but Anton L. never said anything. At most he would occasionally, with profuse apologies and excuses, refuse an invitation from the Hommers to watch television, but even that he only dared do at most once a week, not more often. Anton L. was afraid of Herr Hommer. That was something he had established, to his dismay, while pursuing his favourite pastime of analysing himself. Yes, he was afraid of Herr Hommer. Why? Anton L.'s self-analysis had not got that far. Herr Hommer, on the other hand, had taken a clear liking to Anton L. No one could fail to see how much better Herr Hommer treated his lodger than his wife.

The previous evening they had watched an episode of a fairly long series about the ups-and-downs of a rather extended English family. It was Herr Hommer's favourite programme. He had seen it years ago on Channel 1, then watched in on Channel 3 and was now enjoying the repeat on Austrian Television, which the Hommers could get thanks to a special aerial on the roof. The relationships of the English family were so tangled that a genealogical table had to be shown at the beginning and end of each episode, sometimes even during the transmission. After every three or four episodes a special background programme was put on in which professional genealogists explained the developments within the family. Herr Hommer had also bought a booklet with family trees, which the broadcasting company had had the foresight to publish when the series was first shown.

The previous evening the granddaughter of the oldest

member of the family had married a cousin three times removed. The cousin's uncle was having an affair with his brother's wife who, for her part, was a niece of the very oldest elder of the family, who had died during the early episodes. A brother of the current head of the family found out about it, but went bankrupt, which for the moment prevented him from following the matter up. A son of this brother murdered his wife (or his sister, it happened very quickly and was not quite clear to Anton L.) and the sister of the granddaughter mentioned at the beginning ran off with her piano teacher. The piano teacher (or the bankrupt uncle, that, too, was unclear) had an illegitimate child by a duchess. Unrelated to the family – and therefore not included in the genealogical tables – was a butler who appeared frequently, usually carrying a silver teapot on a tray.

After the programme Herr Hommer, already in his Turkish dressing-gown with the golden cord, had switched off the television, without asking his guest if he would like to watch something else, and gone to plant his evening *cack*tuses. Unlike his morning, midday and afternoon *cack*tuses, his evening planting was not done by the clock, but depended on the end of the television programme Herr Hommer was interested in. That Herr Hommer would have got dressed again after having planted his evening *cack*tuses, in order to go away, seemed highly unlikely to Anton L.

As usual Frau Hommer had scurried in and out of the living room from time to time the previous evening and stared at the television as she gave a bowl, the lampstand or a chair a wipe with her apron – given the circumstances, it was presumably impossible that she had the slightest idea of the family's tangled affairs – then she had heated up the soda water and scurried off to bed shortly after her husband. That Anton L. had deduced from the fact that he could not hear her any more.

Their daughter emerged only rarely, if at all. The reason was her illness. She was called Marianne and had an allergy, which nothing could cure, to clothing. One of the conditions Herr Hommer had inserted in the sublet was that the lodger

14

should neither take offence at nor derive carnal pleasure from the fact that his daughter always appeared unclothed. Understandably, Marianne never went out of the house and every effort was made to avoid her having to leave her room. There were times, of course, when that was unavoidable. When he first moved in, Anton L. had encountered her now and then in the corridor. Since he showed neither visible signs of carnal pleasure, nor of taking offence, Herr Hommer's embarrassment gradually disappeared. (From the very beginning Marianne showed no signs of embarrassment.) The result was that for some time now Marianne had been allowed to join them watching television once or twice a week. She would sit naked on the sofa, and Anton L. took advantage of the fact that Herr Hommer stared at the television set to stare at his somewhat plump but not unattractive daughter. Given that situation, it was hardly surprising that he missed a lot of the circumstances surrounding the English family's strife.

Marianne had not been present the previous evening. Could she have suddenly overcome her allergy, perhaps at five o'clock in the morning, and could the Hommers, overjoyed at this development, have decided on the spur of the moment to take advantage of an improvement, which might be only temporary, and gone out for a walk?

It was seven thirty-five. Anton L. had finished his coffee. It was his standard breakfast, he didn't start feeling hungry until ten o'clock. Then he would get two rolls – one with sliced sausage, one with cheese – and a glass of apple juice from the canteen or, rather, from the makeshift stall the woman who leased the canteen set up in the basement of the office building. The canteen proper did not open until half past eleven.

Anton L. went back out onto the veranda. During the hour that had passed Sonja had not moved. He regarded the animal, which was still staring along a line that was at a precise tangent to his head. A wafer-thin fold of skin of remarkable size hung down from its – or, rather, *her* – chin to her feet. There was a little disc pulsating behind her ears, at least behind the place where you would look for the ears on

15

a normal animal. Seven forty. If Anton L. were to leave immediately he would arrive late, but not so late that a superior would notice.

Anton L. was also an intermittent hypochondriac. At irregular intervals he would suddenly find himself suffering from imaginary ailments. His periods of hypochondria did not coincide with his periods of excessive cleansing, though they did sometimes overlap. Whenever Anton L. found himself in one of his sick phases every cold wind – but also every warm wind – was a threat to his health. He would get an invisible rash underneath the skin from a particular kind of vegetable, for example, or intervertebral spasms from fastening up his trousers too tightly. Various mucous membranes required special care. Worst of all, though, was the swelling of the solar plexus, a condition which he had developed out of a number of other ailments after studying various popular medical handbooks, especially treatises on 'Astrological Medicine'. He subjected his ailments to various naturopathic remedies, for example by wearing two pairs of socks, by closing every window that was open and opening every one that was closed, or by turning off every radiator that was on and turning on every one that was off, but above all by taking it as an insult when people did not notice that he was unwell. The worst excesses of this were, of course, visited on the clients who had the misfortune to be interviewed by Anton L. during such periods, but those who suffered most were the colleagues who shared an office with him. Since Anton L.'s ailments were not recognised by the blinkered practitioners of orthodox medicine, or only rarely, he was not granted a doctor's certificate and therefore almost always had to go to work during his intermittent periods of ill health. In the course of time those who shared an office with him – as mentioned before, they changed frequently – had developed several strategies for dealing with Anton L.'s ailments, which he naturally described at great length and in great detail. Some simply ignored his accounts by pretending not to hear. Others cracked jokes and one – this made Anton L. seriously angry – caught the diseases off him, so to speak, also suffered from a subcutaneous rash

and swellings of the solar plexus, and trumped Anton L. with his *fungal infection of the nervous system.*

Shortly after he got up Anton L. had sensed an ominous grumbling in his solar plexus. Now, at a quarter to eight, the certainty that he was going to be ill again started to flood through him.

'I'm not going to the Tax Office today,' he said to himself. (One day's absence without a sicknote was permitted.) 'I'll phone them.'

The telephone was in the living room. Anton L. knocked on the door, just to be sure. Not a sound. He went in. The curtains were drawn. Even though he had gone into the room without being invited, he still could not bring himself to open the curtains. So he switched on the light. Nothing happened. He flicked the switch up and down a few times. The light did not go on, so he opened the curtains after all. The telephone was on Herr Hommer's desk, which Herr Hommer seldom used. (He wrote one letter of condolence a year, perhaps two, otherwise he wrote nothing at all.) The desk was an item from surplus Tax Office stock which Herr Hommer had bought, for Herr Hommer had also worked in the Tax Office. (That was how Anton L. had found the room with the Hommers. It was also the reason why Herr Hommer had set aside his principle of only taking female lodgers.) The telephone was the only object on the large, heavy, dark desk. Apart, that is, from a thin brochure beside it: the genealogical tables of the English family on the television.

Anton L. knew the Tax Office number off by heart. He picked up the receiver. There was no dialling tone. He jiggled the cradle several times. Nothing. Despite that, he tried the Tax Office number. The line remained dead.

'And that for a sick man with his solar plexus starting to swell!' Anton L. replaced the receiver. The fact that the telephone wasn't working might be connected with the power cut. It was almost eight o'clock already, too late for Anton L. to change his mind and go to work after all. He would have to go down to the telephone box. He grasped the cord to draw the curtains again, then paused. His eye fell on the other door

in the living room, the one he had not come in through. This other door was the one to Marianne's room. He went over to it on tiptoe and knocked. No reply. He had never been in that room. Slowly he turned the handle. It was dark in the room, but he could make out a bed opposite the door. It was empty. Anton L. went in. There was no one there. The bed had obviously been slept in, but now it was empty.

'Well, well,' Anton L. thought to himself. 'So they must have gone out for a walk after all. Or perhaps they take their daughter – naked – out every night, as that's the only way she can get some fresh air? Maybe they got lost today? No, Herr Hommer would never get lost. Perhaps they've gone too far and it was too late to get back before dawn, so they're having to spend the whole day hiding in the meadows by the river? And a good half an hour ago Herr Hommer would have had to plant his *cack*tuses in the open air, without warm soda water, not even with cold soda water . . . Or perhaps a policeman had caught the three of them and arrested them for behaviour likely to cause a breach of the peace.' Anton L. almost felt it would serve Herr Hommer right.

Anton L. went back to his room, put on a second pair of socks and left the apartment. On the second floor, in the apartment of the woman who owned the building, Irma, the Alsatian, was barking. Irma, a fat Alsatian whose mouse-coloured coat had yellowish patches of mange, jumped up against the door when it heard Anton L. go past. That means she can't be looking out today, he thought. Frau Schwarzenböck, who owned the building, was in the habit of peering out through the spyhole in her door at the busier times of day. Her cleaner, a dwarf, peered out through the letter box, which was lower.

When Anton L. came out into the street, all hell broke loose. Dogs started barking in every flat in the street.

'I've never heard that before. Who would have thought there were so many dogs. What can be wrong with them?'

The telephone box was not far from the house, in a park which, lower down, merged with the meadows bordering the river where the Hommer family was possibly even now in

hiding. Anton L. went in, lifted the receiver and put two ten-pfennig coins into the slot. That telephone was dead too. The two coins were returned.

'Very strange,' Anton L. thought.

It was only when he was back in the flat that it occurred to him that he had seen no one. He had not gone very far but, still, the road he had crossed was normally busy.

2

The cat on the wall of St Clarissa's Hospital

He had seen no one.

Anton L. was sitting in his room on his bed. He had taken off the second pair of socks.

'It's a quarter past eight now. If there's no one in the street at a quarter past eight . . .'

The dogs on the veranda across the street were going wild; Anton L. thought he could hear Irma's resonant bark from the second floor as well. The warmth of the bright morning sun was beginning to heat up the veranda and, indirectly, through the window, his room. A peaceful atmosphere, basically.

'At this time, at a quarter past eight, there *must* be someone out in the street. It's just not possible for there to be no one in the street, unless . . .'

We have already mentioned Anton L.'s penchant for self-analysis. Later, when he had the time and inclination to reflect on these hours, he remembered the thoughts that were going through his mind as he sat on his bed after he had taken off his second pair of socks. He recalled the – basically – peaceful atmosphere. He also recalled the huge black worm, invisible but black all the same, that had wound its way in from the street, sucking up the whole of the peaceful atmosphere because there was no one out in the street, no one at a time when there ought to be someone, unless . . .

Anton L. remembered that 'unless' as well, but he could not have said how the sentence would have gone on.

At a quarter past eight what, in traffic terms, was called the rush hour was already over, but on any normal weekday morning the street was always fairly busy, not least because three tram routes went along it. It just never happened that

there was nothing in the street, not a car, not a lorry, not a single person. Unless . . .?

Anton L. attributed the fact that he did not start to panic at that point to two reasons, one general and one specific.

A catastrophe of such magnitude is simply beyond our comprehension. Our mind will refuse to accept something like that. For as long as possible we look for innocuous explanations. A man with sufficient skill can whip the cloth off a set table in a flash without making the crockery even quiver. That's roughly the way it is. Or, better still, like the story of the perfectionist Chinese executioner who slices through the condemned man's neck with his razor-sharp sword as quick as lightning. The man, who has not felt a thing, gives him a questioning look. "Just nod," the executioner says.

The swordstroke had fallen. It was just that Anton L. had not nodded yet.

And then, Anton L. recalled, despite everything his most immediate concern had been the excuses he would have to think up to explain why he had been so late coming to work, for there was no getting out of it, he would have to go to the Tax Office, swollen solar plexus or no swollen solar plexus. Naturally his boss, Herr Melf, the Senior Inspector of Taxes, whom Anton L. considered quite exceptionally stupid, would make sarcastic remarks. It would be an awkward situation anyway, going to work to say that he couldn't go to work. There was no point in explaining a swollen solar plexus to the Senior Inspector of Taxes. Anton L. had already tried once. There was nothing for it but to stay at work and excuse his latecoming by saying he had woken up feeling slightly unwell, but had managed to overcome it out of a sense of duty. Herr Melf, the dim-witted Senior Tax Inspector, would not believe that either. Perhaps he wouldn't be there in the morning? Perhaps he would have an outside meeting? If he did not get the news of Anton L.'s late arrival until the malicious tongue of Frau Kittelmann informed him in the afternoon, things would not be half that bad. At least by then the Senior Tax Inspector would find Anton L. in a flurry of official business, so that he wouldn't be able to say very much.

(Frau Kittelmann was a hypochondriac herself, only a permanent one. She could not stand someone else being more ill than she was. Hearing that this or that person was ill, Frau Kittelmann's response would be a dismissive, "If you knew my state of health . . ." Even when Nörpel, the universally popular office messenger, died unexpectedly, after having been at work lugging the files from office to office literally the day before, Frau Kittelmann immediately said, "Yes, I felt awful during the night as well . . ." It was understandable that it was bound to cause bad blood if, at intermittent intervals, Anton L. responded to her descriptions of her sufferings with indifference instead of sympathy, countering them with his own swollen solar plexus.)

Thus Anton L. had spent the fifteen minutes between a quarter past and half past eight dashing to and fro in the building, his repressed panic – the black worm sucking up the bright sunny day – overlaid with his fear of Herr Melf.

He had tried ringing the Tax Office from the apartment again, without knocking on the living room door, of course. The telephone still wasn't working. Then he had had the audacity – there is no other word for it – to open the door to the Hommers' bedroom. There was no one there. Anton L. discovered, though given the situation he did no more than register the fact, that Herr and Frau Hommer's beds were not side by side, but were arranged in the form of an inverted T. Herr Hommer's bed was the vertical, while Frau Hommer's was at her husband's feet.

On or, rather, in Herr Hommer's bed was a pair of blue-and-green striped pyjamas, tucked in just like a person, with the sleeves over the covers. Anton L. had no time to reflect on what this revealed of Herr Hommer's character. He went out onto the landing and tried ringing the neighbours' bells, initially those who lived in the flat opposite, the one with the veranda with the dogs. The bell wasn't working. Anton L. then tried the apartment in between. A very old lady lived there, together with her daughter, who was also fairly old, and her two granddaughters. The younger of the two was pretty. For some time now Anton L. had assumed she was in love

with him. This assumption was rather undermined by the fact that the young lady completely ignored him. It was only a few weeks before that Anton L. had met Eliane, as the girl was called, on the tram. At the time he had been in the last of his sick phases and had told her about the swellings in his solar plexus. An objective observer would have said Eliane did not seem interested in the swellings in Anton L.'s solar plexus, but he did not notice. At that time a young man had appeared in whose company Eliane often went out. Anton L. interpreted that as an act of defiance on the part of a girl whose love was unrequited. The bell on Eliane's door was not working either. These ladies also had a dog, a bizarre dachshund called Hexi, which was so obese it was starting to bear a faint resemblance to the scale model of a whale.

Now Anton L. started knocking on the doors of people he did not know. There was no sign of life. Only when he knocked at Eliane's door had he heard the whale-dachshund crawl to the door and give a single, weary yap. It made no further sound as long as Anton L. was listening. Possibly the dog had died of fright at his knocking.

He went back to his room, put on the second pair of socks again and set off for the Tax Office.

'There must have been people in the street,' he kept telling himself, 'I just didn't see them. And there are moments, minutes even, when there happen to be no trams or cars going along the street; traffic moves – or doesn't move – in mysterious ways.' And yet he had to confess that he had avoided looking out of the window at the street when he had tried to telephone a second time from the Hommers' living room. Why? Because he was afraid of having his terrible vision confirmed.

'Nothing's happened,' he said to himself, 'nothing at all.' He managed to convince himself, not for long, but long enough for the image of Herr Melf's severe expression to oust the black worm and for the swellings in his solar plexus to reassert themselves, which was why Anton L. had put his second pair of socks back on.

But there was still no one in the street.

'War!' thought Anton L.

It was not a purely random thought. Anton L. could still clearly remember such streets with the emptiness rammed into them like a stake. Towards the end of the last war the Americans had started bombarding the towns by day as well. Once, during one of those daytime attacks, Anton L. had slipped away from the air-raid shelter and gone out into the street. His mother had brought him back in soon afterwards, since it was not only forbidden, it was genuinely dangerous to leave the underground shelter. But Anton L. had seen the street: completely deserted in broad daylight.

Anton L. listened. Apart from the barking of the dogs, there was nothing to be heard. He looked round. All the doors were shut, all the shutters on the shop windows were down.

'No doubt about it: war!'

Anton L. began to run. He ran in the direction of the Tax Office. Why he ran in that direction he could not have said. He just felt that he had to run.

The Tax Office was not far away. Anton L. just had to go down the street where he lived as far as a square and the office was in a side street branching off it. Five minutes, if you ran. As he ran Anton L. looked at the large clock over the watchmaker's: just before half past one.

'That can't be right . . .'

Then the clock in the tower of the large neo-Gothic church in the square he was running towards struck a quarter to nine.

'Electricity!' thought Anton L. 'If there's a war the power will be cut off. The clock over the watchmaker's runs on electricity, that's why it's stopped. The one in the tower, on the other hand, is mechanical.'

As Anton L. crossed the square he met a quail.

'And the Hommers didn't tell me. Typical. I bet they never even thought of me. Didn't bother about me at all, simply left me behind; didn't even think to warn me.'

Had there been any sirens sounding the alarm? No, there hadn't been any sirens. Or was he the only one who hadn't heard them? Or had he heard them, only changed the acoustic

impression into an optical one? Instead of *hearing the sirens*, had he *seen* the pale, yellowish *glare*? Was that possible? (When, some years previously, he had belonged to a group called the Bundtrock Circle, they had spent a lot of time and energy discussing that kind of question.)

Breathing heavily, Anton L. reached the main entrance to the Tax Office.

'If war's broken out,' he thought, 'Melf won't be able to say anything. He should be glad I've come at all.'

The entrance to the Tax Office was closed as well.

'The strange thing is,' thought Anton L., 'I saw the early evening news yesterday, before the English family started, and they didn't say a blind word about the forthcoming war. Could we have still been at peace? Was it not until the eleven o'clock news that . . . But then how did the Hommers hear about it, without sirens?'

The explanation that a war could have broken out was rapidly becoming less and less likely. The black worm of war was almost harmless compared with the much larger black worm of an unknown catastrophe which was now making its appearance on the fringe of Anton L.'s consciousness. Despite that – or perhaps because of it – Anton L. clung on to his war theory; also, if truth be told, because of a bizarre idea that had just lodged in his mind. 'They've barricaded themselves in, Melf and the rest.'

Anton L. shook the heavy wrought-iron door handle. He did have a key to his office but, as a lowly clerk (not even with a permanent post!) he naturally did not have a key to the office building. (Presumably, though, the Senior Inspector of Taxes would not have a key to the whole building either, probably not even the Director, Dr Choddol. The janitor would be the only person to have one of those.)

Now Anton L. saw something he had never noticed before: the Tax Office had a bell. Anton L. rang it. There was nothing, not even the sound of the bell, to be heard inside. Then he remembered: of course, there was no electricity.

He was starting to sweat. 'And it had to happen just when my solar plexus . . .' he thought. He wondered whether to

take off his second pair of socks, but first he went round to the back of the building. There was another door there, a little one, not used by the public.

A flock of small birds whirred from one tree to another. A cat was sitting on the garden wall of St Clarissa's Hospital. In the sunshine the large, open square was a rectangle of brightness against the darker, shadowy mass of the buildings. The red church in the middle looked as if it were standing on a tray. The early morning freshness had given way to the warmth of a day that promised to get hot later. The cat was sitting in the shade of a tree overhanging the wall.

It was, of course, forbidden to leave the office during working hours. By the main entrance it was impossible, anyway, since the sour-faced porter was sitting there in his lodge. One day, however, a colleague in the Turnover Tax Refund Section had discovered that the key to his office also fitted the small back door. So it was arranged that this colleague should open the door at the start of work and, so that the authorities did not find out, lock it again before the end. Since then, those for whom the slightly damp rolls the janitor's wife sold were too tough could nip out through the illicit back door and get some fresh pretzels, a jam doughnut or a Danish pastry from Ulrich's bakery for their midmorning snack.

As was to be expected, the little door was closed. Anton L. gave the handle a perfunctory twiddle. He was quite out of breath and sweating profusely. (Apart from his second pair of socks, he had taken the precaution of putting on a woollen cardigan underneath his jacket.)

'It can't be Sunday,' thought Anton L., 'unless . . . Yesterday, the last time I went to bed, was Monday, so it can't be Sunday unless I slept through the whole week.' That was surely not really possible. Could it be a holiday? No. Corpus Christi had been the previous week. Ascension Day and Whitsuntide had both been before that. Could it be some other holiday? An official state holiday? Had the President died? But then the flags would be out, at half- mast. Anton L. went back to the main entrance. The cat was still sitting on the

wall of St Clarissa's. The clock in the church tower struck half past nine.

'Damn this bloody cardigan,' thought Anton L. (In any other situation he would have attributed his sweating to his solar plexus, not to his cardigan.) An idea had occurred to him, an audacious idea for a clerk in the Tax Office. He wasn't thinking any more, the thoughts just came tumbling out in no particular order.

'I have to get into the office.'

But the direction he set off in was towards the church.

'If it's Sunday there'll be mass at half past nine. There must be people in the church.'

The sun was beating down on the open square round the church. The sweat was steaming off Anton L. He ran right round the church, tried all the doors, even the sacristy door. They were all locked.

'They've locked themselves in too.'

Anton L. sat down on some steps in the shade of a portico. He was breathing heavily.

'A church has always been a sanctuary. They'll have taken the women and children there for safety, perhaps sick people too.'

He took off his shoes and the second pair of socks, put his shoes back on and stuffed the socks in his jacket pocket. He was gradually getting his breath back. When he took his cardigan off as well he felt much better.

'Well it's definitely not Sunday.'

His eye fell on the Tax Office.

In summer the rooms on the south side, most of them crammed to the ceiling with files, were always unbearably hot. Eventually the Staff Welfare Committee had succeeded in getting sun-blinds acquired for the rooms on the south side. They were made of orange linen and were fixed to a frame that could be pulled down or pulled out.

'Not a single sun-blind has been pulled down. In this heat!'

Anton L. stood up. The audacious thought flashed through his mind again.

'Why don't they pull the blinds down?'

He went back to the Tax Office, to the main entrance. No tax official had probably ever had the idea of climbing into the Tax Office. There was a letter box fixed to the wall beside the entrance. Using a jutting-out piece of masonry, Anton L. clambered onto the letter box, then, clutching the window-ledge, pulled himself up to the ground-floor window next to the door. It was an old building, going back to the days when government offices were built like fortresses. The ground floor was very high up. Behind the ground-floor window, as Anton L. knew, was the central mail office.

Bathed in sweat from the effort of his climb on the south face of the building, he pressed his face close up against the shining glass. The central mail office was empty.

He got back down, which was more difficult and made him sweat even more than getting up.

'There's *always* someone in the mail office, *always*. Is it the office outing today?'

No, he had not seen a memo to that effect. One could, of course, always overlook a memo or, for one reason or another, it might not come to all the rooms, but the office outing was invariably preceded by a bustle of activity on the part of the Staff Welfare Committee which Anton L. could certainly not have missed. There was always a collection made; the money allotted for the outing by the administration was never sufficient. It was always Frau Kittelmann who went round with the collecting box and she would have never let him, Anton L., get away without paying, him least of all. No – anyway, even on the day of the office outing the mail office remained open. It had to, otherwise people would have the excuse that they'd brought in their tax return, but the Tax Office was closed. People are quick to cotton on to that kind of thing.

A large bird with slim wings detached itself from the neo-Gothic filigree of the spire. It circled slowly round the tower. A second bird joined it. 'Kestrels, probably,' thought Anton L. He shivered.

The two socks were making a bulge in his jacket pocket. It was irritating him. He sat down on a bench on a shady

footpath running alongside the road round the square to put the socks back on. He had taken off both his shoes and was just putting the sock on his left foot when loud barking rang out from one of the blocks of flats on the other side of the square. Anton L. looked up. The barking turned into a high-pitched yowl. That was the way dogs barked that were being maltreated. Then there was a crash of shattering glass. A large dog had jumped out of the closed window of a ground-floor flat in one of the apartment blocks. A smaller dog followed. The two dogs rushed across the square past Anton L. and disappeared round the church.

He broke out into a cold sweat and shuddered.

'There you are,' he thought. 'You're dead. You've died. Probably during the night. All this talk of swellings in my solar plexus and now I've died from a swelling of the solar plexus. Of course. The pale glare in the night, that was –'

Anton L. took off the sock on his left foot again and put his shoes back on.

'– that was death. And this here is life after death. I can see no one and no one can see me. I'm not actually walking round here. I'm probably lying down. That is, my corpse is stretched out on my bed, perhaps it's even being collected at this very moment. It probably gives old Hommer the creeps. Serve him right. Perhaps it'll be so bad he'll have to give up the apartment and move to another.'

He put the socks down on the bench and walked off.

'Yes, that'll be it. Everything must remain the way it was the last time you saw it. No, the Tax Office was different the last time I saw it. And the clock on the church tower, yesterday at half past four. Things must be different because the clock's still working. But I've never seen a quail run across the square before. Is this paradise or –? For hell it's too . . . hell would have to be more unpleasant. I've never believed in hell. Or perhaps things aren't going to stay as they are. Perhaps it's like this just at the beginning, during the first hours after death. I wonder if Frau Kittelmann'll say that she felt awful during the night again?'

Anton L. set off on his usual way home.

'Or I went mad during the night and this is all the delusion of a sick mind. A special kind of madness in which you don't see people any more. A quail ran across the street here. It can only be a delusion. I can see nobody and everybody can see me. A good job I didn't take off my trousers as well, back there by the church. But why couldn't I get into the Tax Office, then? I *must be* dead.'

He started to run. He ran across the street; he ran back to the other side again. He shook all the house doors, all the shop entrances. They were all closed. Outside the baker's, not far from where he lived, he took an empty beer bottle out of a council rubbish bin fixed to a road sign. Drawing his arm back, he threw the bottle as hard as he could at the shop window. The bottle smashed to smithereens. The window cracked, but did not break. Anton L. ran across to the other side of the street again, but he could not find another beer bottle, not even in other rubbish bins. However a flat stone in the pavement outside no. 4 (Anton L. lived at no. 2) was loose. He noticed it when he stepped on the stone. When he trod on one corner, the other tilted up. He could get his hand underneath and take it out. Carrying the stone, he ran back to the baker's, drew back his arm and threw. Now the window did break. Large splinters formed scales, then fell down and smashed on the ground. The paving stone fell down outside as well. Anton L. picked it up and threw it at the next window display. It belonged to a florist's. That window broke too. This time the stone fell inside the shop.

Anton L. was panting. He clung on to the road sign. Where was his cardigan? He'd left it on the steps at the church. A suspicion began to form in his mind, a suspicion that had tormented him as a child:

'I'm not dead, nor am I mad,' he thought. 'They're hiding. That's what it is. They've all slipped away quietly and they're hiding.'

As a child he'd had the suspicion – an extraordinarily ego-centric attitude – that in fact the world did not really exist, that it was a sham put on for him, Anton L., by all the grown-ups, in fact by everyone else in the world. His suspicion was

based on the fact that people often look alike. It wasn't that they just *looked* the same, little Anton suspected, they *were* the same, only playing a different role. Even his mother was not exempt from Anton L.'s suspicion; indeed, it was she who caused him to think his suspicion was confirmed. Once little Anton told her to her face what he thought. His mother laughed and tried to reassure him. Anton took it as prevarication. Once he came across a man who looked exactly like his grandfather, who was dead. It was during advent. His mother had taken him to the Christmas market. In those days there wasn't much to it, it wasn't long after the war. The old man looked at little Anton, then quickly looked away. 'Now he's given himself away,' was what Anton L. had thought at the time. The suspicion lasted right through his childhood and even into adolescence. It made him wary.

Anton L. went across the road and past the hole in the pavement outside no. 4. The occasional dog was still yapping inside the houses. He was just about to open the main door to no. 2 when he suddenly felt the pangs of hunger. They were long overdue. He looked at his watch. It was eleven o'clock.

'At least they've left something for me,' he thought.

He went back to the baker's and carefully removed the sharp pieces of glass that were still stuck in the bottom of the window-frame. There wasn't much in the window display. As far as possible a baker sells all his daily output, including what is in the window. Anton L. climbed through the window into the shop. The shelves, too, were almost empty. Just one was full of loaves of bread. There were rolls in a large basket. Probably yesterday's. Underneath the counter Anton L. found a pile of plastic bags. He took one and filled it with rolls. They were still reasonably soft. As he was about to leave through the window, he had an idea. He put down the plastic bag and went through the shop into the bakery behind. There he found a pole with a flat piece of wood on the end, a kind of shovel bakers use to get the bread out of the oven. He took the shovel and used it to smash the glass door of Frau Pregler's dairy. There he took a packet of butter from the refrigerator, which was still cool.

On the other side of the road was a delicatessen. There Anton L. not only had to smash the window, he had to break open the folding metal shutters as well. He took a tin of sardines, a jar of pickled gherkins and a pile of sliced sausage, all of which he put into another plastic carrier bag. But there was more space in the bag, so he added a partly cut cooked ham, a jar of honey, a salami, a triangular cheese, another salami, put the jar of honey back and took a bottle of French red wine instead. There was no room for the second bottle in the bag, so he had to put it in his jacket pocket. Now he couldn't get out through the shutters. He went through the shop. An unlocked door led to an office. There he found some keys. One of the keys fitted the shutters, but he couldn't fold them back any more because they were bent. But there was another key that fitted the door at the back of the office, which led into the hallway. A third key opened the main door to the building. Carrying his two plastic bags, Anton L. came out into the street beside the shop. He locked the door

'Strange,' he immediately thought, 'why did I lock the door?' With that he put the keys in his pocket. The baker's shovel was still leaning against the wall, next to the demolished door of the dairy.

3

The butler plays the tango

In a certain sense Anton L. was also an intermittent drunkard or, rather, he had been an intermittent drunkard, twice. It is possible that that was the greater cycle of a lesser cycle; Anton L. had not yet lived long enough for any regularity in his intermittent cycles to have become apparent. There had been two phases of intermittent drunkenness. One took place between the ages of eighteen and twenty-two. It had started shortly before his school-leaving examinations; the discontinuation of his economics course was connected with certain embarrassing, though never fully explained, events during the – speaking in musical terms – *stretto* of the phase, when the intermittent alcoholic periods had almost begun to merge. The second ended shortly before Anton L. joined the Tax Office. Herr Hommer had never heard about these phases, otherwise Anton L. would never have been taken on as a clerk in the Tax Office and certainly not as a lodger by Herr Hommer. Herr Hommer was no teetotaller, he liked the occasional glass of beer. Sometimes in the evening he would open a bottle of wine before watching television. Anton L. was always given a beer or a glass of wine when he watched the lives of the complicated English family with Herr Hommer, but naturally Herr Hommer would never have countenanced a drunkard as a lodger. Nor did he allow his wife and daughter to take alcohol. He believed alcohol was harmful to the female organism. 'And anyway,' he once said, 'it's bad enough having Marianne sitting there stark naked; with a glass of champagne in her hand it would be truly bacchanalian.' Herr Hommer had the word 'bacchanalian' from another of his favourite television series. Anton L. had

never seen it because it was on in the afternoon. Sometimes in the evening Herr Hommer would tell him about it. From what Herr Hommer said, the heroes (of French nationality) must have been a band of perfect hooligans (there seem to have been three of them); it wasn't clear how they earned their living, but despite that they somehow had the knack of keeping the audience on their side. It's not what you do, it's the way that you do it. Something which, in a bald statement, seems a despicable act, looks like a heroic deed in a colourful description.

His first intermittent-drunkard phase had come to an end when Anton L. lost the taste for alcohol. He tried everything, from Chinese rice wine to Greek ouzo, but try as he might, he found nothing he liked. Since there was no one he needed to impress with the amount of drink he could put away – his only boozing companion, someone he'd been with at school and university, had given up some time previously – he could openly admit to himself that he liked buttermilk better. That fitted in with his development at the time in which his intermittent frenetic cleansing and his intermittent hypochondria were already appearing over the horizon.

His second intermittent-drunkard phase was ended by his conversion to yogism. In a short time he had achieved such an incredible ability to stand on his head and think of nothing – something which, given his rather weak constitution, no one would have believed him capable of – that the president of his yoga club became jealous and had him excluded. Anton L. was not unhappy with that, since his enthusiasm for yoga was already on the wane. It was also a good thing in that Herr Hommer would probably have described standing on his head as 'bacchanalian' too. Despite that, there was no recurrence of his second intermittent-drunkard phase, which had been broken off more or less forcibly. Anton L. could accept the glass of wine or beer Herr Hommer offered him in the evening with impunity. Clearly in Anton L.'s case it was a matter of greater cycles, the outward signs of which passed visibly through his life for a while, like mysterious comets, to return – or not – at some time or other.

As Anton L., with his two plastic bags and one jacket pocket weighed down with a bottle of wine, climbed the three flights of stairs (the old building did not have a lift), the dogs were still barking. Not just barking, they were going wild. Irma on the second floor was throwing itself against the door, making the stairwell resound. The two dogs on the third floor were doing the same. Only the bizarre dachshund, Hexi, was quiet, presumably already dead.

Anton L. did not like dogs. It was obvious why they were behaving like this. Their masters or mistresses were not there. The animals, trained to expect to be hit if they relieved themselves in the apartment, were all suffering from painfully distended bladders, not to mention being hungry. Anton L. liked dogs so little that he did not even feel sorry for them. But he did find the noise irritating. He decided to liberate them. He'd have to do it very cautiously, of course, because the frenzied Irma, a powerful beast, might well, stupid as dogs are, attack its liberator.

First of all, therefore, he went upstairs and cut a large piece off the ham in the Hommers' kitchen. Then, taking a large knife, almost a butcher's cleaver, he found in the kitchen, he forced open the door of the apartment of the owner of the building, the vanished Frau Schwarzenböck, with greater ease than he had expected. The dog shot out, snapped up the piece of ham Anton threw down and hurtled down the stairs.

Since the door was open anyway, Anton L. went into the apartment. He knew fat old Frau Schwarzenböck. She was almost bald, but made up for it with a moustache, and always went round in a grubby flowered housecoat, rolled-down stockings and torn slippers, so you could imagine what her apartment would look like. But the apartment exceeded all expectations. Anton L. had not known that Frau Schwarzenböck collected old newspapers. Mountains of yellowing newspapers were piled up against the walls and on all the furniture; in some rooms they were already leaning over to form arches, so that the whole apartment was like a labyrinth of tunnels. The smell that now poured towards the

open door was indescribable. One object right at the back of the tunnel Anton L. took for a coal-box, but it turned out to be a bed. Since it was the only place to sleep in the whole apartment, one was forced to the conclusion that Frau Schwarzenböck, her cleaner and the dog all slept there. Anton L. held his nose and opened a window. He was afraid that if the enclosed smell was left to its own devices and started to ferment, the whole house would soon explode.

When Anton L, holding another piece of ham, then forced open the apartment with the two dogs, he discovered the large dog sleeping peacefully in the kitchen. It had fouled the kitchen and eaten up the small dog. To prevent future noise, Anton L. killed the sleeping dog with the cleaver. Apart from that there was nothing special in that apartment.

Whether it was the smell in Frau Schwarzenböck's apartment, or whether his hunger had simply abated for the moment, Anton L. no longer felt like eating. He sat down in the Hommers' – should one already be saying "erstwhile"? – living room, brazenly took off his shoes and remaining socks, and uncorked one of the bottles with a handcrafted corkscrew belonging to Herr Hommer. Slowly Anton L. began to feel the memory of all the drunken evenings he had spent during the time of his two alcoholic phases trickling down from somewhere behind him. He was now above all that, it seemed to him. Since he had started to think, Anton L. had observed a constant upward development in himself. For that reason he looked down not only on all the people around him as his intellectual inferiors, he also looked down on the old Anton L. as his intellectual inferior. He often shook his head at the self-deluding gnome he had been years, months, even a week ago. Thus he looked down, as if from a high mountain, on the two provinces of his life irrigated by the rivers of beer and wine. It was around three o'clock when he opened the second bottle. At half past four he had emptied that too. He knew that Herr Hommer kept a bottle of brandy in the so-called gentleman's cabinet in the living room. He did not bother to fetch the cleaver, still bloody from the dog, or to look for the key. One blow with a heavy chair and the cabinet splintered. There

were two bottles of brandy in it, one half empty and one still unopened.

Anton L. took off his trousers and tied them round the standard lamp. It sent him into fits of uncontrollable laughter. After he had finished off the half-empty bottle, among his many thoughts of the past and present he remembered Sonja, the iguana.

'The poor beast,' he thought.

Should it be a mercy killing, or should he feed her? He decided to feed her. 'What do iguanas eat?' Anton L. could not remember what Herr Hommer had given her. He went into the kitchen. First of all he took his underpants off and put them in the fridge, then cut a slice of ham. Sonja turned up her nose at it. 'Fussy about what we eat, are we?' thought Anton L. 'All right then.' He unwrapped the triangular cheese portion, placed it on the kitchen table, held it down with his left hand, closed one eye, briefly took aim and cut his index finger.

'I'm going to get some more cheese anyway,' he thought, throwing the whole piece into the terrarium. At first Sonja fled behind a stone in alarm, but when Anton L. stayed still for a while, she crept out, sniffed the bloodstained cheese and ate it up.

"That's a good girl," said Anton L.

He went back into the living room. The rays of the evening sun cast a red glow over the furniture. He dropped into the large armchair, Herr Hommer's favourite, covered in shiny brown leather. He started when he felt the cool leather on his bare behind, but at that moment the door to Marianne's room opened. It was not Marianne who came out, however, but Frau Regula Weckmeier.

Frau Weckmeier was the undoubted star among the female members of the Tax Office. She was a tax inspector. Looking at her, a tax inspector was the last thing one would have thought she was. She had curly red hair and wore the shortest skirts and tightest trousers in the whole Tax Office. At the last office outing but one she had worn an exceptionally short dress that was tied with a bow behind her neck. While they

were picnicking beside a stream Haselpointer, the office joker, had pulled the end of the bow. The dress fell apart and for a second one could see that Frau Weckmeier had nothing, absolutely nothing, on underneath. She gave Haselpointer a clip round the ear, but otherwise just laughed.

It was sometimes said that Frau Weckmeier lived in an anarchist commune. Once, in a men's magazine, there was a series of pictures of a nude photographed from every possible angle, who, if she wasn't Frau Weckmeier, looked remarkably like her. The magazine did the rounds of the Tax Office, of course. Frau Weckmeier denied she was the model. Frau Kittelmann, who naturally harboured a profound distrust of her eccentric colleague, claimed to have made some inquiries, which indicated that Frau Weckmeier *was* the model. For all that, not even Frau Kittelmann could deny that Frau Weckmeier, although she often arrived late and adopted a pert and saucy tone to all her superiors, was an efficient tax officer. That was what the director, Dr Choddol, said when Frau Kittelmann gave him a report on the result of her researches into the matter of the nude photographs and suggested instituting disciplinary proceedings. No such proceedings were instituted. That led Frau Kittelmann to suspect Dr Choddol was having an affair with Frau Weckmeier. She made some inquiries in that direction too, but nothing came of them.

There was clearly no Herr Weckmeier, or at least not any more.

Anton L. suspected Frau Weckmeier was secretly in love with him. To a certain extent that assumption was contradicted by the fact that the redheaded tax inspector made eyes at all sorts of men in the Tax Office, though only ones in senior positions, but ignored Anton L.

Frau Regula Weckmeier – close friends called her "Mausi" – came into the living room. She was wearing a green velvet dress reaching down to the floor and a black blouse. Anton L. tried to open the second bottle of brandy. He did manage to remove the silver foil covering the cork, but he could not find Herr Hommer's handcrafted corkscrew. Mausi switched the television on. The butler to the complicated English

family was playing a tango on a double bass. (In his youth, shortly before his first alcoholic cycle, he had gone through a ballroom-dancing phase, an interest that so far had not recurred in his life and was therefore perhaps part of a very long-term cycle. Together with the foxtrot, the tango had been Anton L.'s strength.)

One reason why Anton L. could not find the handcrafted corkscrew was that he was just feeling around on the coffee table without taking his eyes off Mausi. She was dancing on the spot, hands in the air, clicking her fingers in time with the unremitting, driving rhythm set by the butler. Anton L. knocked off the neck of the bottle on the edge of the coffee table. (The glass table top broke as well.) A torrent of brandy cascaded over Anton L.'s bare knee. Mausi began to turn, no, to spin round on her own axis, first one way, then the other, clicking her tongue. A second butler was clacking the castanets in time with the double bass. Mausi was wearing a green velvet skirt reaching down to the floor and no blouse. In the driving rhythm her alabaster bosom foamed above a black lace bodice.

Anton L. poured two glasses of brandy. One toppled over. Anton fetched another glass. He filled the two glasses. He seemed to have drunk one. A third butler was playing the harp. Mausi was wearing a black lace corset and a belt of gold coins. Herr Hommer came in playing the mouth organ. Anton tried to smother him with a brown leather sofa cushion. By now all Mausi was wearing was her belt of gold coins. Anton L. had managed to wrestle Herr Hommer to the ground, but Herr Hommer was holding onto his feet. Anton L. filled the two glasses again. He dropped the bottle. A fourth butler took off Mausi's belt. Mausi was playing a tambourine which she held in front of her private parts, switching it quick as a flash to her bottom when she turned round. Anton felt his loins were on fire, but Herr Hommer was still holding him tight by the legs. Mausi no longer had the tambourine. Anton L. tried to get to her, despite having Herr Hommer clinging on to his legs. He almost managed it a few times. Mausi was a natural redhead, as one could tell from her pubic hair. The butlers

wrapped Mausi up in leather straps. Trussed up, Mausi continued to twitch to the demonic rhythm. Anton L. thought he was going to shatter into little pieces. Anton L. shattered.

It was night. Anton L. was in bed. Dogs were barking outside. Carefully, Anton L. felt his head. He tried to switch on the light, but it didn't work. He was wearing his vest, his shirt and his suit jacket. A raging pain was coming up from his left foot. He felt it: his left big toe was damp. The distant provinces of memory were shrouded in mist. Two large birds were circling round the dark tower where Anton L. was sitting holding his toe. He got up and went to the toilet. The window faced east. The morning sun woke Anton L. He flushed the lavatory. It was still working.

'Aha,' thought Anton L., 'there's still water, but no electricity.'

4

Do atoms wear out?

His wristwatch had stopped. The Hommers' kitchen clock was electric and had stopped hours ago. Anton L. looked round the apartment. He found Herr Hommer's watch in the bedroom. It was on the bed, inside the left sleeve of his pyjamas. It had stopped as well. The kitchen clock showed just before half past one, Herr Hommer's at five past five; Anton L.'s watch had stopped at twenty-one minutes past eleven. It wasn't too much of a problem. From the position of the sun it must be late morning. The only question was, of which day? During his bouts of drunken delirium it had happened several times that he had slept through a whole day, once even two days. But then there had been other people around, including people who produced newspapers. You could find out where you were – *when* you were – from the newspapers, you knew what day it was. You'd lost a day, but then how often did you spend days you didn't sleep through getting up to pointless things?

'Yesterday,' Anton L. thought, 'that is, the last day I can remember, was a Tuesday. That means today's Wednesday or Thursday, the 27th or 28th, as long as I haven't slept through two whole days, or even three. No, not more than one. Only . . .'

Anton L. had a very uneasy feeling, a cramped feeling, a terribly paralysing feeling of impotence: he might never know what day it was, ever again. He saw now why Robinson Crusoe on his island had kept such a precise calendar. But Robinson Crusoe was lucky, he was not missing a day.

'Someone with enough knowledge of astronomy could probably work out whether today was the 27th or the 28th,'

Anton L. thought. He had, during his yoga phase, been interested in astrology, but he had no serious knowledge of the stars. He dashed to the front door; a futile hope, of course no newspaper had been delivered. At the front door he was suddenly overcome with hunger. Like a lion, hunger leapt into Anton L.'s mind, crushing all other thoughts with one blow of its paw. Even if it was only Wednesday, Anton L. had not eaten for thirty-six hours.

The bag of rolls was still in the kitchen. Anton L. felt one of the rolls. 'It's more likely to be Thursday,' he thought. But they were still edible. He cut open half a dozen of them, spread them with the butter, that had gone rather soft, and cut slices of salami. (With a clean knife, of course, not the bloodstained kitchen cleaver.) The fridge wasn't working. As he was chewing his rolls, Anton L. had a brilliant idea. He would put the butter in the sink and run the cold water over it. After six rolls, he ate half the pickled gherkins. Then he drank the vinegar. He had the feeling it was doing his stomach good. Then he ate a two-inch-long piece of salami without any bread, then a one-inch-long piece of salami, also without bread.

'If it should be the case . . .' Anton L. thought, going out on to the veranda. Sonja looked up and fixed her gaze along a line at a tangent to Anton L.'s head, this time the other side of it. She had eaten up the cheese. '. . . that, for reasons that are totally incomprehensible, I am the only person left on earth, then I suppose I am the one who decides what the date is. The question is, does time pass if there's no one there to register its passing? The stars pursue their courses, yes, some are formed, others disintegrate. But what are they formed from? What do they disintegrate into? Into atoms. And atoms do not wear out. Everything is self-contained, outside time, unless man is observing. Man: that's me. –

'It ate it, or, rather, *she* ate it. It doesn't seem to have made her sick. Still, in the long term . . .' Now Anton L. vaguely remembered Herr Hommer feeding his iguana bananas and lettuce leaves.

'Or should it be a mercy killing after all? I could liberate

her,' Anton L. thought, 'but she wouldn't survive here, not in these latitudes. If she's eaten all that cheese she'll keep going for a while longer. I'll see if I can find some bananas.

'Or do atoms wear out after all? It is strange that physics, where everything is so precisely determined, should overlap with such a nebulous subject as philosophy, where everyone thinks what they like.'

Anton L. gave the iguana some water. It occurred to him when his eye fell on the plastic saucer from underneath a flowerpot, which served as a drinking bowl.

'I tell you what,' he said to Sonja, 'let's give your facilities an upgrade.' He took a shallow China bowl with a gold edge and a floral pattern from the Hommers' wedding set, filled it with water and placed it in the terrarium. Either the iguana was paying tribute to the tasteful floral decoration or the cheese had made her thirsty. She fell on the water with a speed one would not have believed her capable of.

The living room looked like a battlefield. Anton L. discovered he had two injuries, a cut on his left finger and one on his left leg. Both cuts already had scabs. The glass top of the coffee table was in pieces. Herr Hommer's favourite leather chair was overturned and smelt of brandy. There were two circular patches on the floor, one large one, that also smelt of cognac, and one smaller, almost black one, in the middle of which the neck of the brandy bottle was standing with the sharp broken edge pointing up.

'Aha!' thought Anton L. and took a couple of hobbling steps. The bulbous gentleman's cabinet had a gaping hole, like a corvette after a direct hit from a broadside. Parts of a chair were stuck in the breach. His trousers were tied round the standard lamp. Nothing was to be seen of Frau Weckmeier's green velvet skirt, her black blouse or lacy corset. 'Still,' thought Anton L., 'perhaps I'm dreaming now and was awake yesterday, or the day before yesterday, if that's when it was. I admit it's not very likely that Frau Weckmeier would come here and dance and then . . .' He sighed. 'But what is even less likely is that *all the others* should disappear, at a stroke, apart from me.'

43

He picked up a leather sofa cushion. He remembered the men's magazine. 'It was her after all,' he thought. He should know now.

He dropped the cushion and untied his trousers from the standard lamp. Everything else he left as it was.

5

In the Monte Cristo

Anton L. went out into the street. It was like an oven. A hundred metres away the street dissolved in a dazzling haze in which the tram-lines were the only objects visible because they reflected the sunlight even more brightly, stretching out into the distance like white-hot strips, until they too were swallowed up in the glare of the summer afternoon.

The street where Anton lived was ugly. Old tenements from the end of the nineteenth century were interrupted here and there by houses built after the last war. These buildings, too, were ugly, perhaps even uglier than the old ones because the apparent functionality, which had been the ethos behind their design, soon revealed the shabbiness that was its true face. Yet on such a glorious summer's morning all these crumbling façades seemed to have absorbed something of the warmth and brightness of the day, even, one was tempted to say, to reflect the sky, taking on an air of stolid placidity. Here the honest citizen who was not too demanding could find everything to supply his modest needs and simple pleasures on his doorstep, so to speak.

Anton L. was aware of this cosy atmosphere. As an outsider, someone who had been neither born nor brought up there, he was much more open to it, more conscious of it, and sometimes he was put off by its aura of smug self-satisfaction. He was immediately immersed in this atmosphere when he stepped out of the door, it clung to him like the heat of the summer's day. At the same time, however, he knew that it was only the *memory* of its stolid placidity, that behind or above the street and its houses there loomed a mysterious catastrophe, an enigmatic malevolence.

'This peace and quiet,' Anton L. thought, 'is just like the peace and quiet of a Sunday afternoon. Why can't it *be* a Sunday afternoon?' He was seized with a kind of homesickness. 'Why does it have to happen to me?'

In a kind of obstinate sense of duty, which he would have imagined he possessed least of anyone, Anton L. was setting off for the Tax Office again. But then the thought came to him that perhaps everything was not lost after all, that the impossible had perhaps not really happened. And a new explanation occurred to him which immediately filled him with fear: only this district here was deserted, in the rest of the city life had gone on as normal. Perhaps some danger threatened, had done for several days, an explosion or an earthquake, and they had discovered that the earth had opened up and poisonous gases were leaking out, and had evacuated all the inhabitants of the district, or of all the districts this side of the river, and he was the only one who had been forgotten.

He could well believe Herr Hommer would think only of himself, at most of his daughter, and would leave his lodger to his fate. If it had come to the crunch, he would probably have left his wife to her fate too, but she had presumably scurried along with them.

So Anton L. quickly changed direction. No. 2 was the last house before the bridge. Beyond the bridge were the first streets of the city centre.

Hardly had he crossed the bridge than he saw how futile or hopeless his conjecture (or fear) was. There was not a soul on this side either. And all the side streets in the district where he lived were full of parked cars. (Parking was forbidden in the street itself and the police were very strict in enforcing it.) It was an area where more people lived than worked and in the evening the side streets were always full of parked cars. Even if there had been a sudden evacuation and the people had left everything behind, they certainly wouldn't have left their cars. Anton L.'s theory of a large fissure, or a forgotten underground ammunition store from the war, was wrong and that would have been obvious without the scene Anton L. witnessed on the other side of the bridge.

When he was only a few steps from the garden of a restaurant by the bridge, a pack of dogs shot out. There were four or five largish dogs and a couple of smaller ones. The dogs must have been sitting quietly in the garden, but the moment they shot out, they began to bark furiously. Anton L. leapt back, but the dogs ignored him. Their agitated barking was directed at the trees on the embankment beside the bridge. Anton L. took the precaution of retiring a few steps back onto the bridge. At that moment another pack of dogs appeared among the trees. One of the dogs in the first pack, not at all the biggest, broke ranks and rushed at the enemy, checked its run more or less exactly halfway between the two packs, gave a few particularly loud yaps at the others then ran back to rejoin his comrades – at the rear, its bold sortie clearly having exhausted its courage. When it set off on its solo charge its pack had taken precisely one step forward. The others had immediately set up a furious barking.

The birds in the trees flew up. A Pomeranian at the second-floor window of a house slightly to one side barked excitedly from the window-ledge. It was not obvious which side the Pomeranian was on.

A few seconds after the solo charge of the dog from the right-hand pack (from Anton L.'s point of view), the left-hand pack took two collective jumps forward and one back. Confusion threatened the right-hand group and they looked like taking flight, but the ranks still held. They kept up their defiant barking, raised, indeed, intensified it, though none of them dared risk repeating the bold sortie, the fronts were too close. The face-off began.

The left-hand pack opened up with the bigger dogs putting their heads flat on the ground, teeth bared, and sticking their backsides up in the air. The right-hand pack immediately followed suit, though of course the effect was not quite the same. The barking was reduced to a growling and grinding of teeth, from which a single bark flared up now and then. Only the excited Pomeranian at the second-floor window kept up its yelping undiminished.

Suddenly the left-hand pack, raising their growls by a

semitone, crawled forward on their bellies with astonishing speed until they almost touched snouts with the others. Without taking their eyes off the enemy, they immediately crawled back, but not quite all the way to their previous line.

After noticeable hesitation the right-hand pack copied the manoeuvre, though they returned to their original base without gaining ground. This was repeated a few times, with constant growling, as if the dogs were pushing an invisible ball back and forwards between them. The dogs in the left-hand pack, their snouts still flat on the ground, had started stamping their back feet and a grey poodle in the right-hand pack lost its nerve and ran off. Bristling backs tensed on the left, a salvo of barks came from the right, but the right-hand front was wavering, a second dog took flight, a third, they all took flight. As if let off the leash, the left-hand pack shot after them and attacked the fleeing group with murderous intent. A Great Dane and two boxers tore the slower dachshunds to pieces. The grey poodle was tossed up in the air, caught and ripped apart. The faster dogs from the vanquished pack ran down-stream along the river, the victors pursuing them. A brown spaniel, which had quite clearly belonged to the right-hand group, joined the pursuers, without, however, putting on a show of suspiciously exaggerated keenness. The barking faded down the river. Trying to see round the corner when the events moved out of its field of vision, the Pomeranian stepped too far out onto the window-ledge. It fell and hit the road with a splat. The crows were already circling over the battlefield.

Once the barking had receded into the distance, Anton L. cautiously continued on his way. However terrifying the sight of the raging dogs, presumably half-starved, who had turned back into the beasts they had originally been, Anton L. was grateful for having had the chance to witness the cruel spectacle since it served as a warning. It was a warning he was to recall very soon.

There was a car by one of the advertising pillars between the bridge and the city centre. It had obviously crashed at full speed into it. There was no one in the car. A dinner jacket was

dangling over the driver's seat and on the passenger's seat was a gossamer-thin sheath of some emerald-green material.

'If that was a dress,' thought Anton L., 'I'm sorry I never met the lady.' On the floor of the car were two pairs of shoes, men's on the left, ladies' on the right, also emerald-green.

Anton L. had to overcome an inhibition barrier before he could bring himself to fully open the door that had been forced ajar by the collision. He had the feeling the clothes were corpses.

'Nonsense,' he thought. They didn't smell; that is, the gossamer sheath smelt of a delicate perfume. 'Diorissimo,' thought Anton L. He had a sensitive nose and for a while Dagmar had used Diorissimo.

He took out the dinner jacket. The shirt was inside, the vest inside that.

'Just as he was wearing it,' thought Anton L. He put it back in the car. A small roll of paper fell out of the waistcoat pocket: two hundred-mark notes. Anton L. stuck them back in the pocket. He picked up the emerald-green sheath: delicate textiles fell out: a pair of tights with a slight shimmer of gold, very thin, black lingerie with floral decoration.

'Pity I never met the lady,' thought Anton L. again. There was a thick gold necklace on the seat . . . Anton L. put his hand inside the emerald sheath. The fabric glittered. The colour of his hand could be clearly seen through the fabric. 'I can just picture it,' he thought. He stretched the fabric. The scent of Diorissimo grew stronger for a moment. 'It wouldn't have fitted Dagmar. She wasn't what you'd call slim. I wonder if she too . . . if she'd still be here if we'd got married?'

Anton L. held the glittering, transparent fabric in his hand, almost put it in his pocket, but then threw it back into the wrecked car. The dress curled up on the seat like a snakeskin.

'Snakes!' thought Anton L. He had such a horror of snakes he could not even look at pictures of them in the encyclopaedia. 'I hope snakes don't start appearing as well.' He regretted not having brought the Hommers' kitchen cleaver with him, although the idea of coming close enough to a snake to chop it up almost made him sick.

It was not a snake that Anton L. was to encounter. On his way into town he came across a few cars that were not properly parked at the side of the street. In Medea Strasse there was one in the middle of the road. A little further on, just in front of the window of a shop selling basketware, there was a police patrol car. Both had their lights still on, although they were very faint. At one time, under what he later called Dagmar's petty-bourgeois influence, he had taken driving lessons. He had never passed his driving test (not surprisingly his engagement with Dagmar had been broken off, though that had nothing to do with her insistence on him taking driving lessons), but he remembered the basics of how to drive. He walked round the first car and looked in. There was a grey suit on the seat.

'The couple had probably been to the theatre and then gone on to a bar,' he thought, 'but what was this chap doing driving round in the middle of the night?' With some difficulty – it took several tries – he managed to open the boot. In it was a spare can of petrol, a spade, a bundle of straps and a tennis racket. Anton L. closed the lid. Unmoved now, and with his habitual contempt for almost all other people, especially those he did not know, he threw the grey suit and any underwear in it, on the street. Then he got into the driver's seat. The key was in the ignition. He tried to start the car. The engine gave one sluggish turn then died.

'The driver must have dematerialised while he was driving, which meant that when the accelerator was released, the car rolled to a standstill and the engine stalled because it was still in gear. The ignition was still on, the lights as well; of course, it happened during the night. That's why the battery's more or less flat. The other car, the one with the posh couple wearing the dinner jacket and the snakeskin, was probably exceeding the speed limit and had sufficient impetus to ram the advertising pillar. The police car would have been speeding along like mad too, but perhaps it was going straight. That's why it stopped just short of the shop window.' He went over to the patrol car. He felt an urge to complete the job. He took an iron bar out of the car. 'Why,' he wondered, 'did they have an

iron bar with them?' and hurled it at the window of the basketware shop. The baskets tumbled down and a pyramid of decorative handcrafted candles, which had obviously taken a great deal of effort to erect, collapsed.

The patrol car would not start either. Probably a flat battery too. But there were two guns by the uniforms. Remembering the snakes and the dogs, Anton L. stuffed them in his pocket. He also took a torch. A door next to the basketware shop was half open. Anton L. looked in: a dark passageway with the gloss paint peeling off led into a tiled stairwell and, beyond that, to a courtyard. He went out again. It would not be long before that rear courtyard was to be his salvation, despite his guns.

Two blocks further on, the ground floor of a corner house was painted bright red. *The Count of Monte Cristo* was written over the door. The door was open. It was an all-night bar. A display decorated with sequins had pictures of almost, or completely, naked women. 'If it happened while they were performing,' thought Anton L., 'there'll be nothing left to show, at most a few feathers they had on their heads, and a gold tooth.'

Anton L. went in. He was greeted by an odd smell. Some steps with a red velvet carpet led downstairs. On the stairs it was still reasonably light. At the bottom a heavy velvet curtain masked the entrance to the bar.

The place was not unknown to Anton L. An anniversary celebration of the Kühlmann Travel Agency had ended up there. 'The lengths some people will go to in order to avoid paying,' Anton L. thought, remembering. From his very first day there he had seen that Herr Kühlmann was a skinflint, even though Herr Kühlmann made every effort – and, one must say, by and large successfully – to present himself as an 'expansive' character. There were three impressions Herr Kühlmann was constantly endeavouring to arouse and keep alive among those around him: to appear reputable, efficient and imposing. In the generally accepted sense Herr Kühlmann was certainly reputable, if only because he was too mean to indulge in disreputable behaviour. Efficient: fortune had

smiled on Herr Kühlmann's business, it was booming, he was well off, but if you looked closely, you could see he was useless. As far as being imposing was concerned, Anton L. had once been amazed by an experience he had had with Herr Kühlmann. His boss had taken him out in his car on business and had turned left where there was no left turn. There was, however, a policeman there. The policeman blew his whistle and waved Herr Kühlmann to a halt at the roadside. The policeman was a short, fat man with an extremely ridiculous yellow beard. Herr Kühlmann immediately got out of the car, assumed an imposing posture and showered the policeman with a torrent of words: "Can happen to anyone, no need to make a song and dance about it" and, "Do you know who you are talking to?" – "Yes," said the policeman, "a Prussian who has just turned left where there's no left turn." Anton L., who at that point had not yet had the opportunity to become acquainted with the whole of Herr Kühlmann's psychological make-up, assumed his boss would proceed to tear the little policeman to pieces. But what happened was quite different. Herr Kühlmann withdrew, grinned – he had a very large mouth with lots of teeth missing – and retired to his car. He started opening and shutting the bonnet and the boot, poking about in the engine, rummaging in his toolbox and told the policeman, as he was writing out the ticket, that he had business in the house next door (which was certainly not true) and disappeared inside. Anton L. accepted the ticket, attached it to Herr Kühlmann's steering wheel and told the policeman he shouldn't think Herr Kühlmann would pay; he'd rather die.

Later Anton L. happened to run into Herr Kühlmann in the city. At work the boss had always worn very respectable and imposing suits, but it was well known that he could not bring himself to throw away anything, however shabby. When Anton L. ran into Herr Kühlmann the latter was clearly not in the city on business; he was wearing a threadbare macintosh and a hat that would have looked perfect on a scarecrow. Anton L. greeted Herr Kühlmann. Herr Kühlmann did not respond.

The staff were accordingly astonished when Herr Kühl-
mann gave a party to celebrate the anniversary of the found-
ing of the business. He spent days searching out cheap sources
of champagne; to be openly stingy and limit everyone to
a certain number of drinks would have contradicted the
expansiveness of the imposing image he wished to project as a
reputable businessman. The champagne was to flow freely,
but it had to be as cheap as possible. On the other hand, it
mustn't be a well-known cheap brand. Not being refreshingly
open about his stinginess, like Anton L.'s later boss old von
Speckh, a banker who would drive twenty-five miles to get
his hair cut because the barber there was ten pfennigs cheaper,
Herr Kühlmann had a hard time of it.

Frau Kühlmann also attended the party, putting in one
of her extremely rare appearances. One could tell that in
younger years she had been a lively and cultured woman,
but for decades now she had been smothered by a husband
who always knew best. *She* had never stopped thinking Herr
Kühlmann was an imposing figure. Now she was almost blind
and half deaf, probably from spending all her time gazing on
her shining knight of a husband and listening to his inexhaust-
ible flood of words. Frau Kühlmann was soon sent home.
After that the longest-serving of the travel agency employees,
Klipp, the office manager who was bald as a coot and already
tipsy from the freely flowing champagne, suggested they
should really make a night of it for once. Just round the corner,
he said, was the notorious Monte Cristo.

Herr Kühlmann could hardly not join them, but from that
moment on there was a fierce struggle taking place inside him.
It was clear to Anton L. – at that point he was going through
an almost teetotal phase – that when it came to the crunch
Herr Kühlmann's repressed stinginess would prevail. The
means to which the old skinflint would resort were, though,
entirely unexpected.

It wasn't a weekend. The audience in the Monte Cristo was
decidedly sparse. The waiter showed them (six men and two
women) to a table in an alcove. Herr Klipp immediately
ordered three bottles of champagne – Herr Kühlmann was

already feeling uncomfortable – and when it was served raised his glass to Herr Kühlmann, "our generous host". Herr Kühlmann found it almost impossible to produce even a sour smile.

The ladies turned in a mediocre performance. Given the small audience, they took off their items of clothing one after the other without any discernible show of enthusiasm, at most they waved their bras about a bit. It looked as if they were the reserve team. Herr Klipp even claimed that one of them was the cloakroom attendant. "At least," he said, "you can see they've had decades of experience at striptease."

When Herr Klipp ordered a round of whisky and sodas, making it clear beyond doubt that these, too, were on "our generous host", Herr Kühlmann looked as if another of his big teeth was going to fall out. The silence that emanated from him was frosty, though Anton L. was the only one to notice as all the rest were already drunk.

Klipp told jokes. Everyone laughed. Herr Kühlmann did not. That he had hardly said a word since they had been there should have been a warning. Then Klipp declared he was going to dance with the naked ladies. (The number that was being performed was *Jingle Bells*.) They all laughed. Klipp pretended he was serious about it. They held him down amid gales of laughter. But then Herr Kühlmann got up, his face a greenish yellow, and began to skip along with the ladies to *Jingle Bells*. The ladies screeched and ran off. The musicians did not notice right away and played on. Two waiters rushed up and dragged Herr Kühlmann off the stage. Herr Kühlmann made as if to take his trousers off. They threw him out. The horrendous bill was divided up between them. The sum was so astronomical even Klipp sobered up immediately. Some of them – Anton L. was one – did not have enough cash for their share with them. They had to work off their debt in the Monte Cristo kitchen.

'The old tightwad!' said Klipp. 'But we'll make it up with an unofficial go-slow at work.'

Those that were left of the Kühlmann staff were the last patrons (patrons?) to leave the establishment. Clad in dreary,

light cotton overcoats the ladies with decades of experience at striptease called for a taxi. No one who saw them like that would have wanted to see them get undressed. Anton L. was afraid the doorman, who had also changed his gold-braided uniform for a macintosh, would bid them a mocking farewell. He ignored them. He did draw the heavy red curtain aside, though not out of politeness, but only to save the expensive velvet.

The gold-braided uniform was lying on the floor in front of the velvet curtain. Anton L. switched on his torch and ran the beam over the pile of clothes. Had it been the same doorman? The cap had rolled into a corner. It was almost certainly not the same doorman. People moved around a lot in that business.

Anton L. drew the curtain aside and directed his torch into the room. An overpowering smell of decaying flesh hit him. A huge shadow rose up. The torch picked out a set of jaws with terrifying teeth, high above him, or so it seemed. Anton L. dashed back up the stairs as fast as he could. The bear gave a fearsome growl; fortunately it got tangled up in the velvet curtain. By this time Anton L. had reached the top. He tried to shut the door, but it was fixed and it wasn't obvious how. Anton L. ran. Bears are quick when they're annoyed. The torch had startled it. It shambled out and stood up. It was taller than the door. Anton L. ran as fast as he could. The bear dropped onto all fours and ran after Anton L. It seemed to be going at an easy canter, but that was deceptive. It was getting closer, and quickly. Part of an iron chain hanging from its leg was dragging along the pavement. The bear was not far behind Anton L. when he came to the half-open door next to the basketware shop. He ran in and slammed it shut. The bear flung itself at the door, making the passage boom. Anton L. ran into the courtyard behind. There was a wall there, with rubbish bins in front of it. Anton L. climbed up onto the bins and swung himself over the wall. On the other side was a garden and beyond the garden the back of the next row of houses. There was no sound of the bear any more, but

Anton L. still ran. He smashed in the window of a ground-floor flat, opened it, climbed in, walked through to the front and looked out into the street. It was Wasserträger Strasse. Unless the bear had carried on, he had put two street corners between himself and it. He took out the guns, then sat down in a chair to get his breath back.

There was a clock in a glass case on an oak sideboard. It had stopped. Above the sideboard was a picture, a bellowing stag in winter. Crossword magazines were piled up high on a small table. On a stool was a rubber plant. Anton L. got up again. He had run so fast he couldn't settle down for the moment. He went into the kitchen, filled a jug and watered the rubber plant.

'That means it will die one day later,' he thought.

Then he tried firing the guns. He did not know that the bolt had to be engaged first, so he didn't manage to fire a shot. (He had aimed at the clock in the glass case.) He put the guns away; he would try at home when he had calmed down. He looked out of the window again. No bears in sight.

The key was in the lock inside the front door, attached to a ring with a whole bunch of keys. Anton L. opened the door and kept the keys. On a brass plate outside it said Saalegger. To go by their apartment, the Saaleggers must have been quite old. They would surely have been past riding bicycles, but perhaps not others who lived in the house. The cellar was locked but the key was on the ring. There was a place for keeping bicycles in the cellar with three bikes in it. One, a modern, orange lady's bike with small wheels had no lock on. Anton carried it up the steps, peeped cautiously round the door up and down the street, then quickly cycled home. He went a long way round to keep as far away from the bear's den as possible.

6

Evening and night

Riding the bicycle – across the bridge, the refuge of the Hommers' apartment in sight, out of reach of the bear – his terror subsided. To be replaced by a more subtle fear: the thought of the night to come.

It was not difficult to ignore the thought. It was still only the afternoon and these were the longest days of the year. But as the sun gradually set, more and more the thought kept coming back to him that night was approaching inexorably and Anton L. would be alone in it.

Everything Anton L. did on that late afternoon and early evening helped him forget the thought of the lonely night to come. But in the late afternoon, the early evening, the veil of activity was already becoming threadbare, the fear discernible through it. Once you start thinking, 'I mustn't think about it,' it's too late.

He did not go far from the house. He remembered now that he had read in the paper about a small circus doing the rounds of the suburbs. The bear dragging its chain behind it must surely have come from there. Laforte's Circus it was called.

The first thing he did was to go out onto the veranda to try out his – he was so alone by now that he automatically thought of them as 'his' – guns again. It gave him great pleasure to clear the veranda by throwing out the Hommers' enamel buckets, tin baths and stoneware pots, which were all rusty, dusty, chipped and dented. The thunderous crash that could be heard far and wide – they fell three storeys – was a sign of how quiet the world around had become. One dog in a distant backyard started barking, that was all. The dogs had

presumably all died, those that had not managed to escape, that was. At the dull, earthy thud of the stoneware pots a few crows flew up from the courtyard of the next block but one. Sonja, on the other hand, did not move a muscle.

Anton had cleared a bench that was not uncomfortable. It was a bench and chest combined. Anton L. lifted the lid (which was also the seat). It was full of things that bore some similarity to old clothes. A swarm of moths flew up. Anton L. took a handful of clothes and threw them out of the window. It was interesting. As they fell the old rags drew a trail of dust behind them, like a comet. They hit the ground like a bomb and exploded in a cloud of dust. Anton L. enjoyed that. (It stopped him having to think of the night to come.) He threw down another bundle. Again an explosion of dust billowed up. Anton L. threw a third bundle down . . .

He remembered the time Herr Kühlmann, the old tight-wad, had moved house. It was while Anton L. was still working for him. Naturally Herr Kühlmann was too mean to get a removal firm to do the work. Instead he rented, perhaps even borrowed a lorry and detailed his employees (in shifts, the travel agency had to stay open, of course) to transport his furniture. Each one of them was on for two days, Anton L. for one right at the beginning and one right at the end.

On the last day, the second time Anton L. was on removal duty, they cleared out the loft. Given the junk he had to admit to owning, Herr Kühlmann had found it difficult to maintain his imposing façade. If he had simply *owned* it, that would have been bad enough, but to be taking it with him, and that in the presence of his employees, must have set off a mighty struggle inside him between his miserliness and his desire to impress. As always, his miserliness had come out on top.

Herr Kühlmann's old apartment was in a two-storey build-ing; the loft, therefore, was on the third floor, so to speak. It had contained: a few old bicycles; two sets of skis and three single skis; seventeen shoes; a pair of riding boots without soles; around two hundred empty bottling jars; a framed certificate from the Gauleiter of the Warthe *Gau* officially attesting Herr Kühlmann's bravery in the defence of the

Fatherland; four pictures with frames, six pictures without frames; one guitar; one commode; two doors; one file with correspondence (Anton L. read it on the lavatory; it dated back to 1944 and concerned Herr Kühlmann's attempts to avoid being called up and instead get permission for a convalescent stay in Switzerland); several lampshades; postcards tied up in bundles; a number of old cylindrical iron stoves; *Mein Kampf*; a bundle of paper collars; what looked like enough furniture to fully furnish two or three apartments. Anton L. and his colleagues spent the whole day carrying the things down three flights of stairs. When they came to the mattresses someone suggested the simplest thing would be to throw them out of the loft window. One threw them down while the others waited below and cleared them away. There was an explosion of dust there too as they hit the ground. Once Herr Kühlmann, who felt he had to be everywhere at once, walked directly underneath a falling mattress. Anton L. had shouted, "Watch out!" only to regret it the moment the words passed his lips. It made no difference, the mattress fell right on Herr Kühlmann's head, sending him tumbling to his knees and wrapping itself round him. Everything was swathed in dust; when he emerged Herr Kühlmann looked like a very large mouse.

Compared with that, the amount of junk the Hommers had was modest. Anton L. threw down a few more handfuls then sat on the bench and fiddled about with one of the guns. He kept aiming at the veranda diagonally opposite, the one where the two dogs had been, but no shot came. He put the guns down on the bench.

Now the thought of the night to come was raging through his mind. The sun had already sunk below the rooftops. One of the moths had flown through an airhole into Sonja's terrarium. The iguana snapped it up. 'I'll have to get something for her,' thought Anton L., 'she hasn't had anything since the cheese.'

Taking the kitchen cleaver with him – since he couldn't make the guns work, it was the only weapon he had – he went

to the delicatessen he had broken into on Tuesday. He used the keys to get in. A swarm of rats poured through the broken shop window out into the street when Anton L. entered the shop from the rear. He was met by a stale, putrid smell. He opened all the windows and doors. He had intended just to get enough for that evening, but after seeing so many rats, he decided to lay in a stock of provisions. It was a lot of work, and that put off his fear. He found a handcart in the courtyard which he filled with tins and jars and trundled along to no. 2. He had to make four heavily laden trips up the stairs until everything was in the apartment. Then he loaded up the next batch. He made six journeys in all. The goods were piled up in the corridor. He decided to sort them out and store them in the coolest room in the flat, the bathroom.

'I wonder if they're going to come back, they, the other people?' Anton L. took a clear, logical view of the situation and accepted the fact that all the people in the city, possibly all the people in the world, apart from him, Anton L., had disappeared at a stroke during the night of June 25 as a natural phenomenon. There must be some, so far unknown, law of nature according to which human beings, under certain conditions, could desubstantialise. It must be a horrible law of nature, but it was, assuming Anton L. was not mad or dreaming, a fact, and from that one could conclude that there could well be an inverse law, according to which all the people would suddenly reappear . . .

Anton L. decided to tidy up the living room a bit. It was, he had to admit, a disgrace. On the other hand the Hommers ought to be glad he had thrown their old clothes and pots over the veranda; he had, after all, looked after Sonja. Sonja! He had been so busy transporting his provisions, he'd forgotten her. He hadn't brought any cheese, it had all been crawling with maggots. He opened a jar of small, neatly peeled potatoes, genuine luxury potatoes and, moreover, the only thing in the delicatessen that wasn't preserved in vinegar and oil, or something similar. He took out the biggest potato and threw it into her terrarium. She turned her head in the direction of the potato, directing her gaze at a precise tangent to it.

'She's sure to eat it,' thought Anton L., 'if not I'll bring her the cheese, perhaps she likes maggots.' Then he went back into the living room. He picked up the pieces of the glass top of the coffee table and put them in a wooden bowl with ears of corn carved round the edge. Between the ears of corn, in crude letters, also carved, it said, "Give us this day our daily bread."

Evening came. The thought could not be suppressed any longer: the night would come. There was nothing he could do about it, in less than two hours the night would be there. Anton L. felt as if the hour of his execution were approaching inexorably. He put the bowl with "our daily bread", now only containing broken glass, down on the desk beside the television programme guide. The room was filled with grey shadows. The sky had already started to cloud over from the west while he was transporting the last cartloads of provisions. Despite that, the heat was becoming almost unbearable. Anton L. took his shirt off. He felt as if his vest were being soaked in honey. Fear sets a process of regression in motion. The mind abandons one adult region after another, slipping back until eventually it is defending the core that was already there when one was still a child.

The TV paper had two pages for each day. It was open at Monday the 25th. Today was Wednesday or Thursday. Anton L. could just about read it in the semi-dark: Thursday the 28th was the last day in the magazine, after that it would be the next issue. He looked at the clock. He had set it roughly according to the sun. It showed nine o'clock, though it was probably a little earlier. *The Sons of the Prophet: Israel – Old or Young?* A documentary on Channel One. On Channel Two: *The Gallows Tree* an American film of 1953 with Gary Cooper. Herr Hommer definitely would not have watched that. He didn't think much of Gary Cooper films. Channel Three: *The Elite: Discussion and Problems*. Herr Hommer would certainly have switched over to Austrian television, but that was showing *The Gallows Tree* as well. Perhaps Herr Hommer would have watched it after all. Anton L. switched the set on. Nothing happened, of course.

It was unbearably hot. He opened the window. Outside it was even hotter than in the room. The sky was black. Anton L. was a little boy, ten or eleven years old, he just wanted to run somewhere where there were people, to get away from where he was and get somewhere, breathless but saved, where there were lights and people. But there were no people anywhere.

He went out onto the veranda. He had put the police torch down there beside the guns. He switched it on. A bright beam fell on Sonja, who shot away from the potato, dazzled. He switched it off again. If he left it on the whole night, the battery would soon go flat and he would have no light if something really did happen. Who knows what animals there were roaming round the town already. He should have got in a supply of candles. It was unforgivable. There'd been a whole pyramid of candles in the basketware shop. But now the bear was on the prowl. 'I'd better close the living room window, who knows . . .'

He could feel the terror creeping up his spine and hurried back into the living room. He screamed, his hair stood on end: there was a huge bird on the window-ledge. It was only the curtain that had caught in the open window. An almost imperceptible wind had arisen. Anton L. shone his torch in every corner of the room. Only then did he go in. But now he felt as if he was in a padded cell. He opened the window again. It wasn't a wind that had risen, it wasn't even a breeze, just the sluggish displacement of layers of greasy air.

'They must come back,' thought Anton L., 'even if they get angry at the mess in the living room. And I have to get some candles. Perhaps Sterr's has candles.' (Sterr's was the delicatessen.) He ran out, but before he reached the floor below he suddenly remembered the packs of dogs. The horror was seeping up from below, like banks of fog, and down from the loft, which he had always found eerie. Anton L. felt he was about to be crushed. He switched the torch on and fled back into the flat. He had left the shutters open and they were rattling against the window. He decided to take refuge in his bed, pull the covers over his head and try to survive the night. But it would only be the first of a thousand nights.

'And there'll be a snake in my bed, there's sure to be a snake in my bed, there's always a snake in the bed. A thousand nights aren't even quite three years; thirty years would mean ten thousand nights. Each night will pile up its terror, like blocks of stone, on the previous one until there's a towering wall of fear. It will get worse with each night, today is just the start.'

Anton L. went back out onto the veranda, picked up one of the guns, shook it, jiggled everything that could be jiggled (the only thing he did not do was to engage the bolt), put the barrel to his head and pulled the trigger. There was a terrible bang, but outside the building, and at the same time there was a flash of lightning. After several torrid days a violent storm broke over the city. With the initial clap of thunder it started to rain, at first in heavy, single drops, but soon it was bucketing down. The air cooled. Anton L. was exhausted, as if he had been dragging millstones round with him. (He had carried six cartloads of provisions up to the apartment.) There was no snake in his bed. He fell asleep right away, though still clutching the torch.

7

Pfeivestl's legacy

Anton L. did not have a car. The Hommers, he knew, did not have a car either. If his memory served him correctly, the Derendingers on the first floor did have a car. There were two Derendinger families that had flats in the building. The old Derendingers lived on the fourth floor and had been there almost as long as the Hommers. Once in a blue moon old Derendinger would come to see Herr Hommer, though Anton L. could never remember Herr Hommer going up to the Derendingers'. Old Derendinger was older than Herr Hommer and had been retired longer; Anton L. had no idea what he used to do. Some years ago now a junior Derendinger family had split off when an apartment had become available on the first floor. The younger Derendinger was no longer that young when Anton L. became acquainted with these circumstances, but he wasn't yet retired, of course, though it was unclear what he actually did. It would not have been impossible to find out, but Anton L. was not interested. Anton L. would presumably never have come into contact with Derendinger if it had not been for the latter's special interest. This was in sport or, to be more precise, in football, in watching, reading about and, above all, talking about football. "Interest" was, of course, far too mild an expression. For Derendinger nothing existed outside football, the world consisted of football, football was what gave meaning to life. For him the world was a tightly woven net of local, regional, national and worldwide leagues, divisions, championships and cups; all that names such as Milan, Madrid, Warsaw, Cyprus, Ireland signified for him were certain places in football league tables. Parts of the world where football was not played, if

there were such god-forsaken places, simply did not exist for him. For him God, if Derendinger ever reflected on the matter, would have been a kind of primal spirit in the form of a football.

All that was Derendinger's *passion*, but his *love*, his exclusive love, was for a football club known as the Blue-and-Whites. This love was the tenderest, most heartfelt love imaginable, a sensual, earthly love; the love of the most ardent patriot for his homeland, the love of an artist for his art were as nothing in comparison with the all-embracing emotion, rooted in every cell of his body, that Derendinger felt for Blue-and-White Football Club. Derendinger, as already mentioned, did not reflect on theology, but when the Blue-and-Whites had won, he knew there was a God in heaven. Blue-and-White F. C. was never defeated, though unfavourable weather and pitch conditions, biased referees, spectators prejudiced in favour of the opposition, at most a combination of unfortunate circumstances could *rob* Blue-and-White F. C. of victory, but never Derendinger of his faith in the club. Derendinger would have sold his wife and all the youngest Derendingers (three, if not four, presumably fathered during the summer break) into slavery, if it would have helped the club, indeed, he would happily have let himself be flayed alive, like a new St Bartholomew, or boiled in oil, if it would have brought one single winning goal.

It would have been quite impossible for Derendinger to imagine anyone who was not interested in football. Even if one makes the effort, one can only conceive of the fourth dimension theoretically, one cannot imagine it in physical terms. For Derendinger a man who was a teetotaller as far as football was concerned would have been a misbegotten freak, an imaginary creature. Even when they made an effort to take an interest in football, women were misbegotten freaks for Derendinger because they are incapable of an all-pervading enthusiasm for the sport. Derendinger sensed that. For him, as for strict Muslims, women were beings lacking a soul whose value lay in relatively pleasant genitalia and the ability to cook.

When the Blue-and-Whites had won, the release sent Derendinger into a euphoric phase in which he assailed anybody and everybody with descriptions of the game. Anybody and everybody included those he happened to run into, which was how Anton L. had become acquainted with Derendinger soon after he had taken lodgings with the Hommers. Football was a passion that had never taken a hold on Anton L., but Derendinger, carried away with his own enthusiasm, did not notice. The mere fact that Anton L. nodded at his eulogies in praise of the heroes of Blue-and-White F. C and their deeds was sufficient to make him an initiate in Derendinger's eyes.

Anton L. remembered that not long ago old Herr Derendinger had told Herr Hommer – on the stairs, Anton L. happened to be passing – that his son had bought a new car. Anton L. also remembered that not long afterwards he had seen Derendinger getting into a red Volkswagen with the youngest of the Derendinger children. The block of flats had no garages, therefore Anton L. presumed Derendinger would have left his car in the street, probably close by. And the keys would be somewhere in his apartment. So Anton L. broke into Derendinger junior's flat. It did not surprise him that the dominant colours there were Blue-and-White and the walls decorated with photographs, some life-size, of knobbly-kneed footballers. He found Derendinger's jacket on a coat-hook and the car keys were in the pocket. After a short search – Anton L. went out into the street very cautiously, but there were no animals about – the car was found in a little side street.

Even though Anton L. presumably had the whole city to himself and did not have to worry about other vehicles, driving the car was almost his greatest adventure so far. He had not had an easy time of it with his driving instructors. There had been three altogether. The first had put in only a brief appearance, Anton L. could not remember him. The second was a great uncouth lump with no manners at all, the third a furtive little mouse. All the anger that had mounted up inside him because of the uncouthness of the second was worked off on

the third. But one day his rudeness, which was really just the rudeness of his second instructor being passed on, was too much even for the furtive little mouse. He lost his temper – for Anton L. it was like a bolt from the blue – and threw his pupil out of the car.

It happened at a crossroads, where Anton L. stubbornly refused to accept his instructor's interpretation of who had the right of way. When his instructor tried to defuse the situation by suggesting they agree to differ he replied that no, his was the correct interpretation and that was that. Furious, the instructor slid into the driver's seat and drove off, leaving Anton L. standing in the street, in a part of the town he did not know. It started to rain. The consequence was one of the worst swellings of the solar plexus in his life. The instructor, a furtive little mouse again once his anger had subsided, had his own problems. The owner of the driving school came down on him like a ton of bricks. A driving instructor couldn't treat his learner drivers like that. You never knew, it might lead to all sorts of claims for compensation, the school might even lose its licence. Anyway, with the fifty lessons he'd had and a further fifty in prospect, Anton L. was a good customer. The instructor was ordered to go and apologise. Anton L. never found out about that, as he was always out when the instructor called, and after such a humiliating experience he didn't dare go back to the driving school. Thus his driving skills remained incomplete, but they were still sufficient for him to drive Derendinger's red Volkswagen (which of course had a club pennant on every window and a little net with a miniature football and a pair of miniature football boots bobbing up and down from the rear-view mirror) carefully out of the parking space. He drove out without any problem, but then he pressed the accelerator down too vigorously. Also the road he was turning into was very narrow (or, to look at it another way, the curve the car described was too wide), and Anton L. collided with the wing of a larger blue car.

'I wonder if Derendinger's dematerialised molecules are turning in some cosmic grave?' From that point on Anton L. drove with exaggerated care, slowly and making full use of

the whole width of the street, not in order to avoid further damage to Derendinger's bodywork, but to avoid injury to himself.

The thunderstorm and the rain of the previous night had cooled the air. The clouds had cleared away and the sun was still low in the sky. The large triangular shadows stretching across the streets running in a north-south direction contained blocks of coolness which were, however, melting visibly. The morning sun, still thinly veiled, was shooting its gentle arrows along the east-west streets at the trees in the parks and avenues. The trees were motionless, not even the memory of the nocturnal storm made their branches sway. The only legacy the storm had left were the large drops of water falling from leaf to leaf and finally onto the ground, onto the gravel or tarmac, large, peaceful, good-natured drops, which landed with a quite different sound from the other large drops which had announced the approach of the tempest the previous evening.

In one street the gale had blown over an advertising hoarding; nobody would right it. Here and there broken roof-tiles were scattered over the street; nobody would sweep them up. Part of some scaffolding had collapsed. The tattered sacking, with which the scaffolding had been covered, was hanging down in the street.

He saw a few dogs, mostly in packs. Cats were rare. They had presumably returned to the woods. One street in the middle of the old town was cobbled. There was already a shimmer of green in the gaps between the stones.

'That's how quickly it goes,' thought Anton L. 'Of course, the rain.' By the river, but farther downstream, he saw a herd of goats. They were very small goats. Anton L. remembered having seen them in the zoo, some kind of mountain goat from Anatolia or Africa. Anton L. was delighted those goats in particular had managed to escape from the zoo. They had certainly been well looked after there, but their compound was somewhat away from the main visitor routes so that hardly anyone noticed them. They were brown, with a dark, nearly black stripe down their backs; they were

plump and round, almost broader than long or tall, but still incredibly lively. There were also a few very tiny ones among them, still all black, but already plump, keeping close to their mothers and rubbing their plump little bodies against their mother's plump body. The whole herd stood still as Anton L. drove past, all their heads turning towards him, the little billy goats looking as fierce as they could. 'I hope they can defend themselves against really dangerous animals,' thought Anton L.

Even as he drove away from Faniska Strasse the idea of finding somewhere else to live had occurred to Anton L. Since he left his mother – or, to be more precise, since his mother had left him – he had frequently moved, at least ten times. The two years he had lodged with the Hommers was a lengthy period for him. Usually it wasn't long before friction developed between Anton L. and the people he was renting from; add to that his various phases and sooner or later they had an excuse for throwing their lodger out. Despite that, Anton L. had the feeling he would like to settle down. It was a feeling that only surfaced when he was moving into a new place, a feeling that he would spend the rest of his life there. It then sometimes happened that by the very next day he decided he couldn't stand the room or the district or his landlord. In contrast to Herr Kühlmann, Anton L. did not have many belongings. His wardrobe was sparse; he did read a lot, but only rarely did he keep a book, there would have to be a very special reason for that. Mostly he read paperbacks, which he then gave away or simply left lying somewhere. That was one reason why he liked moving, it gave him the opportunity to get rid of half his belongings. Possessions meant nothing to Anton L. Once he had an unheated bed-sitter. When autumn came he needed to buy an electric heater. When he finally got round to doing so, he felt as if he had married a widow with five children. After a few weeks of cohabitation he ran away from the heater and moved to new lodgings.

Given that attitude, it was hardly surprising that Anton L. had never bought a place of his own. He would have found

the possession of all that furniture oppressive. Renting a bed-sitter suited him very well, but even better was what he saw as he drove along Anakreon Strasse, one of the posher streets in the centre of town: a hotel. There is even less that belongs to you in a hotel room than in a rented room. Anton L. decided to move into the Three Kings Hotel. It would be a radical move: all he would take with him would be the clothes he stood up in.

He pulled up outside the hotel, in the middle of the street. The large glass revolving door was not locked. (In such a cosmopolitan hotel there would be a hall porter there all night.) Anton L. went in. He had never been there before but he knew, from his time working in the travel agency, that there were some "suites" on the first floor. A certain Dr. Paolo Nappenbach, a company director from Buenos Aires, had always insisted on staying in Suite 22. The hook for the key to Suite 22 was empty. That meant the suite had been occupied. As expected, there was a porter's uniform on the floor behind the desk. Anton L. looked through the clothes; there was a bunch of keys among them. One was sure to be the master key. He went up the stairs, his steps muffled by thick carpets. Clouds of dust swirled up. The pot plants in the corners were starting to wither. Anton L. decided to water those on his floor at least.

He found the master key straight away. It was dark in the suite, of course, the hotel guest would have been asleep. Anton L. would have preferred it if, during the night, that decisive night, the suite had been unoccupied. But why? Any hotel bed we sleep in has had God knows how many people in it before, and God knows what filthy practices they got up to. ('That hotel room with Dagmar . . . not really what you'd call filthy practices, more of a tragedy.') True, but he still some-how had the feeling there was a corpse in the bed, even though it was only a pair of pyjamas, silk pyjamas with black and yellow stripes and a cord to tie them with. The bed was wider than a double bed, but the man had slept alone, unless, that is, the woman had slept naked. He could find no trace of filthy practices. Just an innocent pair of pyjamas. There is a

difference whether someone got up to filthy practices in the bed where you're going to sleep or simply dematerialised. It was no use however, try as he might, Anton L. just could not shake off the thought of such practices. He drew the heavy curtains and opened the window. It was a beautiful suite (bedroom, bathroom, lavatory, dressing room, sitting room and vestibule) and, anyway, at this time of the year the hotel, this hotel, the best known in the city, was sure to have been full. None of the beds would have been a guaranteed filthy-practice-free zone. He'd just have to change the bed-linen.

Anton L. went into the sitting room. There, too, he opened the windows which, unlike those in the bedroom, looked out onto Anakreon Strasse. His car was parked down there.

'I thought "my" car,' Anton L. said to himself, 'though it still belongs to Derendinger, even if he has dematerialised.' Or did the whole town, did everything belong to him now, to Anton L. who had always been reluctant to accumulate possessions?

Now Anton L. reaped the benefit of the practical training in travel that he had undergone at the various travel agents where he had worked. Naturally the employees cannot go on holiday during the main season, they have to be in the agency for other travellers. But in the off season, late spring or autumn, they get vouchers and special rates for hotels, sleepers, airlines, and are pampered by the hoteliers – with good reason. Anton L. had taken advantage of this, not at Kühlmann's (old Kühlmann had either kept the vouchers for himself or surreptitiously sold them on to regular customers) but when he worked for Santihanser. All in all it had lasted for about four years and this period had coincided with a phase of exceptional sex drive in Anton L. Actually it had been two phases: a longer, what one might call gentler one, in which he had fallen in love with the whore he happened to be with, at least for a few hours, and a shorter, eruptive one in which his sex drive was almost equal to young Herr Derendinger's love of football. At that time Anton L. was familiar with all the brothels of Europe and North Africa. In some of them he

even qualified for a discount. He could afford this hobby because travel and accommodation cost him next to nothing. Thus he knew about hotels and all hotels are similar. With no great difficulty he found the cupboard with bed-linen in the Three Kings. He took sheets and pillowcases and remade the bed in Suite 22. The old sheets he threw out of the window, together with the last guest's black-and-gold pyjamas.

Pfeivestl was the name of the previous occupant. Anton L. found his wallet with his documents. Hans Erhardt Pfeivestl, born 4. 1. 1919 in Treuchtlingen, factory owner. Herr Pfeivestl's suits were hanging in the cupboard. He must have been a short, rather fat gentleman. There were also sixteen ties there, some of them in garish colours.

'Obviously Treuchtlingen's not known for its good taste,' thought Anton L., and threw the ties out of the window. The sun was blazing down on the street again; not a breath of air stirred the colourful tangle below the window beside the old bed-linen. There was a gap in the row of houses opposite revealing a small, somewhat lower square behind. There was a fountain in it. The water was running. Anton L. must have walked along Anakreon Strasse a hundred times but he had never heard the splash of the fountain. Now it could be heard up in the hotel. A cat was sitting in the shadow of the fountain, fast asleep.

8

The candlemakers to the court

Anton L. had already made preparations for the evening. His original intention had not been to move into the hotel immediately, but then he decided to regard the reconnaissance trip which had taken him there as the most radical relocation in his life and not return to the Hommers' apartment at all. (He did go back later, once.) It would have been too much of an effort to lug all the provisions he had deposited there back down the three flights of stairs and transport them to the hotel, especially since the hotel's storerooms were well stocked, as he had already established. He had cooked himself a three-course meal in the hotel kitchen (the gas was still working) and eaten it in the main dining-room. In the dining-room there were eighty tables with – Anton L. had counted – two hundred and sixty-six places already set. In the 'small' dining-room there were almost as many places set. Anton L. did not bother with washing up. He threw the used crockery and cutlery out of the window and in the evening, after he had cooked himself a meal, he sat down at the next place. A little further down the road was a superior gentleman's outfitter's. In the afternoon, when the heat was no longer so oppressive, he collected a pair of pyjamas from there (silk, in various shades of red with a pattern of large flowers) and a few handkerchiefs. More important was the gunsmith's next door. He smashed that window too, with an iron bar he found in the hotel, only to start in horror when an alarm sounded, presumably operated by an emergency generator. But then he took a hunting rifle and, most important of all, the instructions for use. The instructions indicated the the precise type of cartridges for the rifle. Anton L. took two boxes.

Back in the sitting room in his hotel suite he studied the instructions, loaded the rifle and fired out of the window. The report echoed down the silent street, breaking in waves over the façades. Flocks of birds flew up. Anton L. took another shot straight away. He aimed at the window of a bank. Again there was a report, the window shattered and another alarm started up. He fired the rifle again, this time at a window higher up. He missed. A ricochet whizzed past. Anton L. fired the rifle again and again. The bank alarm was still wailing when he had finished both boxes of ammunition. In the building opposite he had only missed three windows on the fifth floor. The sweat was dripping off his forehead. You wouldn't believe how strenuous shooting is. Anton L. went back to the gunmaker's, packed all the boxes of the correct cartridges into a game-bag and immediately continued shooting once he was back home until the rifle was hot. Every window within two hundred yards that was in Anton L.'s field of fire was shot to pieces. There was just one window he kept missing, a dormer window in a corner house. With a smile he granted it a reprieve – for the moment.

An engineer or some kind of technician would have been able to use the emergency generators that kept the alarms operational in some shops, perhaps in all the banks and presumably in hospitals and museums, as a source of electricity that could well have lasted for months, until . . . yes, until what?

It was a fact that during the night of 25 June, probably around half past one, all the people, at least in this city, had disappeared instantaneously, apart from Anton L. It was inexplicable, but logically it did leave open the possibility, already mentioned, that they might all reappear equally instantaneously. Did Anton L. want that? Had he not already set himself up as master of the whole city? What would Herr Hommer say about the broken glass table top? Derendinger about the car he had taken, which now had a dent in the wing? And the people in Anakreon Strasse whose windows he had shattered? Herr Pfeivestl's ties were still lying in the street, undamaged, but the next wind would blow them

away, the next rain wash them into the gutter. What would Herr Pfeivestl say if he rematerialised (presumably naked, since his pyjamas were down there with his ties) in the bed beside a sleeping Anton L., or on top of him, or lying across him? If one mysterious incident could occur, then in future anything could.

Anton L. decided he'd better bring Herr Pfeivestl's ties and pyjamas back up to the room and to move the bed to a different place. That would mean that Herr Pfeivestl, should he rematerialise, would land on the carpet, but understandably Anton L. preferred that to having the fat little factory owner from Treuchtlingen return to the world stark naked and tangled up with him, Anton L. Either way Herr Pfeivestl would be in a bad temper, Anton L. guessed, knowing the ways of factory owners from his time in the travel agencies, but at least he wouldn't be able to complain about his ties.

But, all things considered, it would be simpler if they − all the others − didn't come back. And since the emergency generators would not last for ever, even if he knew how to operate them, Anton L. decided to stick to candles. He shouldered his rifle and set off to get some from a candlemaker's next to the Royal Palace.

It was a fine, mild evening. It was still light and the sky cloudless, apart from a couple of non-threatening smudges to the west. The storm had cooled the air to such an extent that it did not get as hot as before, even after a sunny day. As he walked through the streets shouldering his rifle, he noticed for the first time that the town was not silent. It was almost as noisy as when it had been teeming with people, but the noises were different, strange. Such strange − or natural − noises that at first Anton L. had not registered them. When his conscious mind did become aware of these noises it was as if a tightly closed door had suddenly been flung open. Anton L. was startled at the torrent of sound that flooded over him. What he found almost more startling was the fact that he immediately realised that he had actually registered the sounds, but they had not managed to travel from his ear to his brain. Crickets chirped, dogs or doglike animals (wolves?) howled,

nocturnal birds began their cawing, there were flutterings and scurryings. But, like mysterious veins running through this wall of sound, there were other noises that Anton L. could not identify: a cracking and snapping, a crunching, rubbing, hissing, the creak of wood and, overlaying the others, a gentle hum that came from above, perhaps from the roofs as they cooled down.

'The kind of noise,' thought Anton L., 'that you only hear when you're alone. The symphony of solitude, no, that's going a bit too far. The sinfonietta, perhaps.'

It was still too bright to be afraid, but Anton L. hurried on. In the big square an old prince elector was sitting on his throne, stretching out his iron hand. On either side were two boys bearing the crown and the sceptre. A swarm of mice ran across the square and disappeared behind the plinth of the statue. Since they didn't reappear on the other side, Anton L. assumed they had made their home in the plinth.

The candlemaker's was behind the statue. The Prince Elector was turning his iron back on the former 'Purveyor of Candles to the Court, by Royal Appointment' (which was still written over the shop front). Without further ado Anton L. smashed the shop window with the butt of his rifle and climbed in. As he did so he became aware of a change. Wherever he had broken in before – into Frau Schwarzenböck's apartment, the shops in Wasserträger Strasse, the flat where he had fled from the bear, or the hotel – he had been a little . . . alarmed would have been going too far, but he had kept his breathing firmly under control so as not to be alarmed because there was *no one* there. Even at the hotel it wouldn't have surprised him if, despite everything, the receptionist had appeared from behind his desk. Now, at the candlemaker's, he would have been alarmed if there *had been* someone in the shop. He no longer expected to come across another person.

Otherwise there was nothing – almost nothing – special about the shop of the Purveyor of Candles to the Court. He selected a few nice big candles that would burn for a long time and put them in his game-bag. As he was about to climb back out of the window, he noticed a letter on the floor. It was

76

a plain white envelope that had obviously been pushed under the door after the shop had shut for the last time. Anton L. picked it up. It was stuck down. On the front was written, "For L. All the best, E."

"For L." He was called L., Anton L. But perhaps the candlemaker or one of his assistants was called L. (We are using the abbreviation L-full-stop for Anton L. to indicate, as everyone knows, that his name – a very long name, as it happens – began with L.) On the envelope it just said L-full-stop.

And who was E.? Dagmar was an E. Anton L. put the envelope in his game-bag with the candles. 'There must be thousands of letters lying around in the post offices. I wonder if it'd be worth going to open some and read them? They'll probably be less interesting than you'd imagine.'

Anton L. had stopped by the window of a hatmaker's. On a separate stand, amid less unusual hats, presumably more part of the decor than for sale, was a check deerstalker, Sherlock Holmes' hat, a cap with a peak at the front *and* the back, and earpieces that could be pulled down or tied up over the top. A hat in which extreme practicality tipped over into the bizarre. Without hesitation Anton L. smashed the window and took out the deerstalker. It fitted. He looked at himself in the other part of the window, which had not been broken and in which the big square was reflected together with the old Elector and his palace and, now, Anton L. He had never worn a deerstalker, had never even considered the possibility of wearing a deerstalker, although naturally he had been aware of the existence, in another land and in the past, of such hats. It was a solemn moment. He saw his bearded face (he had not shaved since Tuesday, why bother?) with the check deerstalker above it. It felt as if he were making a statement. He felt as if a dream had come true which he had not even dared to dream before. He was so taken with the deerstalker he forgot the letter, which he had intended to read as soon as he was out of the shop.

A warm breeze had come up before Anton L. was back in the hotel. He had made a short detour to the largest bookshop in the town. There was a small bookshop opposite the hotel,

but Anton L. wanted to be sure to find a particular book. He had started to read it a few days before . . . before the catastrophe? Or simply *before*? With a bookmark between pages 34 and 35, it was on the chair by his bed in the Hommers' flat which he used as a bedside table. Anton L. had seriously considered driving back to the flat to get the book. It's difficult enough to start reading a book. An unread book sometimes resists being read; the unread contents rise up from the first page and repel the would-be reader. You have to break its resistance – there are other, approachable books, books that even approach you; whether they're the better ones is quite another question – you have to find an opening, gain the trust of the first few pages. Once they have calmed down and lie behind you, happy with having been read, they give you their backing and recommend you to subsequent pages as a harmless reader who poses no danger. Once you have passed the middle of a book you can even feel slight pressure on your back. The last chapters, the last pages want to get out of your way, to get you out of their way, the book wants to digest and excrete you so that it can close up again, allow its wound to heal. To continue reading in another copy of a book you have started is almost impossible. The pages you have already read, but not read in *that* copy, rise up like hackles behind you, putting on, with the later pages, an almost irresistible squeeze that literally forces you out of the book.

That was why Anton L. had wanted to get the book from his room at the Hommers', but then he felt it wasn't worth the effort. Anyway, it might be dangerous. Who knows what nocturnal animals might have overrun the building in the meantime. So to be certain of finding the not very widely read book he had decided to go back to the hotel via the large bookshop. In there it was already so dark he had to light a candle, but he quickly found the book he wanted. He took a few others as well, as many as there was room for in his game-bag along with the candles. Putting them in, he came across the letter again, but his curiosity had gone. It had been a rather lethargic curiosity and the vigorous effort needed to rouse itself had been too much for it. It had gone

back to sleep. Anton L. returned the letter to the game-bag unopened.

The warm breeze had been strong enough to lift up Herr Pfeivestl's ties and black-and-gold silk pyjamas and spread them over the whole of the street. The bedding was heavier and had not been blown away.

'He's probably not coming back after all,' thought Anton L., and left the ties and pyjamas lying there.

He had a snack in the dining-room, then went up, watered the plants in the corridor and settled down in his sitting room. He put the candles round the room and lit them. He opened the window in such a way that the gentle breeze, that had a pleasant smell, could come into the room without causing a draught, though the candles flickered a little. Anton L. opened his book.

"But little by little I managed to get out and set off, one step after another, among trees . . ." He read four pages ". . . All that is left for me, old man that I am this evening, is departure, the battle and perhaps a return . . ." Behind the candle that was on a sideboard Marianne came into the sitting room, although there was no door there . . . "Who am older than my father ever was, older than I will ever be . . ." How can Marianne bear *that* dress? Was it a dress? Wasn't her body just painted? In rich colours with gold sequins mixed in? No, it was a dress, a long dress, he could tell from the folds between her legs; but it was also very thin, hugging her body like a stocking, growing visibly thinner, while her breasts and pubic hair began to glow from within: two glowing red points on her breasts and a glowing golden bush below. Like a Chinese lantern. The wind grew stronger. With every gust her breasts and bush blazed up like flames that had been fanned. The dress had faded even more. It didn't even look like paint on her skin any longer, more like a colour slide projected onto her body. Anton L. began to feel the heat. He started to glow as well, especially round his loins. The window slammed shut. Anton L. woke up.

'That'll mean the ties have gone for good,' he thought, 'that's almost a gale.' He fastened the window, put out all the

candles but one and went to bed. Just as he was about to blow the last one out, he remembered the letter. He got up again and took it out of his game-bag.

"L." stood for Ludwig. It seemed to be a surname; the writer addressed the recipient with the formal *Sie*.

"Dear Ludwig, This time I am not mistaken. What we are looking for does exist. Perhaps tomorrow will be the day. Let me have the coirol back, quickly, no later than 9.30. Best wishes, C."

'What's a coirol?' The writer of the letter was called C. The one who wrote greetings on the envelope, E. that is, must just have delivered it.

'What's a coirol?' The letter was handwritten, scribbled, presumably in a hurry. Was the word really coirol?

9

A little Pope, one shoe off and one shoe on

The next day Anton L. could see from his bed that the weather was bad, since the curtains weren't drawn. The previous evening, out of habit, he had taken hold of the curtains to draw them. But then he had realised how pointless it was. Who was there to hide from? He let go of the curtains, but he still felt uncomfortable about leaving them open; he felt it was somehow not entirely voluntary.

'Why should I change my habits even if I am the only person left in the world?' He was filled with a feeling such as Luther must have had when he said, "And even if I knew the world was going to end tomorrow, I would still plant a tree today." When he then put out his hand again to draw the curtain, he was irritated at wasting such express thoughts and feelings on such a minor problem.

'Now that the world can become a simple place again,' he thought, 'it's only practical matters that count.' So he had left the curtains open and in the morning he could see the overcast sky from his bed. He had forgotten to wind up his watch again. It had stopped at about half past two. Anton L. got up, opened a window and looked out. He couldn't tell the time from the sun, but he had the feeling it was, if anything, early. He set his watch at seven and wound it up.

It had stopped raining, but there were pools of water everywhere in the street with Herr Pfeivestl's ties in them. Beside Derendinger's car directly below his window three pigs were slurping up water from the gutter.

'Where did the pigs come from? Domestic animals are probably much less domesticated than we assume. It's not bolts and bars that keep them in their stalls and cages, it's their

own lethargy and indolence, habit formed over thousands of generations. But when needs must, as now, perhaps the pigs (and the cows, of course, the horses and the hens) will break down the gates and escape to the freedom they still remember, despite all the fat they've put on over the centuries.'

Could the animals in the zoo get out of their cages? Rhinoceroses were Anton L.'s favourite animal. There had been a time when he went to the zoo every day to watch the rhinoceroses. Mostly they just stood there in the grass, as if cast in cement. Anton L. had always found it astonishing that their anatomical form was suitable for a living creature. Their long elegant heads are like a ship, like a barque with a pointed prow rearing up. And their eyes are in a place where, as far as we humans can judge, you can't see anything. When, after standing there for a long time as if cast in cement (you're surprised not to see a plinth set in the ground), a rhinoceros slowly starts to move, the rigid sections on its surface shift against each other, and the motion of its legs seems to be merely a mechanical by-product of the mighty force steaming and pounding inside the colossal beast.

'I wonder if the rhinoceroses are free?' Their large enclosure was only separated from the public by a concrete ditch. Anton L. had never thought such a ridiculous ditch could represent a serious obstacle to a rhinoceros. He was sure the rhinoceroses had escaped. (It was probably too dangerous actually to go to the zoo to see.)

The three pigs wallowed a bit, then a pack of dogs appeared. The pigs ran off. The dogs yapped but didn't go after the pigs, they were distracted by the leftovers Anton L. had thrown out of the dining-room window with the plates and cutlery the previous evening. Now the dogs were growling at each other, they hated to see any of the others get a lick at the plates.

'It's not impossible the dogs have started to tyrannise the city,' Anton L. thought. 'It's well known that there have always been far too many dogs in this particular city.'

Anton L. fetched his rifle and aimed at an enormously fat Alsatian. There was a loud report. The Alsatian leapt up, did a somersault and fell back onto the ground, paws in the air. The

other dogs fled in all directions, but only for a few steps, then they stopped, turned and crouched down, looking round warily. Anton L. reloaded and aimed at a big, reddish dog on the other side of the street. Again the shot rang out, the dog gave a howl, a cascade of blood came pouring out of its mouth, it hopped up and down a few times and disappeared round the corner of a house. The other dogs immediately fell on it and the whole pack removed themselves from Anton L.'s field of fire and vision, though he could hear a furious barking and howling. There had been a dark-brown dachshund in the pack. After the first shot it had crept away somewhere but, as the others ran off, it reappeared. It ran across the road after them. Anton L. pulled the trigger. The dachshund stopped, quivered, released a stream of urine and fell to the ground. It slumped, as if the air were escaping from it.

A family of cats had settled in the foyer. The mother was sitting with her kittens in an armchair they had already scratched so much the insides were coming out. A huge, steel-grey tomcat with a touch of Angora about it was sharpening its claws on the carpet. When Anton L. came down it disappeared under a coffee table; the mother cat hissed and bristled.

'It's too wet for them outside,' thought Anton L., 'but how did they get in?' (Later he discovered the window in the room with the switchboard on the ground floor was open.) Anton L. made breakfast. He made some coffee and opened a tin of sausage meat. As he was eating, he remembered the cats. He opened another tin and put it on the carpet in the foyer.

'I hope the cement ditch wasn't an insuperable obstacle for the rhinoceroses after all. They might all have stumbled into it and are stuck there, they might even have broken a leg. Can rhinoceroses break a leg? Maybe they haven't even tried to get out of their enclosure, maybe they've got enough grass there for the moment? Or perhaps they're already grazing down by the river?

'What if it hadn't been *me* who'd been spared by the "incident",' thought Anton L., 'but that old man who used to come begging at the Hommers' door now and then, for example . . .'

Herr Hommer had always thrown the old man out, but Frau Hommer used to give him something when her husband wasn't there. He was an unusual beggar in that he would introduce himself before asking for alms. He wasn't very imaginative in his choice of name, preferring "Müller" or "Meier"; at most he might occasionally go as far as "Schneider" or "Richter". But his first name was always the same: Konrad.

"They're all rogues and secret millionaires," Herr Hommer used to say. Anton L. did not believe that; once he had come across the beggar sleeping under a bridge. He had leapt up and run off, even though Anton L. called out that he wasn't going to harm him.

Would Konrad Richter or Schulz even have noticed everyone had disappeared apart from him? If, for example, he had just managed to beg the 80 pfennigs for a bottle of cheap vermouth and was lying down underneath the bridge, would he even have noticed that the roar of the cars and the rattle of the trams going under the bridge had stopped? When you drink 80-pfennigs-a-bottle vermouth you're dead to the world outside. Anton L. was acquainted with that vicious brew. There had been times when meths had seemed insipid to him, but even then two or three bottles of 80-pfennig vermouth had been enough to get him drunk. Waking up, on the other hand, had been an apocalyptic experience. He thought he was surrounded by slimy, red and chocolate-brown gargoyles who were observing him with cold interest. Waking up was as good as a whole course of detoxification, which was why, during Anton L.'s alcoholic phases, 80-pfennigs-a-bottle vermouth had always been the last stage. But you can get used to red and chocolate-brown gargoyles. As far as Anton L. could tell from his observation of him, Konrad Richter or Schneider had got used to the gargoyles, perhaps even acquired a taste for them. So perhaps Konrad Meier or Schneider would have woken up when a rhinoceros, grazing on the grass by the river, found him asleep and gently nudged him with its horn when it came to seek shade from the midday sun under his bridge. (Do rhinoceroses look for shade? They could hardly be susceptible to sunstroke, Anton

L. had seen a rhinoceros stand motionless in the blazing sun; the heat probably doesn't penetrate their armour. But if there is some shade around, perhaps it would get out of the sun.) Presumably the beggar would have shot to his feet with a scream – gargoyles, yes, but he had never awoken to the sight of a rhinoceros before – and run up the embankment even before the rhinoceros had time to be surprised or alarmed. Perhaps he would have kept running through the streets, still screaming, – the rhinoceros would have forgotten him by then and returned to its grazing – trying to open every door he passed, only noticing after he had tried a dozen doors to shops and houses that for some inexplicable reason they were all locked and there was no one else in the street.

A person like Konrad Richter or Huber, who is all alone and more or less constantly on his guard against something or other, will relate everything to himself. He would have taken the fact that there was no one in sight anywhere as a warning to be careful. He would have been even more cautious, if that were possible, than he was when there were people around, would have kept close to the walls as he walked or, rather, crept, through the part of the city he was familiar with, per-haps Lodoiska Strasse, which has a park running along one side, but then gets narrower and shabbier until it goes under a railway bridge and meets Konkourgi Strasse, where a quite different district begins; or he could have turned off along Abenceragen Strasse where there's the large open-air swim-ming pool and a market garden. There wouldn't have been a soul in either place. Konrad Huber or Schmidt would not have bothered with the swimming pool, but he might have been hungry and climbed into the market garden. He wouldn't have had the nerve to smash a shop window but he would be up to taking a turnip and a few carrots from a market garden.

'No,' thought Anton L., 'he wouldn't, actually.' Konrad Meier or Schmidt had such a meek and mild look, and an honest one, too. A person like that would not only not smash a shop window, he wouldn't climb over a fence to steal a turnip and a few carrots, either. There is only one thing Konrad

Müller or Schmidt would have done once he realised he was the only person left in the world: he would have given himself up to despair. Anything else would have seemed wrong to him. Konrad Müller or Schmidt would have starved to death because he was a born victim, gentle as the lamb on which the world, cynical right to the end, vents its vicious spite.

'It would have been different, of course,' thought Anton L., 'if the Pope had been the only survivor, the Pope in Rome . . .' Anton L. knew Rome (though mainly the Roman brothels, it was during that phase that he had visited the city) but naturally he knew as little about the Pope's private life as the great majority of people. He lived in the Vatican. But now, in late June, would he already be in Castel Gandolfo? Anton L. imagined His Holiness Paul VI Montini, waking up last Tuesday morning, probably a bright, sunny morning in Rome as well, and shouting in vain for the nun. At what time did the Pope get up? They were always being told about the immense amount of work he did for Catholics and their Church, that he always got up at five in the morning. No one wakes up naturally at five in the morning, you have to be woken. The Pope probably wouldn't have an alarm clock in his bedroom; it would be sparsely furnished, with just a few frescoes by Raphael for decoration. It would be the duty nun who had the alarm clock. She would set it for 4.30 and wake His Holiness on the dot of five, not one second earlier, not one second later. But if, on that 26 June the bell had rung in vain at 4.30 in the room of the duty nun, because the duty nun wasn't there any more, then no one would have woken His Holiness and he would have sat up in bed in alarm because the sun was already peeping in through the gap in the curtains at the Raphael frescoes. His Holiness presumably did have a wristwatch. He'd have looked at it and seen that it was, let's say, a quarter past eight. The Pope would presumably not have sworn, but a frown would probably have darkened his face for a moment as he pressed the button – surely there would be one of those? – to ring the bell in the nun's room. But that bell, too, would have rung in vain, if it rang at all.

Up to this point it was fairly certain everything would have

happened more or less as Anton L. imagined. But what then? It's difficult to say. That Paul VI would think, 'Well bugger you, then,' turn over and go back to sleep, is highly unlikely. Presumably he would have got up and tried to telephone – there must be a phone in his bedroom – the monsignor or secretary or whatever the priest was called who was responsible for the Pope's personal household. But the telephone would not be working. Would the 270th occupant of the Apostolic See have put on his dressing-gown and slippers (with the cross design) and gone to see what was happening? After all, it wasn't impossible that the Pope might feel hungry. There must be a little kitchen somewhere near the Pope's quarters. That is where the Pope might have gone in the first instance, assuming he knew where it was. He would have wandered round the echoing marble labyrinth of the Vatican Palace in his dressing-gown and the slippers with the embroidered crosses on (not forgetting his white papal skull-cap; we can't imagine him without it, either he sleeps in it or he automatically puts it on as soon as he wakes up). He would have found the kitchen, but by then he would have lost his appetite because he had not met a soul on his way, not a nun, not a cardinal, not a monsignor, not a Swiss Guard, no one. And, of course, he would have no idea why. Now and then he would have looked out of a window. The Vatican gardens, and the Vatican in general, are usually fairly quiet and deserted, but St Peter's Square – the Pope would never have seen it so empty, and it wasn't even midday when a merciless sun beats down on the marble cauldron that is St Peter's Square.

There would have been no one in the square, not even in the shade of Bernini's colonnade, not a tourist, not a carabiniere, not even a beggar sitting on the ground. There was the splash of the two fountains, otherwise no sign of life anywhere. The Pontifex Maximus continued on his way. In a corridor near the Chapel of Nicholas V the Pope lost one of his slippers under a fresco (by Vasari? Pinturicchio? Ignazio Stern?) representing the martyrdom of St Amoenia. Since at that point he was walking on a carpeted floor, he only noticed the loss on the stone steps (under a late Roman copy of the

Discobolos by Myron), but kept going. He tried to take the lift – it wasn't working – hurried down stairs, crossed empty courtyards that Vignola, Baldassare Peruzzi, Bramante or Antonio Sangallo the Younger had built, until finally he was in St Peter's. A little Pope, one shoe off and one shoe on, getting his breath back beneath Michelangelo's incomprehensibly monumental dome. "TU ES PETRUS . . ." is written in mosaic letters, ". . . ET SUPER HANC PETRAM EDIFICABO ECCLESIAM MEAM . . ." Paul VI lifted up the foot that had lost a slipper. The floor was cold. ". . . ET TIBI DABO CLAVES REGNI COELORUM." It was a fact that the population of the world was now 100% Roman Catholic, but the Pope felt as if all the weight of this immense church were resting on him alone, and not just resting, it was as if he had to balance it too, as if the hierarchical pyramid had turned upside down.

Anton L. was a Catholic. To be precise, he had been baptised and brought up as a Roman Catholic and had been through one phase of intense, profound piety (shortly before his first alcoholic phase). He could remember the Catholic rites and rituals but he had not been to mass for years.

'If a city of this size,' thought Anton L. (it wasn't Rome he had in mind, but the city where he lived), 'is suddenly emptied of people, yet still remains habitable, someone somewhere must notice. Since they clearly haven't, I must assume that the rest of the world is completely depopulated too. Does that mean I am Peter? The apostolic succession, the uninterrupted chain of episcopal ordination from the Apostles to Paul VI – who is presumably not standing in St Peter's with one slipper off and one slipper on, but has disappeared without trace, like all the rest, apart from me – the apostolic succession would remain unbroken,' thought Anton L., 'if my confirmation, which was performed by the bishop, were deemed, with retrospective effect, to be ordination as a bishop. It is probably not a case that is foreseen in canon law, but if emergency baptism exists, then emergency ordination as a priest is at least conceivable. Anyway, apart from that, I belong to the Only True Church, and since no one apart from me belongs to it, I must

of necessity be the head of the Church. Pope Anton. No, for fifteen hundred years every pope has taken a new name on his installation. Shall I call myself Pius XIII? John XXIV? Leo XIV? How many Benedicts have there been? Fifteen? Sixteen? And Gregorys?' Anton L. decided go round to the bookshop some time and get a book on the history of the popes.

10

Difficulties catching Sonja

Despite his odd habits and strange phases, Anton L. was not unpractical. True, he wasn't practical in the sense of being good with his hands, but there were at least times when he was practical in outlook. That perhaps came from his propensity for self-analysis. This was a permanent feature, an institution in Anton L.'s life and had been since he was fourteen, perhaps even ten. There were two types of self-analysis (Anton L. had analysed that, too): spontaneous analysis and premeditated analysis, he called them. Anton L.'s spontaneous analysis was no different from that of other people – when there had been other people – who thought about themselves now and then. Something prompts people to wonder why they did or didn't do this or that, why they feel fine one day and miserable the next.

Anton L.'s psychological speciality was his premeditated (and pleasurable) self-analysis. It was prepared well in advance. The topic, some problematic aspect of his personality, and there were plenty of those, was decided on days beforehand and background material gathered, if necessary. A suitable time would gradually emerge (Sunday morning in bed, for example) and when it came, Anton L. would luxuriate in the contemplation of his own psyche. He found the experience intoxicating, and it would leave him feeling empty, cleaned out and pleasantly exhausted. Sometimes, after a short pause to recover, Anton L. could not resist going through the whole analysis again, though in abbreviated and therefore concentrated form, and often found it almost more pleasurable than the first time.

Since Anton L. had been alone in the world, there had been

no premeditated analyses, no psychological pleasure trips, though there had been spontaneous ones, of course. One had dealt with his state of health. You will recall that on the morning of 26 June he had registered an ominous rumbling of his solar plexus. Normally that would have developed into a swelling of the solar plexus which, given the warm weather, could have lasted for a week, even two weeks. But nothing had happened. Anton L.'s solar plexus and all the other countless parts of his body that were prone to illness had been behaving themselves. The analysis on that subject led to the first doubts he had ever entertained regarding the nature and origin of his illnesses. Another spontaneous analysis was more important. Anton L. realised that if he was to keep himself together in his current situation, he would have to find himself something to do. A "business plan", he called it. The finance officer in him went deeper than one would have thought. The conclusion drawn from this self-analysis was doubtless correct and shows that Anton L., despite all his eccentricities, possessed the practical outlook mentioned above.

Before Anton L. worked out his business plan for the next few days, he made a list: Monday, the last day before the mysterious disappearance of all the other people on earth, had been June 25; Tuesday was the 26th and he had slept through Wednesday; presumably, then, his adventure with the bear had been on the Thursday, that was the 28th. On the 29th he had moved into the hotel, which meant it was now Saturday 30 June. He briefly considered the possibility that he had slept through two days when he had been drunk, in which case it would now be July 1, but then settled on June 30. He took the felt pen he had found among Herr Pfeivestl's things and wrote the chosen date on a light-coloured patch of the patterned wallpaper in his sitting room. Beside it he wrote: shot dogs. After a few days Anton L. took a large tear-off calendar from behind the reception desk up to his room and used that, though without abandoning his concise wall-diary. The date shown on the calendar from the porter's lodge was the 26th; either the receptionist had set the calendar for the next day

when he went home, or a pedantic night-porter had torn off the page for the 25th at midnight, less than two hours before he dematerialised.

The business plan consisted of a series of concentric circles. Anton L. decided to start with a thorough exploration of the hotel, then the streets in the immediate vicinity and so on. In a few weeks' time he intended, with the exercise of due caution and the use of Derendinger's car, to explore the area immediately surrounding the city and, if possible, farther afield. This plan was soon disrupted or, you could say, amended; the concentric circles were intersected by radial excursions. For a long time Anton L. did not abandon his business plan and he never formally renounced it.

It was still before lunchtime when Anton L. entered the first circle of his business plan. He walked along all the corridors, inspecting the work areas, kitchenettes, storerooms etc., even the occasional bedroom, though he was less interested in those. A brief spontaneous self-analysis came up with the explanation that he was still reluctant to be confronted with the remains of the vanished occupants, that is the clothes they had left behind. He still somehow regarded them as corpses. This feeling became more insistent when, in one of the lifts, he found an artificial leg underneath a dinner jacket. This find also told him something about one aspect of the catastrophe: the dematerialisation must have happened in a flash, since the artificial limb was stuck in the lift door, preventing it from closing fully. From the position of the dinner jacket and a walking stick, an ebony stick with a silver handle, he deduced that the man with the artificial leg must have been about to get out of the lift. He had stepped out with his artificial leg, but then he had been dematerialised; it must have happened in a flash because parts of his clothing were still inside the lift. A monocle had rolled underneath a potted palm that was already completely withered. The monocle must have belonged to the man in the dinner jacket, since there were no other clothes in the lift or corridor – 'Unless,' Anton L. thought, 'a bedroom farce was being played out and a naked man with a monocle had been hiding behind the potted palm.'

After lunch – he had cooked himself some goulash soup and to go with it, as a rather eccentric accompaniment, had opened a tin of button mushrooms; he ate them with oil and vinegar, and threw the plates and cutlery out of the window again when he had finished – he made another discovery, one which aroused pity rather than horror. In a large room in part of the basement which gave onto an inner courtyard there were a good three dozen cages with half-starved and completely terrified hares. Jugged hare had probably been going to feature on the menu for the 26th or one of the following days. Anton L. opened the cages. The creatures only ventured out very slowly. Some were so weak Anton L. had to lift them out, but none of the animals had died. On the contrary, a female had given birth to a litter. His first idea was to open a few tins of carrots and scatter the contents round the cellar, but then he had second thoughts. Perhaps tinned carrots might be harmful to the hares? He opened the door to the inner courtyard and then the gate to the quite large garden. Surrounded by walls and, on one side, by buildings that were not part of the hotel complex, the garden was clearly not intended for the hotel guests, more for the staff. A large part was a kitchen garden. The hares quickly caught the scent of the fresh air and lolloped out into the garden where they immediately set about eating lettuces, which were bolting. Then Anton L. remembered Sonja. This produced the first radial intersection of the concentric circles of his business plan. He got his rifle, put on his deerstalker and drove to the Hommers' apartment in Derendinger's car.

He encountered no surprises on the way. The streets he drove along – he took the shortest route – were quiet, still not much different from an early Sunday morning in those days, now apparently long past, when there had been other people. Here and there in the streets that were cobbled Anton L. thought he could see a shimmer of green as tender shoots of grass appeared between the stones. In a few places holes or cracks had opened up in the tarmac. There were hardly any animals to be seen. Once he came across a pack of dogs. He stopped, but they ran off before he could get his rifle from the

back seat. He did see a lot of birds, and by the bridge just before Faniska Strasse there was a deer which, when it heard the car coming, briefly looked up and then crashed through the bushes on the slope down to the river.

All was quiet in the building. Anton L. entered cautiously, rifle at the ready, but nothing appeared to have taken up residence there. When he left, Anton L. had locked the door to the apartment. Now he had to unlock it. It smelt musty and dusty, slightly putrid too. Perhaps some of the supplies he had piled up were going off. Sonja was still alive. She was sitting motionless on her stone, gazing along a line at a tangent to Anton L.'s head.

'Hmmm . . .' How was Anton L. to transport the animal? He tried to lift the terrarium. Impossible. The idea of carrying the iguana and its glass cage down three flights of stairs to the car was out of the question. Hanging up in the kitchen were a string bag belonging to Frau Hommer (whose astral atoms were perhaps even now scurrying round distant galaxies) and a large shopping bag. Anton L. took the string bag and tried to slip it over Sonja. Like lightning she darted into her cave underneath the big stone. Anton L. decided to try cunning. He spent a long time fixing the string bag across the entrance to the cave and tapped on the back of the stone. Sonja did not appear. He knocked harder. Sonja clearly had no intention of coming out. Anton L. tried another ruse. He filled the six-teen-sided kettle with water and poured it slowly through the string into the cave.

'It can't harm the animal,' thought Anton L., 'but it might be unpleasant enough to make it come out.' The animal did find it unpleasant. While Anton L. was refilling the kettle, it shot out of its cave, tearing the string bag from its moorings, and, since Anton L. had left the lid off, jumped out onto the floor. Unaccustomed to the smooth lino on the Hommers' veranda, it skidded, scrabbled, got its footing and in no time at all had vanished under the bench, or whatever the piece of furniture was called.

Anton L. turned off the tap and lay flat on the floor. The iguana had stuck its head in the farthest corner and was

breathing heavily, obviously agitated. He could just reach the end of its tail. He took hold of it carefully. Sonja did not move. He gave it a gentle tug. The iguana let itself be dragged across the linoleum. He had almost got it out from under the bench when it made a sudden and surprisingly powerful twist of its body and shot into the kitchen. Anton L. jumped up in pursuit. The iguana had disappeared. He searched the whole kitchen. Sonja was nowhere to be found. He searched again. Since the other door, the one out into the corridor, was closed, Sonja had to be somewhere in the kitchen. He looked under every piece of furniture, in the kitchen cupboard, even in the oven and the rubbish bin. Sonja wasn't there. When he sat down on the stool to ponder the mystery, he saw that Sonja had hidden in the large shopping bag. He zipped it up and carried it down to the car. When he got there it occurred to him that Sonja might suffocate, so he went back up to fetch a pair of scissors. It was as he was going up the stairs that the idea of arson came to him. He went over his belongings in his mind, to see if there was anything worth saving, worth taking with him. Nothing occurred to him.

'Just a minute.' There was a grey woollen cardigan that had, as you might say, been very carefully faded in the wash. However, he decided to leave the cardigan there with the rest, so as not to endanger the radical nature of his move into the hotel. He didn't go into his own room at all, just pocketed the scissors and set light to the curtains in the living room. He found some matches underneath the gas stove. The flames quickly licked up the curtains. Anton L. ran down the stairs and drove Derendinger's car into the next side street (going the wrong way along a one-way street), stopping where he could still see no. 2. As he carefully cut a few airholes in the shopping bag, he kept his eye on the window of the Hommers' apartment. Initially a fine stream of light-grey smoke came out of the cracks round the window, then nothing. After half an hour or so Anton L. got bored with waiting. He picked up his rifle. The second shot hit the window. A cloud of light-grey smoke poured out, then nothing more. The fire seemed to have died for want of fuel. Anton L. could

not be bothered to start another. It had only been an impulse anyway. He watched for a few more minutes, then put the rifle on the rear seat and the shopping bag with Sonja beside it, and drove back to the hotel. In a street called Löwengraben a pack of dogs ran across in front of the car. Anton L. managed to run over one. Otherwise that journey too was without surprises.

Naturally Anton L. did not have a glass tank in the hotel for Sonja, so he decided to give her the double room, room 14, opposite his suite. A couple called Cuypers from The Hague in the Netherlands had been staying there. (Anton L. had found their passports in the appropriate pigeonhole at reception.) The Cuypers had arrived on the 25th and intended to stay until the 29th. Mijnheer Cuypers was called Philip and was 56, his wife's name was Margriet and she was 41. Mijnheer Cuypers had a preference for check suits, while Mevrouw Cuypers dressed almost exclusively in brown. Only her nightdress, which reached to the ground and was as good as transparent, was old gold. A very odd find occupied Anton L.'s thoughts for a long time: there was a cane carpet-beater in Mijnheer Cuypers' bed. A cleaning implement forgotten by one of the staff and not noticed by an exhausted Mijnheer Cuypers when he went to bed on the 25th? Or an eccentric piece of erotic equipment?

Before he had dinner Anton L. cleared everything out of the room that he thought might disturb Sonja: the clothes, the bed-linen, the toilet things (or was he, Anton L., the one who was disturbed by the toilet things?), and threw them out of the window into an inner courtyard where they stuck on the glass roof of the kitchen. In her terrarium at the Hommers' Sonja had had gravel. He remembered there was a building site not far from the place where he had run over the dog. Anton L. made three trips there and brought back gravel in a tin bath which was so big there was only just room for it in Derendinger's cramped car. The tin bathtub full of gravel was heavy. It was a real labour of love, but Anton L. wanted to give the iguana the environment it was accustomed to. In the middle of room 14 he made a pile of gravel. There was

much more gravel than Sonja had had in Herr Hommer's terrarium. In the following days Anton brought the odd stone or branch he had picked up and spread them round the room. Sonja showed no appreciation, she spent most of the time underneath the bed.

Anton L. was really tired when he sat down, quite late, to dinner in the large dining-room. Despite that, when he had finished he took a turn round the block, of which the hotel and its outbuildings accounted for more than half. The tight net of mysterious sounds from near and far, the creaking hinges of a nocturnal world, had already spread over the city. As a matter of course Anton L. had his rifle with him, but he encountered no danger, although there were countless shadows scurrying and fluttering through the darkness. He was taking a cursory advance look at the concentric circle that was down on his business plan for the next day. In the course of his reconnaissance he came across a small shop, a boutique really, that sold nothing but liqueurs and confectionery and, as Anton L. could tell from the price-tags he saw in the light of his police torch, nothing but the best and most expensive, either. Although he had had quite a substantial meal, Anton L. was struck by ravenous hunger or, to put it more precisely, a ravenous craving. He rummaged through the shelves and took two enormous boxes of chocolates and a bottle of raspberry brandy. While he was still in the shop he ate two dozen marzipan potatoes and three marzipan frogs which were under cellophane on a tray.

Back in the hotel Anton L. lit the candles in his sitting room, and as he read a book about the popes he had found in a bookshop he passed on the way back with Sonja, he ate up the contents of both boxes of chocolates. He also drank a good half of the raspberry brandy, at which the deceased or, rather, dematerialised Margriet Cuypers appeared to him in her transparent old-gold nightdress. Flickering like a candle flame, she stood in a tin bath full of gravel and swelled up – in his dream Anton L. found that very erotic – until her night-dress burst into a mass of particles crackling with static which descended on the aroused Anton L. Unfortunately, he

then woke up with an attack of stomach cramp, presumably genuine this time.

Anton L. was lying on the carpet in his living room. All the candles had burnt down apart from one, and that was about to go out. He replaced them, creeping round the room, almost doubled up. He tried lying on the sofa, but that made his stomach cramp even worse; he tried out every possible position until he found the one that suited him best: on his stomach in an armchair with his head pointing down and his legs stretched out straight above him. He couldn't hold it for long, but afterwards his stomachache was somewhat better.

Then he started walking up and down the living room. He picked up the book on the popes and read as he walked, then put it down again and picked up the book he'd been reading the previous evening, read one paragraph and put that down too. As he did so the letter he had found at the candlemaker's fell out.

He picked it up and unfolded it. "Dear Ludwig, This time I am not mistaken. What we are looking for does exist. Perhaps tomorrow will be the day. Let me have the . . ." Then came the word Anton L. had found mysterious. It wasn't really mysterious, it was just that, the letter being handwritten, obviously in haste and probably resting on something unsuitable, it had been difficult to read. It was no longer causing difficulty. The word was "card". "Let me have the card back, quickly, no later than 9.30. Best wishes, C."

Anton L. decided to incorporate Herr Ludwig, C. and the card in the concentric circles of his business plan.

11

A bath in Frosinone

The period of fine weather came to an end even before the middle of July. August, too, was wet and rather cool. In the Palace Gardens, which were not far from the back of the hotel, on the edge of the old town and soon occupying a place in one of the concentric circles of the business plan, the grass was knee-deep. In many places the weeds had taken over. For a few days the river had burst its banks, perhaps a reservoir up in the mountains had overflowed because of all the rain and no one was regulating the outflow. Even in Anakreon Strasse the water was ankle deep. Lots of water birds had appeared. Herr Pfeivestl's ties had finally gone.

The river had left mud in the streets, although it was now as clear as a mountain stream. In less that two weeks the weeds had shot up there too. Scrub was already growing along the river and there was a small tree on the dome of the Court Church. One night towards the end of August – by this time the noises no longer alarmed Anton L. – Anakreon Strasse reverberated with the sound of a short, violent explosion followed by a rumbling that continued for some time. When he went to see the next day he found that a row of houses in a narrow street by the river had collapsed. The floodwater must have undermined the foundations.

June had hardly ended when Anton L., by then a practised marksman, shot a wolf no more than two hundred yards from the hotel. But it was the ants that were more of a nuisance; Anton L. had to take the rest of the chocolates to the hotel to keep them out of their way.

Sonja was thriving. The dark corner under the bed was still her preferred lair, but she did occasionally sit on the stones and

branches Anton L. had brought. Her favourite food was cherries, of which there was fortunately a large supply in the hotel storeroom. Every other day Anton L. opened a tin or jar for her.

When on 29 August (according to Anton L.'s calendar, it could of course have been the 28th or the 30th) he gave her her cherries, Sonja said quite clearly, "Thank you." Anton L. shook himself, like a dog shaking water from its coat, and said out loud, "Sorry?" but, as usual, the animal was staring along a tangent to his head.

There was no need for Anton L. to feed the family of cats in the foyer, there were plenty of mice in the cellar. The hares had spread out, even as far as the Palace Gardens. When Anton L. went down to the river after the flooding, he saw large trout swimming in the clear water. That gave him the idea of getting a fishing rod and a book about fishing. The gunsmith's had sold angling equipment as well. He had some qualms about sticking the worm on the hook, but he caught a fish at the first attempt and fried it in the hotel kitchen. He had, of course, already had the idea of shooting himself some meat to roast, but it didn't work out very well. Without really thinking, he shot a pig that was grazing on the plants coming up between the cobbles round the Elector's statue near the candlemaker's, but then didn't know what to do with it. With a round of shot he killed one of the domestic hens that had reverted to the wild and were to be found in large numbers by the river. Here the problem was that he didn't know how to pluck the hen. He tried roasting it with the feathers still on, but the stench was so bad he threw it out of the window, roasting tin and all. After that he stuck to killing dogs. He started to keep a tally in July; by the end of August he had shot his four hundredth. The dead bodies, that he always left where they had fallen, had usually disappeared by the next day, leaving only the bones to bleach among the weeds that were bursting through the tarmac in many places.

In the first days of September the weather improved. It was warm again, almost like summer, though there was a distinct touch of brown to the leaves here and there.

On 4 September according to Anton L.'s business plan the Royal Palace was due to be surveyed. He had been very conscientious about sticking to his circles and had discovered several more sweet shops, two further candlemakers and, what was even more important, another gunsmith's. In the previous two months there had also been a number of radial excursions which we will talk about, which we *must* talk about later on. They were connected with Herr Ludwig's letter. The results of his radial excursions and investigations led him back to the Royal Palace almost to the day (a secret sign?) when it was down on the business plan.

There was a big, heavy bronze door set in the greenish stone of the façade of the Palace. In the big door was a smaller one; that, too, was fairly big. It was locked. Anton L. could not open it, even though by this time he had gained a certain expertise in breaking down doors. However, the broad ledges where the large blocks of stone joined made it easy to climb to one of the ground-floor windows, which were quite high up. He smashed one of the panes with the butt of his rifle, then reached inside and opened the window.

Every town preserves kernels of timelessness, as long as overzealous modernisers do not make it impossible. Anyone with an eye for such historical monuments, or who studies the history of a town, is aware of that. These kernels come in different sizes, it could be the cornerstone of a house or the crypt of a cathedral. That the Palace of the Prince Electors – a conglomerate of strata from the centuries, overlapping, interlocking, adjoining – was and had for a long time been a gigantic block of timelessness, almost impossible to overlook, was something that struck Anton L. abruptly as he jumped down from the high window-ledge into the grand chamber. Within a few weeks the city, at least wherever Anton L. had been, had changed. Nature had made deep inroads, even in places where Anton L. would not have thought it possible, or at least not so quickly. The Palace was completely untouched by all this. Here everything had stayed the way it was. An old man is past change, even if he is the only one left in the world.

The room into which Anton L. had jumped belonged to

the most recent, the neoclassical phase of the Palace architecture. There was not a single piece of furniture in it. Three of the walls had colossal murals. Handsome swains with blond locks and bulging muscles, ladies so buxom they were indecent and powerful stallions were jostling around, all larger than life. It gave the impression the artist had wanted to depict more than the available – and really more than adequate – space allowed. Here and there a man on horseback towered over the throng, while the occasional swarthy, grim-faced figure could be seen pushing his way in the opposite direction to the stream of pure and noble flaxen-haired youths. A not inconsiderable number of the gentlemen in the painting were in possession of a harp.

The next room was decorated with similar frescoes, and even the one beyond that. Anton L. walked over the gleaming parquet floor. The two other rooms had no furniture either. The third, the biggest of the three, was on a corner. A large double door, which was not locked, led into a somewhat older part of the Palace, into an immense stairwell. A gigantic stone staircase wound its way up past many floors. When Anton L. let the door swing shut, the crash could be heard echoing through distant tracts. A marble goddess stood on a low plinth at the bottom of the large spiral staircase.

Anton L. went up to the next floor. There he wandered through a series of rooms from the eighteenth century, the heyday of the Palace. The walls were covered with dark paintings surrounded by the dull gleam of gold frames: still lifes with flowers, *galant* scenes with nymphs, park landscapes, portraits of noble gentlemen in ermine or armour. One room was furnished in the Chinese style. The biggest room, however, was the bedroom. The bed, its silk coverlet embroidered with lilies, its baldachin of blue velvet, was facing a wall occupied almost entirely by a window. A balustrade like a communion rail in church separated the bed, which was also three steps higher, from the rest of the room. Two carved, gilded cherubs, each with a trumpet in its hand, hovered at the side of the bed and held up the baldachin. There must have been something uncommonly ceremonial about the sleep of the ruler whose

bed it had been, as if he went to bed with a flourish of trumpets. But behind the baldachin, where it draped down onto the floor, a small, almost invisible door had been let into the panelling. Anton L. clambered over the balustrade and sat down on the bed, cautiously, though not much dust flew up. He only sat there for a few moments, however, then he lifted up the silk coverlet and saw to his amazement that the bed was made up with proper sheets. He put the coverlet down and turned to the door in the panelling. It was unlocked and led down a few steps into a bare corridor from which you could see out into an inner courtyard. Unlike the interior, the courtyard had not retained the unchanging timelessness of old age. It was choked with weeds. The stone gods along the paths were knee-deep in grass.

Anton L. knew the Royal Palace quite well from the past, from the time he worked for a publishing house. Foreign authors visiting the publishers had to be kept occupied somehow or other, so that they didn't get bored and start thinking up awkward clauses for their contracts or impossible proposals for books. They were shown round the Palace. It was always the junior editors who were landed with that task; in return they could go out for an expense-account meal with the authors. The publishers also held a reception every year in one of the grand rooms the Palace administration hired out to reputable firms for such functions. Anton L. had been to three of these receptions; the last time Dagmar had gone too. It was a very warm summer's evening. He hadn't really wanted to take Dagmar, but she had given him no peace until he did. Whenever there was a prospect of high jinks, Dagmar was desperate to be there. She knew nothing about literature but with a glass in her hand she could talk the hind legs off a donkey. It was all nonsense, of course, and embarrassed Anton L., who, after an hour, dragged Dagmar out into the garden (it wasn't the courtyard he was looking down into at that moment) and tried to restrain her. It was too late. Dagmar had already drunk several glasses of champagne. She laughed, played the *grande dame* to Anton L., went back inside and continued to talk to authors whose books she hadn't even

heard of. But the authors were delighted with Dagmar, especially a somewhat older one who had written a book Dagmar had read. She talked about the book, accepted, with ladylike condescension, a light for the cigarette she was smoking in an antique holder and went on drinking champagne. It turned out that the book Dagmar had read was one with a similar title to a book the author had written. Anton L. wished the gleaming honey-coloured parquet floor would swallow him up, but the misunderstanding clearly did not bother the older author. He was still delighted with Dagmar. Anton L. was getting annoyed.

Dagmar was wearing one of a number of dresses she had that were much too tight. Anton L. remembered it: a bright yellow dress, cut low at the back and the front. She could hardly move without her ample bosom being revealed through some slit or other. Gradually, as night fell, a warm, starry night, the company moved out into the open air, into the garden. In the middle of the garden was a fountain with a statue of Perseus. Dagmar declared her intention to take her clothes off and bathe in the fountain. The older author egged her on, but Anton L. just managed to stop her. He grabbed Dagmar, firmly set her last glass of champagne down on a carved, late-seventeenth-century side table and found a taxi outside the Palace. Dagmar was seized with fury and, at the same time, an urgent desire for sex. On that evening Anton L., who on other occasions fully appreciated that desire, had absolutely no reciprocal urge. He felt Dagmar's behaviour had disgraced him and said he wouldn't be able to show his face at the publishers again. That, of course, was not true. On the contrary, Dagmar had made an indelible impression on everyone there, at least on all the men, but then Dagmar only talked to men, other women did not exist for her. Deep down inside Anton L. knew that, even while he was going on about the shame, and it made him angry. It was not so much that he was jealous of the other men, more that he was envious of Dagmar. Anton L. seldom managed to make an indelible impression.

In Dagmar's flat he made a terrible scene, despite which she

immediately undressed and spread her voluptuous curves seductively out on the sofa. For once Anton L. was unmoved. He said a few choice words, then left her, with no goodbye and no sex.

It was not because of the – imagined – disgrace that Anton L. gave up his job at the publishers. That was because, as usual, he did not get on with his superiors. The row at the reception did not mean the end of his engagement to Dagmar either. That came a few weeks later. He handed in his notice for 31 August. On 1 September he went to Italy with Dagmar. She had borrowed her father's car for the trip. (Dagmar could drive, in fact she loved driving.) On the first day, by dint of some furious driving she managed to get halfway down Italy, to Frosinone. Dagmar, carefree, in holiday mood and in charge of the car, drove like a bat out of hell. Anton L., not having passed his driving test, – he was taking lessons but, as we have already noted, was having problems with his instructors – was not qualified to criticise his fiancée's driving and he could not bring himself to come out and say he feared for his life, as he did not want Dagmar to think him a coward. Late in the evening of 1 September Dagmar and Anton L. decided to spend the night in Frosinone. Their idea had been to head for the south of Italy and Sicily, but they never got that far, for on September 2, a Wednesday, one of Anton L.'s cleanliness phases broke out.

Their original intention had been to get as far as the Naples area that day, but they had not managed it, despite Dagmar's heroics behind the wheel. (That was before the north–south motorways had been built.) At eight o'clock they found themselves in Frosinone, a provincial town lacking both charm and sophistication to the south-east of Rome. It sits on a hill, spreading its ugly tentacles out into the surrounding countryside. Anton L. had been feeling hungry for some time, Dagmar not at all. When she was at the wheel all her other urges, even her sex drive, had to take a back seat. In Frosinone she agreed to stop. They went to a trattoria in a street that managed to be both ostentatious and shabby. It consisted of buildings from the Mussolini period, clad in brownish marble,

with massive, grimy columns and pillared arcades lining the street. At that time Anton L. had hardly been away from home at all. (It was before his travel-agency period.) As a child he had been to Carinthia with his parents a few times in the summer, staying by a lake he could hardly remember. Frosinone was by far the most southerly point he had reached in his life so far. Despite its ugliness, this unfamiliar world, with the Italians under the brightly lit arcades rushing to and fro and talking with eloquent rhetorical gesticulations, while the Vespas and Lambrettas buzzed up and down the street outside, struck him as exotic and sent him into a state of euphoria. Dagmar, on the other hand, had been around a lot. She was born in Manchuria, the daughter of a German merchant, later on the family had lived in America for a while; she had spent almost half her life in Spain. She spoke various languages and since she worked as an interpreter and translator for a large company she travelled a lot professionally as well. She had often been to Italy.

Dagmar explained the menu to Anton L. He ordered *pasta asciutta* and *saltimbocca, radicchio* and *zuppa romana*, the kind of things that were almost unknown north of the Alps at that time. After the meal Anton L. was tired, while Dagmar had scarcely got out of the car than her libido asserted itself again. They decided not to go on, but to spend the night there.

Dagmar and Anton L. did not have a lot of money, so Dagmar had got the address of a cheap hotel from the waiter. It was called the *Albergo Misisipi* and was on one of the streets going down the hill to the new town of Frosinone which, if possible, was even uglier than the old town. The *Albergo Misisipi* was not much more than the upper storey of an amusement arcade with American fruit machines, where the man who leased the machines had a few rooms to let. It was an old house, the room was enormous and the amusement arcade indescribably noisy. There were metal bedsteads, quite cleverly painted to look like wood. Above the beds was an oleograph of an iceberg with a fur seal, beside it a portrait of Pope Pius XII. The beds resembled an Italian salami, they were hard and cylindrical. If you just lay on them you

inevitably rolled off to one side onto the floor or ended up against the adjoining bed, at which the two beds would, with an ear-piercing scrape on the stone flags, slide apart and let you fall to the floor between them. Dagmar took her clothes off and leapt into bed. The tumescent mattress gave way beneath the impact of her jump and went to the opposite extreme, forming a kind of trough. When you got out of the trough the mattress, relieved of the weight, sprang back into its original shape with an eerie twang.

For the sex that followed the beds were, as always with Dagmar, of secondary importance. Her sexual frenzy needed plenty of room to manoeuvre. When they had finished Anton L. jumped onto his bed, in the way Dagmar demonstrated, to make it form a trough. Dagmar fell asleep immediately. Given his lack of weight – he was much thinner and lighter than Dagmar – Anton L. spent the whole night worrying his bed might suddenly snap back into its original shape and send him flying through the air. But that was not the only reason he slept badly. The indescribable noise in and outside the *Misisipi Amusement Arcade* continued until late into the night. Also there was a neon sign directly underneath their window and the curtains were much too thin and too skimpy to lessen its brightness at all. On top of all that, the next cleanliness phase was beginning to make its presence felt.

Whenever possible, Dagmar slept late. Anton L., who had managed to get a couple of hours sleep towards morning, when the noise subsided and the neon sign was switched off, was already awake again at seven. The cleanliness phase was in full swing. Anton L. got his washing things and set off to find the bathroom and lavatory. The lavatory was almost bigger than their bedroom. There was a spacious loggia attached which looked out over a dirty yard full of rubbish bins and mountains of empty boxes and crates. The toilet bowl was in one corner; it was pink, which looked very strange to Anton L. The bathroom was next door. It, too, was huge, but it was what one might call an inner room, having no windows apart from one giving onto the stairwell. The door had a lock, but it didn't work. Anton L. pushed a wobbly chair up against it and

tried to get a geyser covered in turquoise tiles to work. After a few attempts he managed to coax some warm water from it. He had a shower, then a bath, then a cold shower, then a hot shower. By this time the whole floor was covered in puddles. Someone pushed open the door, knocking the chair to one side. Anton L. screamed. It was Dagmar.

"You're up already?" she said.

"Did you come down the corridor stark naked?" he asked.

"Yes. Why?" she asked.

Any further reproaches on Anton L.'s part were stifled by the fact that Dagmar immediately proceeded to engage in sexual intercourse. Afterwards she returned to their room to go back to sleep.

Anton L. had another bath. That used up the last of his soap. He wrapped a towel round himself and went back to their room where he woke Dagmar and asked her to go out and buy him a bar of soap, a sponge, a dried sea cucumber (needed for massage), some shampoo and a particular kind of cream for cleaning his toenails. (He had discovered the cream during his previous cleanliness phase.) Dagmar was totally baffled, she had not yet witnessed Anton L. in full cleansing mode from close to. After a brief copulation, more a snack than a full meal, she agreed to get dressed and fetch the things he needed. While she was doing that Anton L., still with the towel wrapped round him, went back to the bathroom. But the landlord was there, sweeping the water Anton L. had slopped over the floor into a drain in the middle of the room. He waved Anton L. away when he made to get into the bath again and jabbered on at him in Italian. This was naturally incomprehensible to Anton L., who, for his part, started to talk agitatedly in German. It developed into an argument which went on for quite some time in the course of which Anton L., who was desperate for his next bath, managed to slip into the tub when the landlord's vigilance relaxed for a moment. He immediately turned the shower on, spraying water everywhere. The landlord shrieked, waved his brush and fled before the stream of water. Then he resorted to a simple solution: he turned off the mains stopcock in the cellar.

The water dried up while Anton L. was having a hot shower. It just dribbled for a while, then stopped completely. Anton L. was immediately convinced that a shower, and a hot one at that, broken off so abruptly was bound to lead to pneumonia, if not to a swollen solar plexus. He turned all the taps on, but of course nothing came. Shivering with cold, he wrapped himself up in his towel, went back to the room and lay down in bed. It was an hour later when Dagmar returned.

"What have you been doing for an hour?" he shouted at her.

"I've been driving all round the town. There's not a single dried sea cucumber anywhere in Frosinone. Nor your toe-cream, either." At least she had managed to get the rest.

"The landlord's turned the water off."

"You did flood the bathroom."

"If I don't get a bath immediately, I'll . . . You don't know what it's like," Anton L. shouted.

"Don't shout like that."

"I'll get pneumonia, and all because of that stupid landlord."

"Then get dressed."

"I want a bath."

"You've already had a bath."

"Please, go down to the landlord and tell him to turn the water on again immediately."

Dagmar went down. Five minutes later she was back. Anton L. was all ready to go to the bathroom, but she told him the landlord had refused.

Anton L. squawked, cursing incomprehensibly. In his fury he jumped up onto the bed with both feet. Under the impact the mattress went from giant salami to trough, but then immediately sprang back, hurling Anton L. to one side. He landed with his hip on the metal frame of the other bed, making a dent in the imitation wood. "Now I've really hurt myself!" he screamed. "Now I've really hurt myself."

It was only in a tucked-away corner of her consciousness that Dagmar found the scene funny, first and foremost she was afraid, afraid of three things: that Anton L. would blow his top,

that he would get violent and that the landlord would come. Her fears gave her an idea that saved the day. "I think," she said, "I passed a public baths when I was driving round." It was completely untrue.

"What use is a swimming pool?"

"No," said Dagmar, "with bathtubs and a sauna and that kind of thing."

Anton L. said nothing, but got dressed as quickly as he could and packed their things. They were soon ready, and while Dagmar was paying the bill (the landlord was so glad to get rid of his crazy guests he didn't make any extra charge for the excessive use of the bathroom) Anton L. was already in the car, clutching his new sponge in feverish anticipation.

Dagmar had resorted to a white lie just to get Anton L. out of the hotel before the landlord saw what he had done to the bed. Now her hope was that his urge to clean himself would subside (she didn't know what his cleanliness phases were like) or that she would actually come across some public baths (she didn't know Frosinone at all). So they drove all over the ugly town. Dagmar asked pedestrians and policemen, but no one could help. Anton L. was becoming insufferable. It was getting towards noon.

"You lied," Anton L. shouted. "You never saw any baths."

"But I swear —" Dagmar lied.

"There's no baths in this hole."

"I could have been mistaken, of course," said Dagmar, now somewhat subdued. "It was as I was driving past."

"So you were lying!"

"But I swear —"

"Stop!" Anton L. shouted.

Dagmar slammed on the brakes. A three-wheeled truck loaded to the top with crates full of live hens almost ran into the back of them.

"What is it?" she asked.

"A barber's," said Anton L., pointing at a barber's shop. "I'm going to the barber's. I'll get my hair washed, I'll have a shave and a haircut. Perhaps they do manicures as well."

Dagmar was relieved. She suggested she go with him to

explain to the barber what Anton L. wanted. He declined her offer, he wasn't a little child, he said, he didn't need her stupid Italian, he could wave his hands about himself. All he needed was the Italian for 'just a little'.

"*Poco,*" said Dagmar.

Thus the disaster happened. By *poco* the barber did not understand 'take a little off,' but 'leave a little on.' Anton L., imprisoned in the barber's chair, watched helplessly as the barber snipped away furiously. "*Poco! Poco!*" he shouted.

"*Si, si,*" said the barber, "*poco, capito,*" and gave him a convict cut.

Dagmar was waiting in a café close by. She only recognised Anton L. from his clothes. Then she couldn't help laughing and that was the final straw. Anton L. grabbed the car keys from her, ran to the car and pulled his case out, Dagmar following on his heels. She said she was sorry, she pleaded with him, all to no avail. Lots of curious Italians, including the driver of the three-wheeled truck, which reappeared from the opposite direction, now empty, looked on as Anton L. took all the money, their joint funds, out of his wallet, counted out half and gave it to Dagmar with the words, "Our engagement is over."

It wasn't easy for him to find his way to the station and buy a ticket, but he managed it. He went home. He never saw Dagmar again. For several years Frosinone remained the farthest south he had been in his life.

He managed to hold back the urge to clean himself until he got home, but then the interrupted phase exploded all the more violently for having been pent up. A dangerous combination of symptoms were added to his swollen solar plexus: the threat of an ingrowing wart on his back, stabbing pains in the ribs, hiccoughs, as always accompanied by scrotal tinnitus, and numbness in the feet together with violent sneezing. It was six weeks before his hair was back to its old length. Despite all this, the events in Frosinone were transformed in his memory. Over the years they took on the aura of a heroic liberation from a woman who, in Anton L.'s humble opinion, was not on a par with him.

He walked on slowly. At the end of the gallery a wide staircase of white marble led back down to the ground floor. On the left was the portrait gallery of the Prince Electors. On the right a door with gold decoration led into the library.

That was what Anton L. was looking for.

Beside the door, between two bouquets of artificial flowers made of stucco, was a large mirror with the bust of a screaming faun in front of it. The back of the faun's head could be seen in the mirror; it had a strangely pointed lock of hair over the back of its neck. Anton L. could be seen in the mirror too. His hair was tousled, with little curls sticking out on all sides. He was wearing a leather jacket with a belt (from an expensive gentleman's outfitter in Anakreon Strasse) which was very practical because it had a lot of pockets. His rifle was slung over his shoulder, and a bandolier with cartridges.

'Just like Leatherstocking,' thought Anton L.

12

Mozart with a Pharaoh and a Pharaohess

The owners of the candle shop, the 'Purveyors of Candles to the Court' behind the back of the bronze Elector where Anton L. had found the mysterious letter, were called Schindler, not Ludwig. (His concentric circles had reached the shop in August.) Herr Schindler's bookkeeping − Anton L. as a, now presumably ex-, tax official naturally understood such things, even though he loathed them − Herr Schindler's bookkeeping was, to put it mildly, simple. However, there was a box-file with copies of the wages slips for the current year and from these it emerged that a man by the name of *S. Ludwig* had been employed there, at a pre-tax salary of 1,000 marks per month. That was the limit to what Anton L. could find out about this S. Ludwig, apart from his calligraphic signature at the bottom of the receipts. Herr Ludwig's 'S.' was something between a treble clef and the staff of Aesculapius. It was only identifiable as an 'S' from the typed version underneath.

Anton L. drove in his, formerly Derendinger's, car to the Central Tax Office, which, as he naturally knew, was the one that would have the relevant records. This tax office, not the one where Anton L. had worked, was not far from the hotel, but it did involve a further radial thrust outside the concentric circles. Anyone who knows his way round one tax office, knows his way round all tax offices. It's just like hotels. He climbed in through a ground-floor window and quickly found the department he was looking for, the room he wanted and the file he needed for the tax returns for the people who worked at the candlemaker's. From the income-tax records Anton L. discovered that Herr Ludwig had the

remarkable forenames of Soliman Maria Xerxes and that he was younger (33) than one would have guessed from his calligraphic signature. The late Soliman Ludwig, Roman Catholic, had been married, had one child and – this was what mattered to Anton L. – lived at 2 Herthum Strasse. Anton L. took Herr Ludwig's card out of the file and, not without a certain sense of satisfaction, simply left the file lying where it was. He even left the door open since he was sure the tax official (Wirminger according to the name written in fine pen on the slip of card in the aluminium frame by the door) would not get into trouble for it.

From the Tax Office Anton L. drove straight to Herthum Strasse. It was in a northerly district of the city. The whole of one side of the short street was taken up by the huge building of a university which, set slightly back from the road behind elegant iron bars, had been built around the turn of the century in the so-called Florentine style. Faced with this monumental structure, the houses on the other side looked stunted. No. 2 was on the corner. Going through the dark entrance, he came to the upper ground floor. There was only one door, but it had two nameplates nailed to it: *L. Ludwig* (brass with Gothic lettering) and *S. Ludwig* (enamel). The arrangement of the apartment was confusing, but in a quite different way from the Hommers'. Parts of the corridor were divided off by large, heavy curtains in dark materials; the walls were covered with pictures it was impossible to make out; everywhere there were monstrous cupboards and cabinets; one cupboard was full of books, but not arranged in rows with the spine visible, they were stacked on top of each other, like piles of papers. There was more dust in the apartment than could have settled since 26 June.

Immediately on the right by the entrance was a double door that led into a room that was strange and gloomy, but in a distinct way. Anton L. immediately assumed it must have been Soliman's room. One wall had a picture on it. It wasn't exactly a wall painting, even though it covered the whole of the wall. Sheets of wrapping paper had been stuck together and pinned to the wall, from the ceiling to the skirting board,

then given a white ground and painted on. The painting was unfinished. The equipment – tempera, brushes, binder – was on a low shelf under the window. The centre of the picture was occupied by a portrait of Wolfgang Amadeus Mozart, a copy of the well-known portrait by Joseph Lange. Bizarre, animal-like cherubim were hovering round Mozart's head, clouds of them going right up to the ceiling. The painter, presumably Soliman Ludwig, had added arms and hands to Lange's portrait. Mozart's right hand was resting on a pyramid, on which hundreds of Egyptian slaves, a couple of inches high in the painting, were working. The pyramid was made of notes. It was, though Anton L. did not realise it, a copy of the manuscript of the opening bars of the Jupiter Symphony. A three-foot-high pharaoh and pharaohess were watching the work from underneath a baldachin. Several other pyramids had obviously been planned for the background. They had just been sketched in with pencil. A red sun was emitting rays in the form of Hebrew characters, quotations from the Old Testament, though Anton L. could not know that either, which snaked in and out between the grotesque cherubim and swirled round Mozart's head. As could be seen from where they had been sketched in, the rays of letters were to have been continued all the way over to the right-hand side, where an almost life-size figure had been carefully painted in. At first sight it looked like a hunchback, but on closer consideration it wasn't a hunchback, but a man who was in some indefinable way misshapen, with a face that was ugly and wrinkled, yet with a friendly, intelligent look, and a huge nose. He was coming out of a cave or grotto which had emerald light shimmering inside. His mouth was open, as if he were shouting. Little suns, moons and stars (of gold foil, stuck on) and the year *1601* in old-fashioned numbers were coming out of his mouth.

There was a desk against the wall opposite the painting, a monstrosity of a desk with lots of elaborately turned columns and a superstructure with towers and battlements like a castle. The rest of the wall was covered with bookshelves, which surrounded the desk like an archway. They contained books

on astronomy, musicology and legal history. Right at the top were the collected works of Karl May in the old crocodile-green edition with the hexagonal gold escutcheon on the spine.

Anton L. searched the desk. He did not find a *card*, but he did find bundles of correspondence, that is letters to Soliman Ludwig, also a book with red lines and pre-printed columns, such as merchants used to use for their accounts. It contained notes. Anton L. took the letters, a whole armful, and the book, loaded them in the car and set off back to the hotel.

He had not gone for long drives in Derendinger's car: from the Hommers' to the hotel, then back to the Hommers' to collect Sonja; he had used it a few times when the concentric circles of his business plan took him farther away from the hotel; and today, to the Central Tax Office and Herthum Strasse. Derendinger probably had not had much petrol left in the tank, since on the way back to the hotel the car came to a halt. First of all the engine stuttered, continued for a short while, stuttered again, for longer this time, then died. The car rolled on for a few metres and stopped. Anton L. had reckoned this would happen, but not so soon. What he had not reckoned with was that it would happen while he was driving through a herd of cows.

It was a broad street, lined exclusively with businesses and public buildings: ministries, institutes, law courts, insurance companies and banks. At the place where the car had stopped it broadened out into a square. There was a twin pair of fountains, one on either side. Following well-known Roman models, these fountains had two shallow basins, one above the other. A sheet of water poured – even now it was still flowing – from the upper to the lower and collected in a deeper basin at the bottom. The outlet of the one on the right was blocked. Perhaps the flood after the storm in July had swept rubbish into the basin. The water overflowing from the basin had formed a pond in the lower part of the square. Already the growth between the cobbles round the pond was more luxuriant than elsewhere. There were ducks swimming on the pond.

In the time since Anton L. had driven past in the opposite direction, a small herd of cows had come to drink. They were emaciated cows, perhaps six or seven of them, with a few calves and a bull. The cows that had just calved presumably had the best chance of survival, since they could get rid of their milk naturally. The others would have died an agonising death. The bull had probably never entirely lost its authority and managed to gather this little herd together, which found a plentiful supply of food in a large park nearby. The cows Anton L. had at first thought emaciated were not, in fact, just skin and bones, they had shrunk, as one might say, to their natural size. They were more muscular, seemed tougher, but also more aggressive than the cows Anton L. remembered. Only the bull was fat. It was just flopping into the pond as Anton L. drove past; the water sprayed up, the ducks took flight. The bull shot up again, presumably annoyed at its bath being disturbed, snorted and turned towards the car, horns lowered. And that was when he had to run out of petrol. The bull took a few steps towards the car. All the cows turned to watch their patriarch on the attack. Anton L. picked up his rifle, but he didn't shoot. Would a bullet be effective against such a big animal? If it only wounded the bull it could make it so angry, or so he had heard, that it would demolish the car and Anton L. with it. He closed the window and waited. The beast did, indeed, calm down after a while, during which Anton L. started to read Soliman Ludwig's notes (more of that later) and continued its interrupted bath; the cows and calves went back to drinking. After an hour the herd crossed over to the other fountain, then disappeared down a side street towards the large park.

Anton L. had made his preparations for this eventuality. Both Pfeivestl and the Cuypers had had a car with them and had parked them in the hotel garage. With the documents he found in their rooms it was not difficult for him to identify their cars. Pfeivestl's was a dark-blue Mercedes, the Cuypers's a large, beige Opel. Once the cattle had gone, Anton L. made his way back to the hotel on foot, got into Pfeivestl's Mercedes and drove back to collect Soliman Ludwig's papers

from Derendinger's car. He spent the evening immersed in the letters to this clearly highly remarkable man.

In all there were more than thirty bundles, each one containing the letters from one person. Some were fatter than others; the biggest contained five hundred letters, the smallest ten. Soliman Ludwig had kept the letters, unfolded, without their envelopes, in cardboard files tied up with ribbons. The fattest bundle – the five hundred letters from a certain Simon List – consisted of four such files. The address of the correspondent was noted on the outside of the folders in Soliman's beautiful calligraphic handwriting. If the correspondent had moved, as had happened quite a lot since the letters went back fifteen years, to the time when Soliman was still at school, the old address was lightly scored out and the new one written neatly below it. Since 1959, when he had started corresponding with Soliman Ludwig, Simon List had moved house eight times. According to the order of the addresses, Simon List had lived in Vienna at first, then in Graz, in Vienna again, then in New York, London, Malta, then in the vicinity of Salzburg and finally in Salzburg itself.

On the back of each folder was a series, some longer, some shorter, of dates, presumably the dates on which Soliman Ludwig had written his replies. Almost all the correspondence continued up to recent times. As a survey of the dates showed, Soliman Ludwig had written four letters shortly before the catastrophe: one to a Herr Dr Frankenstein in Tel Aviv on the Friday, two on the Saturday to a Frau Weiss in Hamburg, a lady who, as her letters revealed, specialised in the history of medieval mathematics; and to a professor in Teheran, and one, to Simon List, on Monday 25 June. Anticipating later developments, we can say here that this was to provide the most important clue leading Anton L. directly to the discovery of the secret of Soliman Ludwig and his friends. Soliman Ludwig and his friends had been close to discovering the secret, but that was to be a privilege reserved to Anton L., helped by a lucky chance. However, if one takes into account the fact that Anton L. was the only person spared from the catastrophe, the general dematerialisation,

then one must ask whether that 'chance' really was simply chance.

There were letters in many languages, especially German, English and French. In correspondence that started in later years there were less common languages: Portuguese, Polish, even Russian as well as Hebrew, Persian and Arabic. Soliman Ludwig had mastered all these languages, but that was only a by-product, of which, as far as one could tell from the letters to him, he was hardly aware, of his primary interest, which was in classical languages. The earliest correspondence, which, however, had been discontinued for no obvious reason over six years ago, was the most informative in that respect. Even while still at school Soliman Ludwig had been one of that rare breed, an enthusiastic student of Latin and even more so of Greek – Anton L. remembered well his own problems in that area. Then Soliman Ludwig appeared to have gradually plumbed the obscure depths of older and older languages: Hebrew, Egyptian, Babylonian, but also Old Norse, the Celtic languages and the like. Once, while he was still a student, Soliman Ludwig seemed to have been consulted by a committee of scholars as an expert for the dating of an important collection of documents that had been discovered. The dating apparently depended on a precise knowledge of certain dialects of Old Babylonian which Soliman Ludwig possessed.

In law, too, Soliman Ludwig's interests slowly but surely turned to archaic systems. He only seemed to have dealt with current law insofar as it was necessary to pass his examinations. Soon he was studying the history of Germanic law which he quickly, if Anton L. had interpreted the letters correctly, came to feel was too recent for him. As was inevitable, he moved on to Roman law and soon to juridical papyrology. He appeared to have written some articles on Assyriology and done some translations in that area. Around 1970 he had fallen out with the professor who was supervising his thesis. The letters did not tell Anton L. whether the remarkable step, for one of his talents, of taking a surely rather lowly position in the candlemaker's was the cause or the effect of this quarrel. One possibility is that it was connected with his marriage and

the birth of his daughter, who was called Eschiva. Herr Schindler, who owned the candlemaker's, was a cousin of Soliman Ludwig. Perhaps at least part of the explanation was that at the age of thirty Soliman Ludwig, who, together with his parents (he seemed to be their only child), was not particularly comfortably off, wanted to be financially independent in order to be able to pursue the matters which even then had preoccupied him and his friends (we'll come to it soon). Perhaps the work for his cousin in the candlemaker's was pleasant enough and gave him plenty of free time. Perhaps Schindler, too, had been interested in Soliman's later researches.

Since the middle nineteen-sixties – at that time the correspondence with Simon List had intensified – Ludwig had increasingly concerned himself with mathematics and astronomy, then with a specialised branch of philosophy, with the mediaeval and early Christian movements which are nowadays looked on as heresies: Manichaean, Gnostic and Nestorian ideas. From the documents Anton L. had at his disposal it was impossible to tell whether this was merely out of scholarly historical interest or whether some kind of personal belief played a role. Perhaps his supervisor had been disappointed by this preoccupation with abstruse topics, which would necessarily have distracted him from the Assyriology of his thesis, and that had perhaps led to the above-mentioned falling out between them.

The ledger was a disappointment. Soliman Ludwig had started to use it as a kind of diary shortly after he left school. There were about a dozen pages of brief entries on books he had read and lectures he had attended. Rather more extended was the description of a two-week trip to Venice in the summer vacation of 1962, but in that, too, he contented himself with listing the churches and museums he had visited. Amongst other places, he had visited the island of San Lazzaro, twice in the first week of his stay and a third time on the day before he left. At the end of the last entry on San Lazzaro Soliman Ludwig had written – in red pencil, which he had not used anywhere else in the whole book – 'Father Rub'. It is on San Lazzaro that the Armenian Catholic

Mechitarist monks have their monastery and their famous printing house.

He could not find any correspondence with a 'Father Rub'.

Soon after his stay in Venice, Soliman Ludwig began to use an old-fashioned script that was almost illegible, then he kept his diary in Latin and finally in a secret code. Since, however, he still used the normal numerals, it was clear that he had kept up the diary almost until the end. The last entry was dated 19 July of that year.

The sections in the old-fashioned script contained further notes on books he had read, lectures, plays and concerts he had attended, but also the record of a remarkable journey : he had travelled via Innsbruck and Bolzano to Ferrara, then to Florence and Rome, to Macedonia, Durazzo and Corfu, to Athens, Constantinople and Jerusalem, to Baghdad and from there to the fortress of Alamut in Persia where Hasan, the Shaykh al-Jabal or the Old Man of the Mountain who had been living there in secret for a thousand years, took him into the hillside and showed him the hundred and twenty-one Secret Books of the Assassins. This last section of his travel diary suggests that that part of the journey at least, though more probably the whole journey, was nothing but a hoax.

The person who had sent the brief note to Soliman Ludwig that Anton L. had found in the candlemaker's shop had signed it 'C.'; the one who had delivered it and written greetings on the outside was 'E.'. There was neither a C. nor an E. among Soliman Ludwig's thirty or so correspondents. This was not in itself surprising, since they both lived in the same town so would not need to write to each other. However, in Simon List's letters a very old man called Lorenz Eschenlohe was mentioned and a publisher's editor whose name was *Candtler*.

The name, and the fact that the man had been a publisher's editor, brought to mind someone Anton L. had met during his three years working for a publisher. The spelling of the name was unusual and it was highly unlikely there would be two people in publishing with it; moreover the letters mentioned facts relating to Herr Candtler which Anton L. also remembered. Herr Candtler had had a senior position with a different

firm of publishers from the one where Anton L. had worked. For many years he had been editorial director of B., a venerable publishing house of the old school. Any kind of fuss or hustle and bustle was alien to the firm of B., which had been publishing books for two hundred years and was now in the seventh generation. What they did have were marble stairs, oak bookcases, solid double doors and a lift of exemplary slowness. It was not impossible that the lift was, in a way, the motto of the firm (calm, quiet, reliable) and at the same time a means of attuning even the most dynamic and agitated author to the atmosphere of the publishing house. In the first place it took a long time to arrive. Then two solid doors, one of iron, one of wood, silently slid apart. You got in and pressed the button for the floor you required. Nothing happened. Only when the impatient passenger had got out again to complain to the porter (who, oddly enough, was almost always a pretty girl), would the inner, wooden door close, gently but firmly, then, after a suitable pause, the outer, iron one too. Passengers could not tell whether the lift was actually moving, the motion was so slow. If you sit on a tree you can't feel it growing. The passengers were surrounded by luxury that was almost too lavish: a mirror, an upholstered bench, a stool, an umbrella stand, a brass coat-hook, all of the best quality and in the best of taste. However, given the time the lift took from the cellar to, for example, the fifth floor, the supply of furnishings was not unreasonable. When the lift at last arrived on the second floor and first of all the outer door, after lengthy, silent deliberations, opened, and then, finally, the inner door, the author who stepped out was calm and restrained, completely purged of the burning self-righteousness or blazing anger he may have felt as he got in on the ground floor. In any case, one could never justifiably feel blazing anger towards this publishing house. Everything was a model of correctness. There was no lack of money. Indeed, one sometimes had the feeling they did not need, perhaps even could not be bothered to sell their books. (Their *literary* books, that was, not, of course, their extensive publications in a quite different, very important area of publishing which formed the mainstay of the firm's commercial activities.)

Candtler was a short, slim man with a handsome bald head. With the loss of their hair most men lose a considerable part of their good looks, but Candtler was one of the fortunate few who, thanks to the elegant shape of their skulls, have more to lose by keeping their hair. To go with it he had a grey moustache flecked with white which was – there is no other word for it – "aristocratic". He looked rather like an English officer who had returned home after years spent in the colonies. Such people have a refined vagueness about them, not from a lack of acuity, but from a distaste for the modern world. Things move so fast that one has to run just to keep up with them, and that they refuse to do. They develop a gentle cynicism and, by remaining *au-dessus de la mêlée*, a precision of thought and expression which shows that, at a deeper level, they are quite capable of "keeping up" with things. Such a man was Herr Candtler.

Anton L. first met him to discuss the inclusion of a story by an important author, one of the most important German-language authors of the twentieth century, in an anthology Anton L.'s firm was publishing, but later on he had seen and spoken to him on a number of occasions. In the course of those conversations he had never noticed any sign that Candtler might be interested in the matters Soliman Ludwig was involved in, matters that were close to the occult. (If Anton L. had had the old catalogues of Candtler's publishing house to hand, he would have made a discovery. In 1962 they had published in their series *Studies on the History of the Middle Ages* a short book entitled *The Libraries of the Assassins and the Consequences of their Destruction by Il-Khan Hulagu in 1256*, written by Soliman Ludwig.)

Once he had found the letters to Soliman Ludwig, Anton L. curtailed his business plan to devote his time to reading the correspondence, even though it provided few clues for what had now become almost a piece of detective work. What did emerge was that Soliman Ludwig, Herr Candtler, Eschenlohe, who undertook tasks of a more practical nature, and Simon List (by correspondence) had come together with no less an aim than that of drawing up a catalogue of all the secret

libraries in the world. It appeared that Soliman Ludwig had a mind to investigate the contents of libraries that had disappeared. Simon List repeatedly advised against it, but in spite of that it seemed to have become the focus of Soliman Ludwig's interest. One of Simon List's letters sounded almost angry. In the very last year Ludwig seemed to have started to concentrate on one particular point, on the unveiling of a special secret he believed he was on the track of. What it was could not be deduced from the letters. Simon List always referred to this philosopher's stone somewhat coyly as "what you are looking for" or "what we must find" or simply "IT".

Anton L. wondered whether he should find out where Herr Candtler had lived, or even go to Salzburg to search Simon List's apartment (he had that address from the file of letters); perhaps Soliman Ludwig had been more open in his letters to List, who presumably would have kept them. But that turned out to be unnecessary. One day at the end of August he ignored the concentric circles of his business plan completely and spent his time reading Simon List's letters, which he had almost finished. The file was lying upside down on the table, and as Anton L. came back into the room after a brief interruption to his reading to feed Sonja, his eye fell on what was written on the back of the file: the dates of Soliman Ludwig's letters to Simon List. The last date was 25 June.

The letter could not have been delivered, even if Ludwig had written and posted it early in the morning. Anton L. was expecting a painstaking search, having to sift through the contents of the local post office, for example, but he found the letter at the very first place he looked. Soliman Ludwig had written it after the candlemaker's had closed, while Eschenlohe was on his way to the shop with Candtler's message, and only posted it late that evening, after the last collection on the 25th (there would never be another collection). When Anton L. broke the postbox open with his crowbar, thirty or forty letters fell out. He immediately recognised the envelope with Soliman Ludwig's beautiful calligraphic handwriting.

13

A letter

"My dear friend,

I know that you still don't believe it, but it is not a game, I am persuaded. Though perhaps persuaded is the wrong word, wrong for the moment at least, since I have not yet found evidence, *conclusive* evidence. So instead I will say that I am sure, sure not in an occult, mystical, cabbalistical sense, but in a matter-of-fact, logical sense. I have always been as susceptible to logic as to all things cabbalistical.

Now I am telling you.

I have already told you, of course. I did so the last time you were here. I'm *writing* it. I don't actually *need* to do that, because I know you remember what I told you and C. and E. I am writing it *for myself*, even though I am going to post this letter.

What is the world – I mean the cosmos? A tangle of more or less living particles. The more alive these particles are – in which case we generally call them cells – the more they are in a hurry, and have been since time immemorial, to do One Thing, which was and is the be-all and end-all: to make more of themselves. Everything wants to form a matrix. Every cell, every cluster of cells, from the infusoria to man, has but One Tendency: to multiply. Every living organism tends, no, is impelled to create organisms corresponding to itself around it or to modify existing structures according to its own image.

'Did I believe in God?' you asked me the time before last. I will define my position on that as follows: for some time now I have doubted the non-existence of a god. If the Nice

(Evil? Angry?) Old Man does exist – at the moment I'm in doubt, so I can be disrespectful 'without prejudice' – then the Biblical form of the Lord could well be a possibility, and in that case we would know that even a spiritual being is not free from the pressure of the matrix: he created Adam *in his own image*. (Although, cynics might say, better models were feasible.)

Even the mind is not free from this urge to procreate, not in the least! The history of the sciences is a history of proselytising. Every scholar has his students on whom he hopes to put his stamp. Everywhere everything is converting, re-forming things after its own image, in its own way the amoeba is no better in this than Plato. There is therefore some justification for my suspicion that the world, our world, the earth and its creative factor, feels the urge to become a matrix. The result was IT: the Book.

The cosmos cannot create a second cosmos beside it. It is impossible, if you like, for reasons of space, because of the limited number of atoms etc. The urge to become a matrix, initially fanning out into the immense range of the multiplicity of worlds, has, under pressure from the 'will to procreate' which could find no other path, concentrated in a focus, and it is in precisely this focus that the new image of the world – a new image with the stamp of the old – *had to* arise.

The only contingency that would render our search vain, the *only* contingency, would be if this focus had not yet formed, if it were still in the future. In that case we would naturally not be able to find it.

I do not know whether this focus was the work of one single man, in whom all human knowledge gathered as a revelation incomprehensible even to himself, or the result of a group of people laboriously writing it down over the centuries in secret. My assumption is – though this is of secondary importance, a mere arabesque – that it was a dynasty of minor emirs of the Assassins who composed the work over some two hundred years in a castle on the northern slopes of the Elburz Mountains in Persia. It must have been completed by the time the Mongol Hulagu destroyed all the fortresses of

the Assassins in 1256. Perhaps it was taken to the safety of the other branch of the Assassins in the Nusayriyah Range in Syria, who survived the massacre, perhaps it was buried. It is well known that Hulagu was annoyed that he did not find the treasure of the Assassins, despite the years he spent looking for it.

My assumption that the world 'matrixed' itself as a book is based entirely on negative reasoning: in what other form could it do it? As I said before, the world was under pressure from the urge to put its stamp on something. It will have chosen the way that was, relatively speaking, the simplest; or, rather, the urge will have made its breakthrough at the point where it was easiest. In what form can knowledge be more easily and more simply represented in a relatively small space than in a book? Thought → language → writing → book: those are the four stages of the world matrix. Therefore there must have been − therefore there *was* a book containing all the knowledge of the world. The book still exists. With the one alternative mentioned above: the book *will* exist. That I grant, and in that case we are doomed to fail. However, I do not believe that to be the case. We are, I think you will agree, closer to the end of the world than the beginning, and the world will not have been so dilatory in forming its matrix.

The one drawback is that the world has done nothing to help spread the book which bears its stamp. Just like most units of life, it lost interest in its image once it had produced it. It is, of course, possible that it has been lost. But then the world would immediately have taken steps to leave another image with its stamp. Perhaps it has done so anyway, after a pause to recover such as is necessary after every act of pro-creation. Perhaps that book in the Elburz Mountains is the thousandth. The simple, if superficial reason I am searching for *that* book is because I have clues as to where it is, but not for any others.

Eschiva can already count up to twenty. Recently I explained Hebrew characters to her. In drawing she quickly picked up the principle of perspective. We're wondering

whether to put her straight into primary two when she starts school in the autumn. *The Magic Flute* here was really good. Schindler's away next week, so I'm stuck in the office on Saturday. Anna's finger is better.

With best wishes

Soliman Ludwig"

14

A painting by Canaletto

It was only a few hundred yards from the Palace to the hotel. Anton L. had gone on foot. Now – it was almost evening – he was returning through the tall grass and weeds that had long since shot up between the paving stones and out of all the gaps in the tarmac. The weeds were growing profusely on the roofs as well. From some of the balconies the growth was hanging down like a luxuriant green beard.

Anton L. had not found the Book in the Palace library. He wasn't disappointed at that, indeed, a quick, cheap success would have made him suspicious.

But he had something else with him: under his arm, wrapped in a linen sheet he had taken off the gigantic bed of the Elector, he was carrying a picture. It was the celebrated view of the city by Canaletto, an outstanding work by the artist which Anton L. had seen hanging in the Elector's bedroom when he passed through on his way back from his unsuccessful search in the library. A ray from the setting sun was slanting across the room, glinting off the gold lilies on the blue velvet canopy and illuminating the Canaletto. It was not a large picture. It was a view of the city from the other side of the river. At that time neither bank was built up. The river spread out into several arms that meandered through the meadows and marshland. In the foreground a few cows were grazing and various genre scenes were taking place on the bridge over the river and as far as the city gate (the gate still existed): pedlars were haggling, a wooden cart had a broken wheel, families from the town were taking an idyllic walk, a little dog leapt up, an elegant four-in-hand was driving past with closed curtains, a beggar had raised his hat to a sedan chair.

In the background was a panorama of the distant city with its many towers. The evening sun was reflected in the copper dome of the Court Church, which at that time had just been built, and the Baroque block of the Palace rose above the closely packed houses of the citizens; the city walls were still standing, but the poorer quarters were already spilling over onto the area outside. Above the city stretched the clear sky of an autumn evening with the hot, dry *Föhn* blowing down from the Alps. Canaletto's manner of painting these unutterably crystal-clear skies with vigorous yet subtle brushstrokes was almost a personal signature: blue and yet golden. A magnificent picture. Anton L. immediately decided he would have it in his hotel room. At the same time he decided to fetch Rembrandt's small self-portrait and what was perhaps his favourite painting, the moving, almost Impressionist picture of *Christ Crowned with Thorns* that Titian painted when he was almost a hundred, from the National Gallery, though the size of the latter, he reflected, might well cause transport difficulties. For Sonja's room he thought of van Gogh's *Sunflowers* from the New State Gallery.

Outside the old Main Post Office, on the corner where Anakreon Strasse entered the Palace square, there was a rustling in the weeds. The great flood had left a large puddle, almost a pond, in a depression where the road surface had sunk. A cellar had probably collapsed underneath it. Carefully Anton L. put the Canaletto down and propped it up against a pillar of the Court Theatre. He unslung the rifle he carried over his shoulder. (He knew that rustling well.) It was already dark among the houses, but Anton L.'s eyes had long since got used to that. A flock of pheasants flew up. Quickly he brought up his gun and fired twice, then once more. One pheasant reeled, flapped its wings and fell down into Anakreon Strasse, opposite Michelleuthner's silk shop. The reports echoed through the streets, but the sound no longer startled Anton L. Flocks of other birds flew up and swirled round the rooftops for a while. Suddenly there was a different noise, a clatter as tiles fell to the ground. On the far side of the square were the buildings on which the bronze Elector was turning his back,

one of them housing the candlemaker's. The roof had prob-
ably already been in need of repair and the plants growing on
it would just have made things worse. The shock wave from
the three shots had been enough to loosen the tiles, the whole
of the roof had slid down and piled up on the edge, like a flat
avalanche, then fallen down. The tiles smashed as they hit the
pavement. The clatter continued for some considerable time;
when it stopped the entrance to the candlemaker's was
blocked by a pile of rubble taller than a man.

"Strange," said the bronze Elector.

'Yes, strange,' thought Anton L. 'Now I wouldn't be able to
find that mysterious message any longer. Not that it matters
now that I've followed the route it indicated almost to the
end. Only I'll have to find another supply of candles.' He
didn't use many candles any more. In the course of the
months since 26 June his body clock had adjusted to the
daylight. When it was light, he got up, and when it was dark,
he got tired and went to bed.

Anton L. picked up the pheasant he had shot and hung it
from his belt. It was only when he had almost reached the
hotel that it suddenly struck him. 'Did the Elector speak to
me just now, or am I imagining things?'

He stopped, turned round and propped the Canaletto
against the hotel wall to save him the effort of carrying it to
the square and back, even though it was only a couple of
hundred yards.

For some time now Anton L. had stopped feeling afraid.
Fear is something you get out of the habit of, even if, like
Anton L., you are an innate coward. Fear gradually fades, just
like the feeling of vertigo you first get when you move into a
flat on the top floor of a high building. Once you've lived
there for some time the drop becomes familiar, your body
adjusts to it. Anton L. had come across that years ago, when
he was working for the publishers. The offices were in the
three upper storeys of a seven-floor office block with a huge
courtyard. All the rooms gave onto a narrow, open walkway
running round the courtyard, which yawned like an abyss.
'Sing Sing' they all called it, but of course that had other

connotations as well. Anton L.'s office was on the fifth floor. At first he always felt sick when he emerged from the lift onto the walkway and had to go almost right round the abyss to get to his office. But with time the feeling of vertigo had faded. He could even go to the railing, the abyss had become familiar; Anton L. looked down as if there were nothing to it, waved across to people on the other side as if he were on the ground floor. But only on the fifth floor. If he had to go up to the sixth or seventh floor, the feeling of vertigo immediately returned. He felt as if the walkway, together with the railings, were slowly leaning down into the abyss. He did not have to go up to the sixth or seventh floor often enough for his fear to go away. All the time he worked for the publishers, whenever he had to go up to the sixth or seventh floor, he kept close to the wall, despite the fact that it meant he sometimes collided with people who came dashing out of their offices in a hurry.

Anton L. was past feeling afraid of a bronze Elector who might speak, or of any similar phenomenon.

The sun had already gone when he reached the statue. The roofs were dark too. The sky was light. The square was full of grey, gossamer-thin threads, that delicate, smoky autumnal twilight where you are never quite sure whether it is real mist or just the shades of night that have not quite fully closed in. The statue of the elector was like a spiky, shapeless block of black in the middle of the square.

"I wouldn't leave the Canaletto there," said the Elector.

"Who's going to steal it?" said Anton L.

"It would have been safer if you'd taken it into the vestibule. *I'm* not going anywhere," said the Elector.

"A rhinoceros isn't going to stick its horn through it during the few minutes I'll be away," said Anton L.

"But perhaps you're not the only person in the city."

"So far I haven't seen any trace of another human being," said Anton L.

"What if it should start to rain?" said the Elector. "The Canaletto would be ruined."

"Get away!" said Anton L. "A clear, cloudless sky? If it starts to rain in the next four hours I'll eat"

". . . the Canaletto," said the elector.

"If you insist," said Anton L. "Anyway, I wrapped it up in a sheet."

"In one of *my* bedsheets, you mean," said the Elector.

"You're not trying to tell me that sheet comes from the eighteenth century? It came from the Department of Castles and Ancient Monuments, you – your – your –"

"Your Royal Highness," said the Elector.

"– Your Royal Highness never slept in it."

"But it was on my bed," said the Elector.

"Still," said Anton L., "I'm sure Your Royal Highness would prefer the sheet to get wet, rather than the Canaletto."

"I simply couldn't bring myself to leave a Canaletto leaning against the wall of a hotel," said the Elector.

"All right," said Anton L., "I'll go back. I suppose one of those bloody dogs might just piss on it."

He turned and left.

"Good night," said the Elector.

"Sorry," said Anton L., turning round and sketching a bow. "Good night."

"Just because you're alone in the world doesn't mean to say everything belongs to you, you know," the Elector called out.

"Yes, yes," Anton L. said. He had already set off along Anakreon Strasse. "Good night, Your Royal Highness," he shouted. A flock of coots scattered in alarm.

The Canaletto was still leaning against the hotel wall, undamaged.

It was almost night. While he was talking to the Elector, the smoky web of twilight between the houses had dissolved into clear darkness. The night noises, now long familiar, started up: the gentle twittering from above, the scurryings and scufflings in the grass, a sudden loud quacking, squawking and yawning, a distant, soft whistle, now and then a growl. A gentle breeze got up, here and there a star glinted in the sky, or a pair of watchful eyes in the tall grass. (Only a few days previously Anton L. had seen a lynx behind the hotel.) By now, of course, none of this was any cause of concern to him. The constant awareness and concentration his situation demanded had

become second nature. But he still did get a fright when the horse leapt up just as, carrying his Canaletto, he was about to enter the covered driveway to the hotel. He *got a fright*, he wasn't *frightened*. The horse must have been resting in the open entrance, a kind of outer foyer. It was a very large horse, greyish brown, and it gleamed a little in the dark, as if it had stored up daylight in its coat.

It set off up Anakreon Strasse, in the direction Anton L. had come from. The horse was limping a little; from the irregular clip-clop of its hooves you could hear that it must have lost one of its shoes. Then it galloped across the street and down the slight, curving incline of Abenceragen Strasse. By that time, however, Anton L.'s attention was entirely occupied with the great explosion, which the horse had perhaps anticipated a few seconds earlier.

What had probably happened was that in some store or factory two incompatible chemicals, perhaps due to the flood or the collapse of dividing walls, had eaten their way through to each other and produced an explosive mixture. Across the river a pillar of fire, a swirl of red and gold with streaks of black, shot up taller than a tower. A clap of thunder followed. The explosion was obviously a long way out on the eastern edge of the city and presented no danger to the area round the hotel, yet Anton L. still ducked and carried the Canaletto into the protection of the hotel entrance. And a good job too. A very short time later the shock wave from the explosion swept through the street like a tornado, tearing everything with it that wasn't fixed down or had come loose: flowerpots, lumps of wood, windows, street signs, planks and small trees. Part of the overhead cable for the trams was blown down and rolled along like a messy ball of wool, getting bigger and bigger, until it stopped almost directly outside the hotel; then a tin roof came sailing by, clattering along the buildings and knocking off all the signs that projected from the façades, before disappearing in the direction of the Palace. The pots and pans Anton L. had thrown out of the window flew past. As you will recall, the windows of the buildings in the vicinity had been the victims of Anton L.'s first shooting practice. A few had

remained unbroken. The shock wave now destroyed them, along with numerous hotel windows, unfortunately. Anton L. was forced against the wall, otherwise he was unharmed. Once the shock wave had passed he got up and peered round the corner. Small, slender pillars of fire were shooting up on either side of the large one. The large pillar of fire became a greenish yellow and then quickly turned black, merging with the night sky in the east. Soon a red glow, which lasted for several days, spread over the eastern horizon.

Anton L. put the pheasant in the kitchen, then carried the Canaletto up to his suite. As he feared, it had broken windows, eleven panes in three casements. He immediately hit on the simple idea of replacing his broken windows with intact units from other rooms on his floor. All the windows on that floor were the same, only those on the upper floors were smaller. The windows had not been damaged in Sonja's room, which looked out onto the courtyard.

Anton L. plucked the pheasant – it wasn't the first bird he'd killed – and roasted it. As always since the gas had stopped at the end of August, he used the wood from chairs in the conference room to heat the oven. He kept a supply of these chairs piled up in one corner of the large hotel kitchen, the axe beside them.

While the pheasant was cooking, Anton L. took a chair – the last time anyone would sit in it, the next day it was chopped up for firewood – pulled it up to the oven and thought. One member of the family of cats, which by now had reached an estimated twenty-five, saw the pile of feathers on the floor, drew back in alarm, put up its tail, hissed and leapt at the pile, sending the feathers flying. The swirling feathers drove the cat wild. It jumped at them, bit at them, swatted them, sometimes with both forepaws at once. After a while it was so out of breath it lay down by the oven, curled up and went to sleep.

There was a candle lit in the kitchen, a very large candle. There was light from the fire in the oven as well. But Anton L. did not read while the pheasant was cooking and a very acceptable smell gradually filled the kitchen. He never read

while cooking, he thought instead. He thought things such as: I'm world champion in all sports, world champion at the high jump, world champion at the long jump, world champion at one hundred metres, world champion cyclist, world champion weightlifter . . .

He stood up, picked up the heavy block of wood he used for chopping the chairs and lifted it above his head. When he let it drop on the floor, the cat woke up, gave him a reproachful look, yawned and curled up the other way round.

'World champion weightlifter?' Can you be world champion tennis player just by yourself? Chess player? Even if I couldn't lift the heavy block of wood, Anton L. thought, only that box of matches, for example, I'd still be world champion weightlifter, and even if I could only limp and hobble and took an hour to get to the bronze Elector, I'd still be world champion at the 1,000 metres. But here's a question: am I world champion at something I can't do? At gliding, for example? Or bridge? Golf?

The pheasant was done. The enforced practice meant he had acquired a certain skill at cooking. Despite that, the roast pheasant was not one that would have increased the gastronomic reputation of the hotel. A regular such as Herr Pfeivestl would doubtless have sent it back as too tough. But it was edible. Anton L. put out the candle in the kitchen, closed the oven and served the pheasant up on the sixty-third setting in the large dining-room. He had half a tin of peas with it. Sonja got the other half.

Before he went to bed he took his binoculars (from the hunting equipment shop diagonally opposite the hotel), leant out of the window and scanned the eastern horizon. The red glow had spread out evenly, no details could be made out.

The glow remained until near the end of the next week when the autumn rains started.

15

The Chinese pavilion

When the rain started towards the end of the following week – by now it was the beginning of September – it was clear that summer was over. There were a few fine days later, in October, but the autumn storms started as early as September. Summer was over.

Anton L. had abandoned his concentric explorations for the time being, having decided to undertake another radial sortie. First of all, though, he had to solve the heating problem. The cold rain that spread an unpleasant dampness over the outside walls reminded him that he would have to prepare for the winter somehow or other. He wasn't actually feeling the cold yet, he just shivered when he looked out at the rain. Sonja was shivering too.

The hotel had central heating; to make matters worse, it was supplied by a district heating system. He couldn't expect that to function. There were electric heaters as well, but they were of no use either. There were no solid-fuel stoves. The kitchen was the only place that got warm, when Anton L. lit the oven, but he didn't fancy spending all his time in the basement.

At first he put on warmer clothes and fetched some warmer blankets. His attempt to make a fire in his sitting room by burning parquet blocks from other rooms in a large copper bowl was not a success. The bowl, heavy and fairly shallow, was underneath a pot containing a huge philodendron in the foyer. The philodendron was one of the plants Anton L. was watering. It had formed air-roots which had crept under pieces of furniture and carpets and into gaps in the parquet floor and it wasn't easy to drag the bowl out from

underneath it. Then he lugged the bowl, more of a wide basin really, up to his sitting room, crumpled up some newspapers (there were masses of them on the hotel's newspaper stand, all from 25 June, sometimes Anton L. glanced at them before he used them to start a fire), prised up some parquet blocks in room 16, the room beside Sonja's, with his axe and made a fire. He soon had a crackling blaze, but it also produced an immense amount of smoke. In next to no time the whole suite was filled with black fumes. He flung open the windows and poured water into the copper basin. It hissed. The basin was too hot to touch, so Anton L. tied a belt round one of the handles and pulled it out into the corridor, where it smoked quietly for another hour. In his sitting room parts of the ceiling and walls were black with soot. (To continue his wallpaper diary, he had to wipe the soot off. For that day's entry he wrote: 'Conflagration in the room.') Where the basin had stood was a large brown mark on the carpet. For days there was a stench of cold smoke, even though Anton L. was constantly airing the room; there was still a stench in November, when he moved for the last time.

There were several reasons for moving again. At the beginning of November the first snow had fallen and it turned icy cold. Sonja looked as if she was on her last legs. Anton L. put her cage in the kitchen. This time she was easier to catch since, probably because of the cold, she hardly moved any more.

It never got really cold in the kitchen. It was in the basement and didn't have many windows. Also Anton L. never let the fire in the big oven go out; at night he carefully pushed the embers together. The chairs from the conference room had already been used up, now he was burning other pieces of furniture, two or three cupboards or chests every day, plus smaller items. By the beginning of November he was already having to bring furniture down from the second floor. The end of his supply was in sight.

Now Anton L. spent his days in the kitchen, when he wasn't out and about. It was cold in his suite, but he continued to sleep up there until the effects of all the broken windows

from the shock wave of the explosion started to show. Rain and snow came in, forming puddles, which kept freezing and thawing, breaking up the floors. Within a few weeks Anton L.'s rooms were beginning to get damp too. Fungi appeared on the walls, except where they were covered in soot. Even the most basic measures to protect such a large building from damage were beyond the strength of a single person. Anyway, there was the crack. It appeared on 19 November or, to be precise, during the night from 18 to 19 November. Anton L. was woken by an ear-splitting bang. At first he did not know whether he had dreamt it or not but then, indubitably wide awake, he heard a distinct trickling noise. He leapt out of bed. (It was what you might call 'sixth-floor fear', that is, the degree to which Anton L. had not yet accustomed himself.) It was not as cold in the room as it had been during the last few days, even as it had been the previous evening. (That, as it later turned out, was the explanation: it had started to thaw.) Anton L. slept in his clothes. Since that day in June he had had no more cleansing phases or swellings of the solar plexus. Anton L.'s underwear had achieved a colour and a (for Anton L.) comfortable smell such as consideration for those around him had made impossible in his previous existence. But at the end of September he had to part with the underwear he had grown so attached to; or, rather, it was the underwear that parted with him. One morning he felt some strange padding round his hips. The remains of his underpants had slipped down inside his trousers. He went to Sperber's, the superior gentleman's outfitter's on the corner of Anakreon Strasse, and got himself a new and, given that winter was approaching, warmer set of underwear. The familiar smell soon returned.

Anton L., then, was fully dressed, apart from his boots and his deerstalker. When he leapt out of bed after the bang it was still night, completely dark. He lit the lantern he always kept by his bedside and looked round the room. There was nothing to be seen. He went out into the corridor. He could see nothing there either. The trickling had stopped. He went back into the room, put on his boots and deerstalker and picked up his rifle. Then he went back out into the corridor.

At Suite 20 (his was Suite 21) he noticed that the double doors were askew. He pushed them apart and cautiously entered the room. He was almost in the open air. There was a gaping vertical crack two foot wide in the outer wall. The floor had split from the door to the window and there were fragments of tiles scattered all over it. Anton L. shone his lantern on the ceiling. That had been torn apart too.

Quickly he ran down and out into the street to look at the building, but it was too dark to see anything. The somewhat warmer air had brought clouds and rain, compared to the clear skies of the preceding cold days. All he could see was that there were fragments of tiles and masonry on the ground outside the hotel. The next morning, when Anton L. went back to the hotel to collect various things, he saw that the building was split from the roof down to the first floor. At the bottom the crack was two feet wide, considerably more at the top, below the roof. Over the crack the roof had caved in completely. On the second, third and fourth floors the façade was already bulging out slightly.

The idea of moving had already occurred to him the previous day, when he looked into the possibility of doing some repair work (nailing up broken windows, for example) to protect the building and eventually concluded there was no point. In the weeks since September he had spent many days in the Royal Palace, which, clearly a solider building than the Three Kings Hotel, had not yet suffered damage. He had considered moving into the State Rooms, not only for that reason, but also as a sign of his claim to absolute possession of the city (of the whole world?). After the Canaletto, his eye had been caught first by a lovely little genre scene by Frans Hals and then by a mythological painting of a naked woman with a panther by Guido Reni. As he was carrying the second picture, which was appreciably larger than either the Canaletto or the Frans Hals, back to the hotel, the bronze Elector said, "Why don't you just move into my palace? You wouldn't have to spend your time lugging all these pictures round then."

"I haven't got anything else to do, Your Royal Highness."

"It was just an idea. All that heavy work."

"And anyway, the hotel has a kitchen. And stores of food. And Sonja has a room –"

"It was just a suggestion."

"And then I've got used to the hotel."

"Well if it were me, *I'd* move into the palace."

"I'll think about it, Your Royal Highness."

And Anton L. did keep thinking about it, especially after conditions in the hotel started to get so unpleasant. He also wondered whether it made sense to move from one large building to another, even larger building, at least for the winter. He put off making a decision until it was made for him by the crack that appeared during the night of 18 November.

He hurried back into the hotel, listening carefully for the trickle or rumble of things falling down. All was quiet. He fetched his ammunition from the sitting room and went to get Sonja. But Sonja had gone into hiding, he couldn't find her in the large kitchen with all its nooks and crannies.

Anton L. slept through the rest of the night. He spent it in the Elector's huge state bed, but the next day he started to arrange more suitable accommodation for himself. In the Palace garden was a small lake, already becoming choked with reeds, with a miniature palace, really little more than a pavilion, beside it in the shadow of the great Royal Palace. It was older than the main part of the Palace, which was in the style of early nineteenth-century neoclassicism. The pavilion was the architectural expression of an eighteenth-century princess's taste for chinoiserie. Everything seemed small, doll-like, although it was not really small, in fact it was larger than a detached house in the outer suburbs: a small drawing room with Chinese vases, a small cabinet of mirrors, a small spiral staircase to the first floor, where there was a small, panelled boudoir with a small balcony looking out over the lake. The walls round the four-poster bed were covered in carved and gilded chinoiserie. The boudoir was hexagonal because the pavilion itself was hexagonal and the upper floor consisted of just the one room. The carved panelling concealed cupboards, one in each of four of the walls; the fifth wall was where the spiral staircase from below ended, and a small door behind the

bed in the sixth wall led up onto the flat roof, a small, hex-agonal platform with a wrought-iron balustrade and views over the lake and the park. The ornamentation on the wrought-iron balustrade already had Anton L.'s initials in it, elaborately intertwined. The princess with the taste for chinoiserie had been called Antonia Ludovica.

Most important of all, however, was the fact that the whole of the pavilion could be heated from a fireplace in the ground-floor vestibule.

Princess A. L.'s pavilion was a compact residence which could be heated and the maintenance of which would prob-ably not be beyond the powers of one man, despite his general lack of skill in practical matters. It had one disadvantage: there was no kitchen. But the Palace had an old, historic kitchen which used to feature on guided tours because of its valuable Delft tiles.

The bronze Elector was also in favour of a move to the Chinese pavilion.

Anton L. went about it systematically. The pavilion had just one door, an old, carved, oak door which had, however, a modern Yale lock. Of course he could have used his by now traditional method and broken it open with a crowbar, but he did not want to do that. He wanted to be able to lock the door. Where there was a lock, there must be a key. The Palace had been, among other things, a museum. In the New Palace there was a porter's lodge and a large room where tickets, guidebooks and postcards were sold. There Anton L. found several bunches of keys. He removed those which obviously would not fit, leaving him with about forty Yale-type keys, which he tried one after the other. The eleventh fitted.

As Anton L. had assumed, the inside of the pavilion was covered in dust and spider's webs, which was why he had brought a broom, a bucket and a cloth with him from the cubby-hole in the porter's lodge. By midday he had got the rooms reasonably clean. He went back to the hotel and brought 'his' two cars, driving them right up to the entrance to the pavilion, which had in the past been forbidden, of course. On each trip he transported part of his possessions. It

was the most substantial removal he had ever undertaken; he felt like his former boss, Herr Kühlmann, the old tightwad. He took with him: as much of the hotel furniture, chopped up, as possible; his armoury of guns and ammunition; the Canaletto, the Frans Hals and the Guido Reni; his stock of candles; his stock of matches; a pile of newspapers; a carload of tinned food, which he did not store in the pavilion, but in the Palace kitchen. That very evening he cooked with the royal copper pans: Bassermann's lentils with smoked bacon, preceded by a tin of Campbell's turtle soup – the Three Kings had only the best. And of course he took Sonja too. Since the hotel kitchen had cooled down, Sonja had gone stiff and was easy to catch, once Anton L. had found her in a china cupboard. Sonja was allocated the cabinet panelled with mirrors. Later on Anton L. put a box in the room for her, but the animal still managed to dirty the floor and, strangely enough, the mirrors up to a certain height. The room soon stank, but Anton L., thanks to his own distinctive smell, did not notice. By the evening he had completed the first stage of his move. During the following days, further transports proved necessary, or at least desirable, for example a load of chocolates from the third sweetshop through the contents of which Anton L. was just starting to eat his way. He kept the confectionery in three of the four wall-cupboards in the upper room (it was while he was doing that that he discovered the door onto the roof.) In the fourth cupboard he put Soliman Ludwig's letters and documents and everything else relating to The Book.

The fireplace worked perfectly. In no time at all the whole pavilion was warm, the only problem being that he needed a lot of wood. The load of chopped-up furniture he had brought only lasted three days. Naturally Anton L. did not use the pavilion furniture, he took what he needed from the large stores and office blocks on Luitpold Allee, chopping it up on the spot and transporting it to the Palace in a handcart in order to save petrol. He chopped up counters and shelves, tables, chairs, doors, wooden panelling, parquet floors, wooden stairs, in short, anything made of wood. One after another he plundered, all in numbers 1, 3, 5, 7 Luitpold Allee, which bordered

on the Palace Gardens: a bank; a very upmarket shop for ladies fashions (his attempt to burn the fashions themselves was not a success, they just smouldered); an antiques shop; another bank; a carpet dealer (not very productive, not many shelves and the carpets did not burn either); a furrier's; an extremely exclusive shop for camel-hair products; a ladies hairdresser's (not very productive, almost everything was plastic or glass); a cinema and a branch of a chain of fried-chicken restaurants. The cinema and the restaurant lasted longest because of all the wooden seats and because both floors of the restaurant were wood-panelled. On a whim, Anton L. left one seat in the middle of the cinema. Now and then he sat on it and looked at the screen. The huge, empty space echoed. When, after further flooding in the late spring of the following year, the cellars of 1–7 Luitpold Allee were, and stayed, under water, many rats appeared. They made an unpleasant noise when they scurried round Anton L.'s seat in the dark, so he chopped up that seat for firewood too.

Towards the end of the period when heating was needed, his forays for wood took him to a gallery for modern art which had its premises on the second floor of number 7. At the time of the catastrophe it had been showing an exhibition of works by a sculptor called Gustav Hübbe. The name was still decipherable from a fading poster on the door. Gustav Hübbe had worked in wood, mainly on a small scale; Anton L. hardly needed to chop the sculptures up at all. At one point he noticed a pile of leaflets with one of the sculptures (already burnt) on the cover, together with a picture of the artist: a young, pleasant-looking man with a button nose and very large ears. The rest was obscured by a rampant beard. Anton L. took the pile of leaflets and burnt them, apart from one, which he pinned to the bedroom wall. The sculptures were made from tree roots. They all had a reddish tinge and were, in some way Anton L. couldn't quite put his finger on, obscene. Once he had an obscene dream (such dreams were becoming noticeably rarer) connected with one of the sculptures. The dream was more frightening than satisfying.

As a precaution in case of illness or some other emergency

he always collected more wood than he needed for that day, stacking the surplus round the outside walls of the pavilion. Some he stored in the Palace kitchen.

Back in September he had temporarily suspended his explorations of concentric circles. A radial excursion – actually two excursions along the same radius – was of significance. They took place, by car, in late September, when he was still living in the hotel. The reason was to visit the site of the explosion and fire on the edge of the city beyond the river. He only ventured out there after some rain had fallen and there were no more signs of fire. He set off early in the morning, across the bridge and up the steep slope on the other bank. He reached the area of devastation much sooner than he expected, after he had been driving for less than ten minutes. There was a smell of damp ash. The streets were lined with the façades of burnt-out buildings; here and there one had collapsed. Blocks of fallen masonry and charred beams made progress difficult, eventually blocking the road. Anton L. had to turn back. He tried to continue towards what he assumed was the area where the fire had started, taking other roads, but it was always the same. During the course of these attempts he drifted southwards and came to a wide road leading out of the city to the motorway. The fire had clearly not managed to cross this road before it was extinguished by the rain. The buildings on the left were burnt out, some of them had collapsed, while those on the right were undamaged. Anton L. followed this road almost to the city boundary. Ignoring the motorway slip road, he drove back along the minor roads of a residential suburb. In the gardens of the detached houses the weeds stood higher than a man. The fences were covered with a tangle of thorny scrub. At one place in a narrow street with gardens on both sides creepers like something out of the jungle, glowing red in their autumn colours, stretched right across. Anton L. tried to accelerate and break through, but the car got stuck. There, too he had to turn round, that is to back out of the street and take the next one, that wasn't blocked by creepers.

Around midday he stopped for a rest. He had taken the precaution of bringing some food: one packet of crackers, two bars of chocolate and a bottle of champagne. He got out of the car, but as it was raining he went into a tram shelter that was half open. At the back of the shelter was a long red wall. Anton L. ate the crackers, popped the champagne cork and drank the champagne out of the bottle, all the while staring at the long red wall. Behind it was a cemetery. It was the cemetery in which Frau Rosa L. was buried. Frau Rosa L. had been Anton L.'s mother.

Anton L. was his parents' only child, was their only *possible* child, if what his mother had told him was true. Albert L., Anton L.'s father, she said, had eventually forced her to marry him through constant tears, threats of suicide and so on. After years of being wooed in this manner, and after Albert L. had managed to frighten off all other suitors by intrigues, cunning ploys and even violence, she had agreed to marry him, though under one condition: she wanted to remain a virgin. Albert L. had promised, she went on, but on their wedding night he had gone berserk (Rosa L. told her son this when he was about twelve or thirteen). Naked and exposing his enormous male member, he had thrown a fit in the bedroom, shouting, then begging and crying; reminding him of his vow to allow her to remain a virgin had had no effect whatsoever. He tore off her wedding nightdress, but she had taken the precaution of wearing her woollen knickers and vest underneath, so that she managed to keep her virtue intact, not only on her wedding night, but for four whole years. She had, however, had to watch her husband like a hawk, and even a hawk will sleep once in four years. That had been in 1931. She had, she told her son, forgotten to lock the bathroom door. Albert L. wanted to get something out of the bathroom and had burst in. She screamed, she had nothing to cover herself with, the towel was hanging behind the door. Immediately a funny look came over him. Quick as lightning he undid his flies and his enormous male member came popping out. Then, not bothering to take his clothes off, he threw himself on her. Seconds later her virginity was gone.

146

Never in her life, his mother had said, had she felt so depressed as that day in the bathtub. She felt nothing but disgust at the sight of Albert L. stowing his male member, no longer that enormous, back in his wet trousers. Albert L's clothes had soaked up so much water that there was almost none left in the bathtub and Rosa L. had started to feel cold. From then on all she had felt for Albert L. was contempt, she said. Her only comfort had been when shortly afterwards a friend explained to her, from a book for housewives called *Be Your Own Family Doctor*, that she was with child. Nine months later she had given birth to him, Anton L. To spoil her husband's pleasure in his newborn son, she had had him christened Anton. His father had insisted he should be called Albert, as he was. She had agreed, but only as a pretence.

The christening took place after his mother had recovered from the birth. His godmother, the friend who had *Be Your Own Family Doctor*, had been in on the plan, she explained. They had gone to the church, and when the priest had asked what name, his godmother had said, "Anton." At that his father had said, rather loudly given that they were in church, "Albert! Albert!" But his mother had had the presence of mind, she claimed, to say, "Yes, Albert's what the father's called." The priest had called for quiet and had christened him Anton. So that was that. Anton, his mother had added, had been the name of the last of her other suitors before she got married. Albert L. had got rid of him with a particularly mean trick.

Back home the old man had thrown another fit, she said, but the baby was called Anton and nothing he could do would change that. He had ranted and raved, almost as much as on their wedding night, only this time without the enormous male member; instead he had gone red in the face, as if he was about to have a stroke. He had even gone so far as to lay hands on her. He had grabbed her rather firmly by the ear, but she screamed so loud the neighbours came dashing out, on the stairs and even in the courtyard. She screamed loud and long, even after her husband had let go. Only when he had

finally gone down on his knees and had asked, had begged her forgiveness, had she stopped.

Of course, seeing the man on his knees, begging her forgiveness, had only made her contempt for him even greater. Her friend, Anton's godmother, had agreed. In that situation, she had said, all she would have felt would be contempt.

Despite that, in the years that followed Albert L. still insisted on making occasional attempts to have his way with her, but she just started to scream and that put a stop to it. Her virtue had remained free of further abuse.

The depths to which Anton's father had been prepared to stoop only became fully apparent with the outbreak of the Spanish Civil War. Although until then he had done nothing but moan about Hitler, he immediately volunteered for the Condor Legion, probably because of the smart uniform and the opportunity to satisfy his lust for excitement and pursue his pleasures uncontrolled. Her only response to such a time-serving weathercock was even deeper contempt; Anton's godmother had felt the same. Her friend had concocted a brief note to the Gestapo which she, his mother, had sent off in order to put a spoke in the old fool's wheel (he was already over fifty). Presumably the letter never reached the right place; two inexperienced women such as his mother and his godmother naturally hadn't known the exact address and she could hardly have asked Albert L. So the old man actually went to Spain; he even came back with a medal.

By that time her letter had, by some circuitous route, obviously reached the appropriate authority, for one day Albert L. was summoned to the Gestapo. When he got back he said that if he found out who had denounced him, he'd wring their neck. He probably even had the gall, Rosa L. had said, to show off his medal to the Gestapo, even though he still made disparaging remarks about the Führer. In that case the Gestapo officer, who probably didn't have a medal, wouldn't have been able to touch him. Of course all that about wringing the writer's neck had just been an empty threat. She, Rosa L., had had the sense to send the letter anonymously.

In 1939, when the real war came, the old man had once

more dropped everything and volunteered on the very first day. During the whole of the war he didn't feel the need to write home even once. He didn't come home on leave either; that is, he did come once, but that was at a time when she had gone with the child and her friend to stay with her friend's mother. Her friend's mother lived in St Meeri, a tiny village in the mountains. For years she had been going to stay with her friend's mother in St Meeri at the same time in the summer, the old man must have known that, she said. He probably arranged it deliberately so that he came home on leave at that precise time. And, his mother had added, she would rather not know what he had got up to in the empty flat in the town while he was there on leave.

When the air-raids got worse, Rosa L. moved to St Meeri, where her friend let her have two rooms in her mother's house. Anton L. was eleven. Shortly after they heard that his father was a prisoner of war. Things got worse and worse, but during those uncertain years, when no one knew what was going to happen and lots of people clung to things they later preferred to forget, business boomed for Frau Rosa L. She went to people's homes telling fortunes from the cards. She only went to regular customers; it was better the police did not know about her activities.

Frau Rosa L., her friend and her friend's mother also organised séances, which were regularly attended by Father Smeckal, Anton L.'s scripture teacher. That was after the war. These séances were also held in secret. At the time many important people were staying in St Meeri, for a variety of reasons, and some were not as broke as they would have people believe. Now and then after a séance a gold coin was left on the special table that was held together with wooden pegs only. Father Smeckal did not need to pay; on the contrary, Frau Rosa L. and her friend vied with each other in pampering the reverend gentleman with jam pancakes, his favourite food and very difficult to find in those days. Rosa L. obtained the eggs from the local farmers, in exchange for her gold coins. Later on the officers of the occupying army came as well – her friend had been to the grammar school and

spoke English. They paid with cigarettes, which were almost as valuable as the gold coins.

When Anton L.'s father arrived back from the prisoner-of-war camp – that was in the summer of 1947 – Anton L. happened to be away at the Boy Scouts' summer camp. He did not see his father at all, since by the time he got back from his holiday his father had already left. Her husband, his mother told Anton L., had immediately shown himself at his worst. Hardly had he come in than he set about stuffing himself with a cream cake. His father had devoured a large piece before she and Aunt Hilda (her friend) had managed to get it away from him. They had baked it for Father Smeckal, who was expected that evening.

"And then?" Anton L. had asked.

"Oh, we cut up the undamaged part, it was more than three quarters, thank God, into portions, like you get from the baker's. Father Smeckal didn't notice."

"I mean father."

He'd left, his mother said.

Later Anton L. learnt that his father had waited outside the school for a while. The janitor told him about it when school started again in the autumn. The janitor had gone out and asked him what he was waiting for. For Anton L., the man had said. But it was the holidays, he, the janitor had said, he'd been surprised his father didn't know. Then his father had asked whether Anton L. was doing well at school, to which the janitor had said he didn't know, he was only the janitor.

About one year later his mother disappeared. This event was preceded by noticeable tension and then open, if carefully muted hostility between Frau Rosa L. and Aunt Hilda. When his mother was alone with Anton L. she would complain about "ingratitude" and having "nurtured a viper in her bosom". The police appeared to have received a tip-off about Frau Rosa L.'s illegal fortune-telling as well, though they seemed in no hurry to start their investigations. When they arrived Frau Rosa L. had already disappeared. Father Smeckal disappeared at the same time.

A few days after that his father came to take Anton L. back

to live with him in the city. Later on Anton L. asked his father how he knew his mother had disappeared.

"Aunt Hilda sent me a telegram," said Albert L.

"Did Aunt Hilda have your address?"

"My address was on the letters I sent."

"You wrote letters to Mother?"

"No," said Anton L., "not to her, to you."

"Oh," said Anton L.

At that time Anton L. was sixteen. Several times during the following years, while he was living with his father in his old flat in the city, he was on the point of asking how much of what his mother had told him was true. But at that age one is too embarrassed to speak openly of such things.

His father died when Anton L. was in his first year studying economics. His father had taken out an insurance policy that would have financed his studies until he had completed his degree, but a lack of enthusiasm for economics and for university studies in general intervened, not to mention his first alcoholic phase.

Almost ten years later, when he was working for the Santihanser Travel Agency, he received a demand from the regional lunatic asylum for the burial costs of the late Frau Rosa L., who had died in the asylum. Anton L. bought a wreath and went to the funeral. There were no other mourners apart from him, only a disgruntled young priest and four gravediggers. In view of the minimal attendance, the priest did not bother with an address but merely read out the prayers and blessings demanded by the service, muttered something about "Condolences" to Anton L. and left. Anton L. tipped each of the gravediggers two marks, at which they too assured him of their condolences.

He had never been back to the grave.

The rain started to come down more heavily. Anton L. had finished his lunch. He left the champagne bottle and the remains in the shelter. (Later, in a discussion with Jacob the hare, he said, "The environment can take the pollution I cause. Look at the river. It's crystal clear. Do you seriously believe it

does any harm if I throw my plates out of the window?") He left the shelter, turned up the collar of his coat, the ugly half-length coat in a blue-and-green check with the warm lining he had taken from the hunting equipment shop where he got his ammunition, and went along the cemetery wall until he came to the gate. The gate, a large, wrought-iron affair with bars, was locked. ("Opening hours: May–October: 8 am–5 pm, November–April: 9 am–4 pm.") As far Anton L. could see through the gate, the cemetery was very densely over-grown. Hardly any of the gravestones could be seen. It wasn't worth the trouble of climbing over the gate or forcing it open, it would be almost impossible to get anywhere in that wilder-ness. Added to which, he couldn't remember the position of the grave. Do the dead make particularly rich manure? Or was it because the cemetery was already closely planted with all kinds of bushes and shrubs? A huge flock of crows rose from the thicket, rearranged itself in the air and came back down. The rain became heavier. A pale yellow bank of cloud appeared in the west. Anton L. returned to his car and drove slowly along the road that led back to the river.

He was quite close to Faniska Strasse. From the high embankment he could see the spire of the chapel of St Clarissa's Hospital, which was opposite the Tax Office, his Tax Office. It hadn't been Anton L.'s intention, but since he was there, he turned into the narrow street leading to the door used unofficially by the staff at the rear of the building which had been locked on 26 June.

He stopped directly outside it. What if it were open now? He shuddered at the very thought. He switched off the engine, but stayed in the car. A heavy shower drummed on the roof and the windows. If the door was open, that would mean there was someone else there, apart from him. Like Friday's footprint. Anton L. was not sure how he felt about the idea.

In the first place, it would depend if it was a man or a woman. If it was a woman that would make it clear why he, Anton L., had been spared from the catastrophe, always assum-ing it was a young woman, still capable of bearing children. Then he and the woman would be the new beginning.

Though if further procreation were required, the children, at least in the first generation, would have to resort to incest. It was a problem the Bible skipped over in embarrassed silence, though on the other hand Catholic theologians in particular clung to the theory of descent from *one* couple because of the doctrine of original sin, which was the presupposition for the divine redemption through Jesus Christ. When Anton L. had asked him about this, Father Smeckal had had no answer, he had simply lost his temper. As a punishment Anton L. had had to learn three hymns to the Virgin off by heart, one of which had no fewer than fourteen verses. This incident made a not insignificant contribution to Anton L.'s disaffection with the Catholic Church, which eventually became a complete break, as far as belief was concerned, when he went through a Buddhist phase after his first alcoholic period. The Buddhist phase passed with no after-effects and was not repeated. The break with Catholicism, however, was irreversible, although outwardly, as far as his liability for church tax was concerned, Anton L. had remained a member of the One True Holy Catholic and Apostolic Church. Why? Perhaps he ought to discuss it with the Elector? After all, his uncle had been an archbishop.

If, on the other hand, the person who might have opened the little door were another man, then they would have to share the world between them. That could prove difficult. It was almost inevitable that one would be subordinate to the other. Or vice versa. Basically there are only three numbers: one – two – many (certain southern hemisphere negroes are said to count in this way). One = alone; two = not alone; three = four, five, six, infinity. The leap from nought to one is what one might call the creation; the leap from one to two bridges the gap between being and possibility; the leap from two to three is the move from quality to quantity. After three the floodgates are open, three is as good as many. In order to avoid a struggle, that could well be hopeless anyway, Anton L. decided to subordinate himself straight away.

But the small side door was locked. Anton L. broke it open with his crowbar. He went along familiar but stuffy,

putrid-smelling corridors. The water from the flood had probably filled the cellars to the ceiling. The files in the Tax Office archives were probably rotting away down there. All the windows in the building were still sound. The whole district was in the lee of the slope Anton L. had just driven down and had not been damaged by the shock wave from the explosion. Anton L. went up to the second floor. As he opened the door from the corridor to the stairs a matted curtain of spider's webs ripped apart. He still had the key to his office on his key-ring. He opened the door. Both desks were covered in a thick layer of dust. In the tray marked *OUT*, under an equally thick layer of dust, were the files Anton L. had dealt with on 25 June. The office messenger would have collected them on the 26th. The messenger had a high trolley with a lot of pigeonholes which he trundled from door to door. He took the new files out of his trolley, brought them into the office, put them in the tray marked *IN* and took away those in the tray marked *OUT*. "You see," the senior executive officer, who had conducted the training sessions for new staff, had said, "the files have to get from the *in-tray* to the *out-tray*. That is administration." A sense of achievement for the diligent civil servant comes when the stack of *outgoing* files the messenger takes away is bigger than that of the *incoming* files he brings. If the stack of files heaped in his *in-tray* happens to be bigger, that is still no cause for concern to a civil servant. If the stack of files in his *in-tray* is always bigger than that in his *out-tray*, a civil servant is said to be *overburdened*.

The fact that Anton L.'s in-tray was empty did not mean he had dealt with all his files. There was also a filing cabinet in which he kept the difficult cases he was putting off. "Do not," the senior executive officer had said during the training session, "have an 'out-of-sight-out-of-mind' folder. Files are like the female of the species, the older they get, the more unpleasant they are." However Anton L., like everyone else apart from a few keen types, did have an out-of-sight-out-of-mind folder. He opened the filing cabinet. There was not so much dust inside it. Right at the back was the file labelled: Smetana Ltd. In December Anton L. had made a serious error in

dealing with that file. There was a complaint and the file landed on the boss's desk. It was such a complicated matter that the boss did not immediately see who had made the mistake, but it was a close thing. In January, when they got back to work again, the file came back to him with a note from the boss: "My office immediately."

Anton L. took the file up to his boss immediately, but, as luck would have it, his boss was not there. So Anton L. took the file down with him and put it at the back of the filing cabinet. He could have told his boss, "I came up to your office immediately," with a clear conscience, but for the time being his boss forgot the matter. If at that point Anton L. had drafted a decision – a tricky task in itself – everything would have been sorted out, at least as far as the client, Smetana Ltd, was concerned. Anton L. kept on putting it off.

By March the file was like a millstone round his neck. In April came an official request from the boss for the file plus a written report. Fortunately, however, the boss managed to get the file reference number wrong. So Anton passed the other file, the one with the wrong reference, up the line, together with a report. That made for more confusion and the possibility that the matter was now in the boss's own 'out-of-sight-out-of-mind' folder. That did nothing to alter the fact that the problem would inevitably crop up again in July, at the latest in August, when the new tax returns were due. The least Anton L. could expect was a yellow card. Several times he seriously considered quietly taking the file home and destroying it. But he wasn't sure whether the colleague who shared his office didn't know the file was at the back of the filing cabinet. His colleague had his own millstones in there, though none as heavy as that one. Once, in a stupidly trusting mood, he had even said to his colleague, "If only the Smetana file would somehow disappear."

'If only the Smetana file would somehow disappear.' Anton L. had the file in his hand, a large, fat file, held together by a strip of official horsehair tape with a buckle. Was such a trivial reason, a completely trivial reason, sufficient to explain the catastrophe of 26 June?

'Scarcely,' thought Anton L.

He opened the window, undid the file and scattered the documents to the four winds. The rain had stopped. The documents fluttered to the ground, some landing on the bushes growing rampant on the narrow strip outside the building; most fell on the wet road.

As Anton drove away, round the corner and along the front of the Tax Office, he took great satisfaction in driving over some of the documents, sending the fragments swirling up behind the car.

There was a rent in the bank of cloud to the west. The trees in the grass along the river were ablaze with autumnal colour. One tall tree next to the bridge was blood red. As if taking their cue from this majestic tree, the clouds to the west of the city turned to gold, then orange, then blood red too. A sunburst of rich gold pierced the gap in the cloud, striking the towers of the city and setting the roofs on fire, in a distant reflection of the world of Canaletto.

16

An Elector wrapped up in corrugated iron

In the second half of August Anton L. had been back to Soliman Ludwig's apartment. He didn't spend long there. He was looking for something specific and he believed – correctly as it turned out – he knew exactly where to find it.

"Dear Ludwig," it had said in the letter Candtler had written and Eschenlohe had delivered, "This time I am not mistaken. What we are looking for does exist. Perhaps tomorrow will be the day. Let me have the . . . back." Anton L. had initially read the word as "coirol", now he knew it was "card". Candtler had separated the downstrokes of the "a" and the "d" from the circles. "Let me have the card back quickly, no later than 9.30. Best wishes, C."

From Ludwig's correspondence Anton L. knew that Herr Candtler was looking through a library whose librarian, Dr. Gebesser, was a friend of Candtler's. A few weeks before the catastrophe, Candtler had come across clues to a work by a medieval doctor called Ah-Mery. The book had a title into which one could read everything or nothing: *De Mundo*. Ah-Mery had been a Scottish crusader who had fallen prisoner to Sultan Saladin in the battle at the Horns of Hattin which brought the first kingdom of Jerusalem to such a gruesome end. After his release he had stayed on in Egypt and studied with the famous doctor and philosopher al-Ismin. Later he returned to Europe and lived in Venice. The original of his book had been lost, but there was a commentary on it by Giovanni Battista Nani. Nani, who died in 1678, was the author of a semi-official history of Venice and thus had access to all documents, even ones that were usually inaccessible. That included Ah-Mery's manuscript which, presumably

because it was the work of a heretic, was kept in the secret archives of the Palace of the Doges where, along with all the other books, for example the *Golden Book* of Venetian aristocracy, it was burnt after the conquest of the city by Napoleon. (For that alone the Corsican dwarf deserves to be consigned to a circle of hell beyond even what Dante devised.) Ah-Mery's manuscript was no use as a source for Nani's history of the city, but it seems to have impressed him so much that he wrote the above-mentioned commentary. It was published anonymously in Amsterdam in 1704.

In the library of which Dr Gebesser was in charge, Candtler had found a book by an obscure Belgian historian called Claudius Lactans Count of Hompesch. Published in 1895, it was completely lacking in interest, except that one chapter quoted passages from Nani's commentary on Ah-Mery's manuscript. Hompesch's book was called *The True Bible*. Superficial and slipshod as it was, it still excited Soliman Ludwig and his friends because it openly expressed their theory about a book which explained the mystery of the world. There were two annoying things about Hompesch's book (in one letter Simon List called it "a shoddy piece of work"): in the first place the quotations from Nani's commentary were so imprecise it was impossible to distinguish between Ah-Mery's original and Nani's commentary; in the second, there was no indication of where and how Hompesch had found Nani's book, the anonymous publication of 1704.

Thanks to Dr Gebesser, however, it was very quickly established that there were three copies of the 1704 edition extant: one in the Saltykov-Shchedrin Library in Leningrad, one in the Jagiellonian Library in Cracow and one in the British Museum. The British Museum was prepared to photocopy the book for Dr Gebesser.

Anton L. could only guess at what had happened next. Presumably Candtler had learnt on the 26th that the photocopy – it would be a substantial parcel – had arrived. In order to collect it he would need his library card, which, for some reason, Soliman Ludwig had. (Would Candtler need the card even though the director was a friend? Was he perhaps away

on holiday at the time?) Anton L. needed the card in order to find out which library it was.

'Candtler must have assumed that Ludwig would have the library card on him, otherwise it would have been pointless to slip the message under the door of the shop after it had closed,' Anton L. reasoned. 'When he wrote "no later than 9.30" he was obviously counting on Ludwig not having to go back home to collect the card. That would presumably not have been possible while the shop was open, either. So all I need to do is look in Soliman Ludwig's wallet.'

And that was where he found the library card, made out in the name of Horst Candtler and valid for the Rare Books Department of the State Library. It was signed by Dr Gebesser.

Anton L. put the card back in the late Soliman Ludwig's wallet. The State Library was halfway between Ludwig's apartment and the hotel, not far from the place where, not that long ago, Anton L. had been frightened by the cows. He had not been in the State Library for a long time, but he had a general idea of the layout since he had had occasional business there when he worked for the publishers.

He broke into the large, neoclassical building in his by now traditional manner, with his crowbar. A sign beside the entrance indicated that the Rare Books Department was on the second floor. When he got there Anton L. had to search for a while and was beginning to think the parcel must be somewhere else, perhaps in Issues or Inter-Library Loan. But then he found the parcel, a cardboard box, on Dr Gebesser's desk. On the box was a note: "For Herr Candtler. To be collected. 22. 6." With it was an invoice. Candtler would have had to pay 120 marks.

Anton L. sat down in the Librarian's chair and opened the box. In it was a pile of photocopies. The top sheet was a magnificent engraved title page. The author's name had been added by hand: G. B. Nani, Venice, together with a library classification followed by a long number and the stamp of the British Museum. Then came the shock, though Anton L. could have anticipated it: the book was written in Latin.

Anton L. had taken Latin at school. He had not been

particularly good at school, but in Latin he had been particularly bad. And since then he had not used his Latin, such as it was, at all. He put the photocopies back in the box and left. But the next day he came back and set to work. He remembered that there were dictionaries in the reading room on the first floor. He fetched the seven volumes – he had to make two journeys – of the *Thesaurus Linguae Latinae*. When he realised it was far too detailed for his purposes and, anyway, only went as far as M, he fetched the *Langenscheidt Shorter Latin-German Dictionary*. You had to find the verb, Anton L. remembered. He also found a Latin grammar useful, especially the appendix with all the common irregular verbs.

It was like deciphering a code. The difficulties receded perceptibly as the work progressed. Every day Anton L. spent one or two hours in Dr Gebesser's comfortable chair working on it. To start with he did a written translation, that is, he he typed out his translation on Dr Gebesser's typewriter, which was on a small table beside the large desk. After about thirty pages he saved himself the bother and only wrote the translation down, between the lines of the original, for the occasional more difficult sentence which was awkward to work out. He found he was making quicker and quicker progress. By the end of August he could, with a clear conscience, already call his work on Giovanni Battista Nani's book *reading*. It has to be said, however, that it made rather boring reading. Messer Nani indulged in lengthy philosophical and theological speculations, interrupted by moral sermons in which the author was obviously determined to leave no doubt whatsoever as to the soundness of his Roman-Catholic faith. The rest of the book, on the other hand, was somewhat less clear on that point; Nani had probably been a secret Jansenist, that is assuming he had not been tempted by ideas beyond the pale of Christian belief.

What was said about Ah-Mery (Nani called him Almerius) was rather hazy. In part two, where the book became more interesting, Nani recounted Ah-Mery's story, but in such a way that it was once more evident that Nani was concerned to clear Ah-Mery of the suspicion of apostasy and heresy.

Nani maintained that Ah-Mery had died as abbot of some monastery. That was clearly pure fiction; on the one hand Nani did not say which monastery it was, on the other he claimed to have seen documents from "that monastery".

It was the last four pages that contained the decisive find.

'If I'd known that,' Anton L. said to himself, 'I wouldn't have read the preceding two hundred and thirty-six.'

The last four pages were written in old German, printed in a different type and had obviously only been bound into Nani's book. Nani was certainly not the author of this appendix.

The four pages read as follows:

"During the *Carnival* season, anno Domini MDCC—, a young prince, Philipp Moritz, Duke of B★★★, came to Venice. This Duke Philipp was the second son of the Elector of ★★★ and destined for the priesthood. The bishoprics of Münster and Paderborn having recently become vacant, both sees were intended for Duke Philipp, who was also to become *Coadjutor* of his uncle, the Elector of K★★★. The young Prince had not yet been ordained, indeed, his taste seemed more inclined to a variety of worldly pursuits. At the time in question he was about twenty years old. He was accompanied by his tutor, a Count Jacobus von Zweiffel, who had served the Prince's father, both during his *Glorious Crusades* against the Turks and in his ill-fortune as an *Exile* banished from his homeland.

In Venice during the *Carnival* it is the custom for everyone, both high and low, to don a mask. Duke Philip's tutor had no objection to allowing him to do the same, considering it a harmless amusement such as young people are ever wont to indulge in. In order not to leave his charge to his own devices, however, Count von Zweiffel was compelled for good or ill to assume a mask himself. The young prince was inestimably fond of following the common people's custom of dancing in the squares to the splendid music that is played, more splendid than is often to be heard at princely gatherings, even though in those aforementioned squares it is only common *gondolieri, pifferari* or even beggars who play. Towards the end of the

Carnival his young charge became so besotted with the dancing that his poor tutor was out of breath almost before they had left their lodgings. Duke Philipp having pointed out that the *Carnival* would only last a few days more and that *Senators* and *Patricians* took their pleasure *incognito* among the common people, he was allowed to go out alone.

After things had proceeded in this manner for a few days the tutor could not fail to observe a change in his young charge. Although the tutor had had to take to his bed because of the gout brought on by the damp that prevailed in the city by reason of the many *Canals*, he called the young Prince to him and addressed him as follows: "I am old and know what manner of adventure can befall a young man, especially when dancing masked. You can tell me."

The young Prince flushed in embarrassment but at length, when his tutor insisted, he confessed that he had danced with a young woman who had seemed to him nothing less than an angel.

This news caused the tutor to groan more than his gout and he said, "I might have known!" and, "What will His Gracious Majesty, your father, say if you should become entangled in an unequal *Liaison*? Especially when you are intended for the priesthood."

"Devil take the priesthood," said the young Prince, "and the sees of Münster and Paderborn too, he's welcome to them. I'm going to find out what she's called at least."

If I forbid it, thought the tutor, that will only make him all the more determined. So, groaning, he got up from his sickbed and put on his mask, saying to the Prince, "The good Lord forgive you for forcing an old, gout-ridden man to put on a mask, like a young popinjay, and make a fool of himself." Thus they set off to seek out the woman whom the deluded Prince thought an angel. But she was nowhere to be found, which was not surprising since during the last days of the *Carnival* all the streets and squares of Venice are filled with a frenzied throng, everywhere there are clowns and buffoons up to their tricks and a hundred *Gondolas* sweep up and down the *Canals*. The Prince kept calling out, "There she is!" but it was not she.

On the first day of *Lent*, when all the pranks and masquer-
ades had vanished from the streets, the Prince said, "Now I
will never find her. I don't even know who she is." And he fell
into a decline. The tutor groaned from his gout, but soon the
Prince's groans were even worse, so that the tutor had to
forget his own groaning and wrote to His Majesty, the
Elector, to say that his son had fallen into a decline.

The Elector sent a bill of exchange drawn on a *Jew* in
Venice; he also sent a letter to the effect that the best phys-
icians and doctors, for which Venice was famed, should be
consulted and that he hoped it was not a certain disease that
often befell young *Gallants*.

As he had been commanded, the tutor brought all the doc-
tors to the Prince's sickbed, but he just turned his face to the
wall and groaned and grew very weak. The doctors bled him,
injected a *Clyster* and applied salves and various *Arcana*, but all
to no avail.

Finally, on the twelfth day of March, another physician
came who had heard of the Prince's illness. He was an
Armenian and went by the name of *Hormisdas*. He carried a
leather pouch with him and said, "I have heard of the Prince's
unknown disease, but it is not an unknown disease at all. Here
in my leather pouch I have both the disease and the remedy, if
you, sir, are willing to pay one hundred and twenty *Zecchini*."
The tutor tore his hair and said, "These *Arcana*, whether in
leather pouches or no, are gobbling up the Elector's bill of
exchange. First of all I want to see what's in the pouch." But
the *Armenian* physician said, "The money must be paid first,
only then will I show what's in the pouch."

The door happened to be open and the sickly Prince
straightway called out, "Give him his *Zecchini*." Since this was
the first time for days that the Prince had made any sound
apart from moaning and groaning, the tutor was immediately
convinced of the magic power of the *Arcana Hormisdas* had in
his pouch and paid out the hundred and twenty *Zecchini*.
Then the *Armenian* physician went to the Prince and took a
small portrait out of his pouch, which he showed to the
Prince, who straightway leapt up, crying, "This is she!" He

pressed the picture to his heart and kissed it with his lips, leaping up and down until he was quite exhausted because he had not eaten anything for several days. When he was back in his bed he said, "Take me to her, if you do not want me to perish." However, he was too weak and the *Armenian* promised to return the next day; in the meantime the Prince was to take some leek soup to build up his strength.

But the Prince died on that same day. At once the tutor arranged the funeral and communicated the sad news to the Elector. Then he prepared to journey back to M★★★ without the Prince. Just as he was about to depart, the *Armenian* reappeared. "Your *Arcanum* was of no avail, doctor," the tutor said, "nor the leek soup."

"I know," the *Armenian* said, "the Prince is dead. But the lady, whose name I may not speak, has sent this." He gave the tutor a casket the size of a brick, sewn up in a linen cloth and fastened with a seal. "The lady," he went on, "is the last of her line − do not ask! − and is in a convent, where she intends to remain."

It can't be a fraud if he's not asking for any money, the tutor said to himself, and accepted the casket. On the way back to M★★★ he broke the seal, undid the linen and found in the casket a strange book with empty pages. Since, however, the binding was unusually beautiful he gave it, along with all the Prince's other belongings, to the Elector, who, together with his wife, was in deep mourning. The book was bound in fine blue leather with red and gold stars, and on the spine a golden snake, which had split and formed a figure of eight.

Anton L. could find no reference to a prince with the name of Philipp Moritz in any of the encyclopaedias on the open shelves in the State Library. Using the *Almanach de Gotha* is a science all of its own and beyond Anton L. But in volume 1 of Ysenburg-Loringhoven's *Genealogical Tables Relating to the History of the European States* he found the Prince.

The date of his death, 12 March 1719, was correct as was the fact that the Prince was the second son of the Elector.

And then Anton L. saw that the Prince was the great uncle of the bronze Elector standing outside the Palace with his back to the premises of the candlemaker's to the court, where Soliman Ludwig had worked.

But what had happened to the book? Presumably the old Elector, mourning his son, would not have thrown it away. Surely he would have put it in his library, or in his collection of curios, which meant it would have stayed in the royal family down to the time when the monarchy was abolished. And then? The works of art had remained in the Palace, likewise the jewels. By that time no one would have known the history of the book any more.

Thus it was that at the beginning of September Anton L. decided to search the Palace. He found the library, but not the book.

When, a few days after the explosion, Anton L. headed back to the Palace once again, he found the bronze Elector all wrapped up in the roof that had been blown along Anakreon Strasse like a corrugated-iron sail. It had come up against the statue, got stuck and been bent round it.

"Got our winter clothes on already, have we Your Majesty?" said Anton L.

"Stop talking nonsense and unwrap me," said the Elector.

"That's easier said than done," said Anton L. "It's a complete roof."

"You can't leave an elector all wrapped up in corrugated iron, even if you do steal his pictures."

"You can't really call that stealing –"

"What else can you call it, Herr L. Even if you are the only person left in the world, that doesn't necessarily mean everything belongs to you."

"That's a rather tricky legal question. Anyway, how do you know my name is L.?" Anton L. asked.

"Nothing to it," said the Elector, his voice muffled by the corrugated-iron wrapping. "If there's only one person left alive, and he's called L., then your name must be L."

"Am I the only person left alive?" Anton L. asked.

"Well I haven't seen anyone else," the Elector replied.

Anton L. tried to push the ends of the tin roof apart. It was pretty hard work and he didn't get very far.

"It's no good," he said.

"You're not going about it the right way. Fetch your car and tie a rope to the rear bumper."

"What a good idea," said Anton L. He went back to the hotel and returned with the car and a rope.

"The rope's much too thin. And it's too short as well," came the Elector's muffled voice.

"How do you know? How can you see it when you're all wrapped up?"

"I can see what your eyes can see, dimwit," said the Elector. "Or do you think I'm really speaking?"

"I was going to ask about that." said Anton L.

"Now's not the time for questions. The towrope you've brought isn't a rope at all, it's not much more than a piece of string. There's a length of the overhead cable from the trams over there, why don't you use that?"

The shock wave from the explosion had brought down a few dozen yards of the overhead cable and wound it up in a neat roll. Anton L. unrolled it and cut off a long piece. He had to go back to the hotel again for that; it had a workshop with tools, including heavy wire cutters.

"Not like that," said the Elector as Anton started tying the cable round the trailer coupling. "When the thing comes loose it'll shoot into the back of the car. You need to make a kind of pulley. Take the cable round one of the pillars outside the theatre so you'll be pulling in the opposite direction. The pillar can stand it."

Anton L. did as he was told.

"Then you have to make two holes in the roof, so you can thread the cable through. Then you'll have to –"

"Have to, have to, have to," said Anton L., though under his breath.

The Elector said nothing more.

'Perhaps he's taken umbrage,' thought Anton L.

It took a good hour's hard work. Three times the clumsy knot in the unwieldy cable came undone when it took the

strain. Only when he wrapped another piece of cable round the knot did it hold. Anton L. stepped on the accelerator, the roof came free with a clap like a thundersheet, the car shot forwards and the corrugated iron clattered across the square towards the theatre, ending up on the steps. The Elector was freed. Only his dagger was bent.

Anton L. got out.

"You could at least say thank you," he said.

"Thank you," said the Elector.

17

Hormisdas II

In November, after the first snow had already fallen, there came a few fine days. The trees were almost bare, just the occasional leaf clung obstinately to the branch and now shone like a jewel in the cold, clear November sunshine. It was dry, the ground frozen and covered with a thin, white, crunching layer of frost that stayed during the day where it was in the shade. Since, however, there was no wind, in the sunshine it was almost like late summer.

After two such days – Anton L. had chopped wood out of doors in his shirtsleeves – when the next promised to be the same, Anton L. undertook his last and longest expedition, his last radial intersection of the concentric circles he had long since given up exploring. He didn't chop up any wood at all on that day. He emptied a jar of cherries into the silver bowl from the royal tableware that Sonja ate out of, took two bottles of champagne for himself, a packet of crackers, a jar of pickled gherkins, a leg of the hare he had shot and roasted two days ago and four boxes of chocolates, and drove off. He headed east again, avoiding the area he knew had been devastated by the explosion. A long avenue led to the motorway. There were mountains of rotting leaves piled up against the buildings, especially in the corners and recesses where the autumn wind of the last few weeks had blown them. A horde of mice came pouring out of a particularly large pile at the bottom of a high wall and scurried across the road. Not much farther on he saw a fox. As he drove past, the fox hid behind a tree.

The houses receded, open fields lined the road. In the distance the dark strip of the forest appeared. A pale but clear

blue sky arched over the late-autumn landscape. Swarms of crows flew up from a field of corn that had not been harvested. Once he was on the motorway Anton L. drove almost too quickly. Water had collected in an underpass a couple of miles out of the city, practically a small lake. When he slammed on the brakes as he saw the water speeding towards him the car skidded, spun round and only came to a stop when all four wheels were in the water. A few ducks swam off, quacking, into the dark watery cavern.

The engine had stalled. Anton L. wound the window down. The water smelt of decaying matter. Brightly coloured oily streaks were spreading sluggishly over the leaf-strewn surface. Once he had recovered from the shock, Anton L. tried to start the engine. It worked, the engine started. Carefully he reversed out of the water, turned the car and drove back.

'On the wrong side of the motorway,' he thought, 'and no police to stop me.'

Now he drove slowly. After a few hundred yards there was a farm track running alongside the motorway. At a place without a crash barrier Anton L. guided the car slowly down the slight embankment. The track went to a village. He parked in the village square, beside the church. In front of the wall round the churchyard was a war memorial, an angel holding a laurel wreath was raising a soldier, whose rifle was falling from his grasp. *To the Fallen* was written in gold letters on a plaque of polished black stone with, underneath it, an iron cross and below that *1914–1918* followed by two dozen names. On the other side was another polished black plaque: *1939–1945*. Since the plaques were kept symmetrical the names there had to be carved in smaller letters. There were four dozen of them. On both the plaques a striking number of the dead were called *Mausberger*. Their rank was also included: *Mausberger, Georg, L Cpl, 4 IV 1917, Arras; Mausberger, Heinrich, Cpl, 28 XI 1917, Cambrai*. On the second plaque there was another *Mausberger, Georg, Inf, 6 VII 1943, Orel; Mausberger, Günther, NCO, 31 VIII 1942, El Alamein*. Anton L. remembered the places, they had been talked about often enough, during the war. He read through all the names. The was

a lieutenant among them: *Rossrucker, Ludwig, 1945, missing, Eastern Front.* That was the highest rank there. That had struck Anton L. before, when he had visited a war cemetery with his father in Austria. His father was looking for the grave of a comrade who had been killed in the war. They walked along endless rows reading the names. It was rare to come across a lieutenant or a captain. "Where are the generals buried?" Anton L. had asked his father. His father laughed. "Generals," he said, "see a hero's death from a different perspective."

It was midday. There were a few wooden benches either side of the war memorial. Here, too, the weeds had grown rampant behind the benches and on the grass round the memorial. Now they were limp, pale and yellow. There were no leaves left on the trees and the sun was shining through the branches onto the seats. Anton L. took out his provisions and sat down. The leaves, that were heaped up everywhere in clumps and piles, gave off a sharp, tangy smell, almost a little like smoke. Anton L. bit off a chunk of the cold leg of hare and ate a cracker with it. When he found it too dry, he opened one of the bottles of champagne. The "pop!" of the cork flew through the still air like some strange, black bird whose great wings darkened the late-autmun day for a moment. It was only after the noise of the cork that Anton L. became truly aware of how quiet it was.

After his meal he walked up and down for a while, taking his rifle with him, even though he was never more than two hundred yards from the car. He deliberately dragged his feet through the clumps of dead leaves. At the village inn he looked through the little windows. The chairs were up on the tables. It had been after closing time when it happened. There was a thick layer of dust on the window-ledges inside. The panes were covered in spider's webs. He walked round the building. The gate to the inn-yard was open. The skeleton of a dog was still attached to the chain. Rats scurried into the barn. Anton L. went back to the car, put the rifle on the seat and picked up a box of chocolates. It was his usual dessert; he finished off the bottle of champagne with them. When he put his fourth chocolate (*praline*) in his mouth and bit on it with

his left-side back teeth, a stab of pain shot right through him from his forehead to his toes. He opened his mouth wide, not daring to continue chewing, scraped the chocolate off his teeth and threw it on the ground. The pain receded, turned into a dull ache, which was almost pleasant compared with the previous spasm, levelled off, subsided. Cautiously Anton L. shut his mouth and bit his teeth together, gently at first, then more firmly – nothing. He took a deep breath and only then realised he had not breathed for several seconds. He bit his teeth together again, he knocked them against each other – nothing. Thank God. He caught himself thinking, What will the Elector say about that? Slowly he placed another chocolate in his mouth, but kept it to the right-hand side when he chewed, avoiding the left. No pain.

A tangle of yellowing nettles hung over the graveyard wall. They must have been taller than a man. Anton L. ate his sixth chocolate, still avoiding his left-side teeth.

Everywhere among the bare trees were tangled blobs of black, bird's nests. The first sound he heard, apart from his own noises, since he had been in the village was the iambic quacking of a duck, at first loud, then getting faster and quieter. There was probably a village pond. He ate his seventh and eighth chocolate. The distant duck quacked again, then a third time; after that it was silent once more. The box of chocolates was getting empty.

Opposite the church was the presbytery. There was nothing that said it was the presbytery, but only priests' houses have that comfortably solid look, smooth and sexless, so to speak, which immediately distinguishes them from other houses in country villages. There, basically, there are only three house types: the farm, the inn and the presbytery. All the others are later accretions.

'What,' thought Anton L., 'if the priest were suddenly to come out? Let's say he hadn't heard me drive up, he'd been asleep. What would be the first thing he'd say? An awkward situation.' Anton L. would certainly grab his rifle straight away. 'Nonsense,' he thought. 'Or not nonsense? Perhaps the priest would have a rifle too? Of course he'd have a rifle by

171

now. "Hello," that's what the priest would probably say, or, "What are you doing here?" ' Perhaps he should introduce himself straight away: "My name is Anton L." Then the priest would say, "My name is –" Then he remembered a thought that had occurred to him earlier. In that case the priest would undoubtedly be the pope. Anton L. ate the last (the twenty-third) chocolate. He got up and walked slowly over to the presbytery. There were bars on the ground-floor windows. Here too there was an inch of dust on the window-ledges. Anton L. knocked on the window. Inside the house a door creaked. Anton L. felt an icy shudder run down his spine. It was as if someone behind him were gripping his shoulders with invisible hands. A door in the room he was looking into slowly swung open, creaking again. A cat peered round it. The hands loosened their grip, but a few after-shudders ran back up his spine to the nape of his neck. The cat came into the room and looked at the window, its tail flat on the ground, ready to flee. The cat looked well fed. Either it had a secret way out of the presbytery, or there were enough mice by now to keep it supplied with food. The cat withdrew. To give it an escape route, in case it didn't have one and its supply of mice should run out, he smashed a pane with his rifle butt, reached inside and opened the window. The cat didn't come back.

'It'll notice soon enough,' thought Anton L.

He drove on along a narrow country road. The forest, a dark spruce wood, closed in, then opened out again. A second village came into view. Anton L. drove through without stopping. Again the forest closed in on the road, forming a tunnel. It became hilly. When the forest opened out once more a largish village was visible on a hill where the road was heading.

It was still bright daylight, but the sun was already starting to sink towards the forest in the west. The trees threw long, sharp shadows over fields that had not been mown. Gradually Anton L. felt a sense of insecurity creeping over him. Was it because evening was approaching? He wouldn't like to have to spend the night out here. He would feel he didn't belong; more, and stranger still, here he would feel *alone*.

In the village on the hill the narrow country road met a broader one. To the left it continued south, to the mountains, to the right it went back to the city: "74 km". It gave Anton L. a shock. No, he had enough petrol, all the canisters in the boot, but what if there should be some other problem with the car? He might never get back to the city! He accelerated, then remembered the motorway underpass. There might be that kind of thing anywhere. He slowed down. He passed through a few villages, checking his progress on the yellow signposts: "61 km", "58 km" and, finally, only "24 km", then, oddly enough, "25 km", although he had driven for two kilometres since the previous signpost.

'Even if it is wrong,' he thought, 'it doesn't matter any more.'

Once a group of strange-looking animals ran across the road. It was a flock of very skinny, greyish-white hens, which appeared out of an overgrown field of maize. Heads down and necks stretched out, they ran to a ditch with alders along the bank.

'That's what hens *really* look like,' thought Anton L.

The sun had already set by the time he reached the out-skirts of the city. At one point he took a wrong turning because he did not know the district. Once he had to make a detour because some scaffolding had fallen into the street. It was dark by the time he got home.

'So I am the pope after all,' thought Anton L. He lit the fire in his miniature palace. (Sonja had only eaten a few of the cherries. She hadn't eaten much at all since it had got colder. Do iguanas hibernate?) Anton L. still usually read something, if not for long, before he went to bed, so he lit the large candle, put a bottle of champagne and the crystal goblet from the Palace Museum that he normally drank out of on the little chessboard table, had a drink and ate the rest of the roast hare, two pickled gherkins and a further box of chocolates. Then he picked up the guide to the art treasures of Rome – *Italy* vol. V – which he had taken from a book-shop when he was still living in the hotel because it had a list of the popes.

"John XXIII, Angelo Giuseppe Roncalli . . . since 1958" was the last entry in the list. Aha, the book dated from 1962. After that there had been Paul VI, Giovanni Battista Montini. When had Pope John died? 1963 or 1964? Probably 1963. Now Anton L. remembered that it must have been 1963, the year when he had taken up his studies again. He picked up a pencil, crossed out ". . . since 1958" and wrote above it, "1958–1963". Underneath he put in Paul VI with the dates "1963–1973". He wrote it too big, so that there was hardly enough room for the next entry, he had to squeeze it in: "., Anton L., since 1973." But what name should he choose?

<div align="center">

Paul VII?
John XXIV?
Pius XIII?
Benedict XVI?

</div>

"Benedict, Benedict, come and get your backside kicked." No, Benedict was not a name for him.

Anton L. returned to the list, going back down the centuries:

<div align="center">

Leo XIV?
Gregory XVII?
Clement XV?

</div>

He liked Clement. He put it on one side, so to speak, on the short list. Then:

<div align="center">

Innocence XIV

</div>

'A ridiculous name, really.'

<div align="center">

Alexander IX

</div>

'Not bad, not bad. Put it on the short list too.'

<div align="center">

Urban IX

</div>

Fräulein Urban had been the name of the nude model for a life-drawing class Anton L. had taken at night school. She had been really quite pretty. The course started in October (it must have been in 1970 or 1971 since Anton L. was working in the Santihanser Travel Agency); by November it was getting chilly. The class was held in the art room of an old school. Fräulein Urban was terribly sensitive to cold and always had a scarf tied round her neck, even though she was otherwise completely naked. The central heating in the room was poor, so a portable wood-burning stove had been placed beside the dais on which the model posed. Fräulein Urban kept on breaking her pose to stoke the fire. That had an odd effect, at least on Anton L. As long as Fräulein Urban was on the dais, she was just a model to him. However, when she stoked the stove, she broke through the glass wall of asexuality and turned into a girl, naked but for a scarf round her neck, who was putting more wood on the stove in full public view. Anton L. was perceptibly aroused. He tried to chat Fräulein Urban up after the class, when she was fully dressed again, but got nowhere. There was a young man who always came to meet her.

This memory meant that Anton L. felt the name *Urban* was unsuitable, almost obscene, at least for a pope.

Sixtus VI

'Another funny name.'

Marcellus III?
Julius IV?
Adrian VII?

He didn't like any of those.

Calixtus IV?

That one even less.

Nicholas VI?

That was a possibility. So it was Clement, Alexander or Nicholas. Perhaps there was another one he'd like.

The next pope, or, rather, the preceding one, was printed in italics: *Felix (V) 1439–1449*. A comparison with the dates of Eugenius IV, Gabriele Condulmero, 1431–1447, and Nicholas V, Tommaso Parentucelli, 1447–1455, indicated there was something dubious about this Felix. Presumably he was an antipope, and he seemed to have made himself unpopular into the bargain, since his number had been put in brackets.

Now Anton L. scanned the centuries more quickly. There were Benedicts, Clements, Gregorys galore. Celestine V was asterisked and there was a footnote at the bottom: 'The only pope voluntarily to resign his office.' That deserves something, thought Anton L., and put Celestine VI on the short list.

Then came interesting names, unheard-of names: Lando, Formosus (with the addition "Corsican?", he ruled from 891–896), *Anastasius* (another italic pope), Sisinnius, Conon, Agatho, Deusdedit, Pelagius, Silverius, *Dioscorus* (another obscure one, but his italic rule had only lasted one year). Then Anton L. gasped:

"Hormisdas," it said, "(from Frosinone) 514–523."

'Frosinone . . .'

So I am Pope Hormisdas II. Anyway a low number seemed less presumptuous to Anton L. He went to the end of the list and added:

Hormisdas II, Anton L., since 1973

'Just a minute.' He leafed back through the list and put 'I' after the old Hormisdas.

The box of chocolates was empty. Pope Hormisdas II picked up the candle, put it on his bedside table, took off his shoes, lay down in bed and blew out the light. Pope Hormisdas II resolved to clean his teeth, starting the next morning. During the night His Holiness had a mild ache in his lower left teeth, but he was not sure whether the pain was

not merely an unpleasant memory in his dream. Apart from that, Pope Hormisdas II dreamt of Fräulein Urban. It was a very clear dream and there was no way it could be reconciled with the principle of celibacy.

18

The deer calendar

The winter was decidedly mild. Apart from a few flurries at the end of October, which was still really during autumn, hardly any snow fell until February. Also, apart from the fact that, because of what happened during the first week after the catastrophe, Anton L. did not know exactly what day it was anyway, he did not think of Christmas or the New Year. Only on the day in February when the snow fell did it suddenly occur to him, 'We're into the new year already.' Then he stopped short. 'We? Who, we? Why, the Elector, the hare and me.'

He hadn't been to see the Elector for a long time, even though the statue was less than two hundred yards from his pavilion (more of a small winter palace, really). He scarcely left the pavilion at all. He went out to collect firewood, that is the furnishings from the nearby buildings, he fetched sweets and chocolates from a new confectioner's opposite the branch of the bank where he'd chopped everything up for firewood and now and then he shot himself a deer to roast. He'd given up tinned food since more and more of the tins he opened had already started to go off. It had happened that he had to open six tins before finding one that was edible. (Sonja, though, was happy to eat the contents of tins that had gone off.) Initially, while he was still living in the hotel, he had only hunted small animals, mainly poultry: pheasants, partridges, quail, later the odd hare. He taught himself to skin and gut the carcasses, however roasting became increasingly difficult due to the lack of fat. All the packets of butter, margarine and lard he found in the supermarkets, which were swarming with rats, mice and other vermin, had gone rancid. The olive oil in tins and

bottles was the only thing that lasted longer, but it was clear that even if that supply did not run out these, too, would eventually go off. During the winter, the real winter, in February after the snow had fallen, Anton L. shot a deer. He observed the animals in the park from his perch on top of the pavilion. Roe deer, wild boar, even red deer came and gnawed at the bark of the trees. It was during one of those nights that he was awoken by a noise. Usually he slept well, a deep, sound sleep, almost like Sonja, but that night he woke up. He could hear a piercing, long-drawn-out howling. He got up and looked out of the window. In the bright light of the moon the trees cast nets of deep-black shadow on the snow. And other shadows were scampering though those nets, all going in the same direction. As one stopped abruptly for a moment, two eyes gleamed. There was no doubt about it, they were wolves.

'That's okay by me,' thought Anton L., 'as long as they leave Jacob alone. There's far too many animals in the park as it is.'

By the time it was light, the wolves had disappeared. Anton L. never saw a wolf during the day. Jacob, the hare, was of course far too cunning for the wolves to catch him.

It was the hare himself who had told him he was called Jacob.

"I'm called Jacob," he said, "Jacob with a c, not a k like these modern German Jakobs."

Anton L. had been on his little balcony, looking down at the park, when the hare had trotted along, sat up on its hind legs and started to talk to him, a general conversation about the weather, how things were and so on.

"It's just not *possible*," Anton L. said. "I'm not dreaming, I'm not mad, it's just not possible that you're speaking. Or have I gone mad after all?"

"Of course you're not mad," the hare said. "There's a quite natural explanation. Haven't you noticed that all I'm saying is what you're thinking, or could be thinking? It's the same with the Elector."

"So you're not really speaking?"

"No, of course I'm not really speaking. Has anyone ever heard of hare speaking or a statue –?"

"– or an iguana."

"That's right, or an iguana," said the hare. "It's yourself you can hear in me. It's a well-known psychological phenomenon, that is. I'll give you a clue, if you like."

"You mean people hear voices –"

"You must've read about that man Chichester, the one who sailed round the world, alone in his boat for weeks on end?"

"He heard eddies in the water talking."

"You see? You do know. I can't tell you anything you don't already know, even if it's lodged in some long-forgotten wrinkle of your brain. Chichester was a down-to-earth Englishman and he still talked to the eddies. And you've read about trapped miners who heard voices, even saw apparitions."

"And what causes this phenomenon?"

"That I don't know – 'cause you don't know, never did know."

"I'd be interested to know if you're one of the hares I liberated from the cages in the hotel."

"When was that?"

"Last summer."

"For hares there's two generations between last summer and now."

"Aha. Then perhaps you're descended from one of those hares?"

"Genealogy's not something we hares go in for much."

Anton L. laughed. "Of course not. You can't know because I don't know."

"Got it in one."

"There's just one thing that puzzles me," said Anton L. "You say you're called Jacob. How can that be? How could I have known that?"

"No problem. Your great-grandfather was called Jacob, Jacob L., your father's paternal grandfather."

"That's right. That explains it. So you hares do go in for genealogy after all."

"Only human genealogy."

After that Anton L. decided not to shoot any more hares. It was, anyway, easier to hunt roe deer and the yield per animal was much greater, especially since during a closer inspection of the Palace kitchen he had discovered an implement that he only knew of by hearsay, or at most from historical films: a roasting spit. He studied the mechanism, then put the skinned and gutted deer on the spit, lit a fire from the furnishings of the superior bank, slowly turned the spit and roasted the deer in its own fat. Bits of it got burnt, but in general it was edible. By this time his gastronomic expectations were low. He'd also stopped bothering with all that fancy nonsense about crockery and cutlery. He took his hunting knife and cut off a hunk. It was still bloody inside, so he continued turning the spit with one hand, while holding the hunk of flesh on his hunting knife to the fire with the other, taking a bite now and then. With time he developed a taste for bloody flesh. After each bite he took a swig from the bottle. Fortunately champagne did not go off in the bottle. When he had eaten his fill, he stopped turning the spit and covered the embers with ashes. Sonja also ate roast deer, if it was chopped up finely enough.

A deer lasted him for a week or a week and a half, and that was only eating the better parts, that is those that came off easily. Towards the end of the week the meat started to get rather tough and tasted almost exclusively of charcoal. 'Perhaps it's good for the digestion,' thought Anton L.

Here is perhaps the place to mention a problem that one or other of our readers may perhaps already have wondered about. As long as Anton L. was in the hotel there was no difficulty: the water was still running, therefore the sewerage system worked too. The late Herr Pfeivestl's suite naturally had a private lavatory. The princess who had lived in the Chinese pavilion had not had a lavatory of her own. Back in the eighteenth century they looked on those matters differently. But there were toilets, doubtless added on in the twentieth century, in the large Palace, the residence of the prince electors. The ones closest to the pavilion were at the back of the porter's lodge. But these were too far away for a nocturnal

or matutinal call of nature, or an urgent one at any time, for that matter. In those cases Anton L., presumably like the princess before him, used a porcelain pot that was kept in a discreet little compartment in the panelling beside the bed. And the secret bowl was not everything.

'You don't learn this kind of thing at school,' thought Anton L. 'They weren't that stupid in the eighteenth century either.' The discreet compartment also contained a kind of enamel funnel with a tube that went down and exited at the rear of the pavilion. As long as the snow was lying, Anton L. kept shovelling it over the exit point. It helped, but in the spring – not to mention the summer! – a stench rose from that spot, enveloping the whole of the building. The discreet compartment also developed a similar smell. Huge numbers of flies came as well, but they did not bother Anton L. either, even less Sonja, who had woken from her winter sleep and ate the flies with relish. However, after he had yawned while the window was open and inadvertently swallowed a handful of flies, he decided to do something about it. Even the Elector had complained about the smell he gave off, the first time he went to see him in the new year. The Elector suggested he construct an earth closet and also that he pour a bucket of water down the enamel funnel now and then.

So Anton L. dug a pit at the back of the pavilion, directly under the exit point of the tube. From time to time he shovelled a layer of the earth he'd dug out back into the pit. Even in the early summer the vegetation there was particularly luxuriant.

In the hotel Anton L. had had his wallpaper diary. At first when he moved to the pavilion he kept counting the days. He cut a notch in the panelling of his bedroom every day, but he very quickly got confused. Had he cut a notch the previous day, or had he forgotten? He gave up, and another time scheme established itself almost unnoticed: the 'deer calendar'.

During his seventh deer – that is, around the end of February or the beginning of March – Anton L. woke up during the night again. It had snowed the whole of the

previous day and the thick flakes had still been quietly falling when he looked out of the window before going to bed. Everything was silent. When Anton L. woke it was still silent, but, as he was immediately aware, it was a different kind of silence. It was the silence after a noise. Had the noise not been loud enough to wake him? Had it only been the strange following silence that had roused him from his sleep? He stayed lying in bed for a few minutes before sitting up and listening. He could not hear anything. He got up and looked out of the window. It had stopped snowing and it was strangely bright. He recalled the pale glare he thought he had seen, still half asleep, on the night of 25 June the previous year. He went downstairs. Sonja was awake as well, sitting on the little triangular table where she almost always sat. Anton L. went back upstairs, put on his boots and his padded hunter's jacket. Then he went up to his outlook post on the roof.

The sky was a reddish yellow. Four tongues of light rose up from the horizon: one to the south behind the Palace (only the tip of that tongue was visible), one, in the west behind the range of buildings between the Palace Gardens and Luitpold Allee, one behind the grace-and-favour lodgings to the north of the Palace Gardens and one behind the tall, bare, snow-covered trees to the east of the little lake. The tongues of light had horizontal stripes, as if crossed by thin clouds. The first explanation that occurred to Anton L. was some phenomenon like the northern lights. They were not flickering but steady against the sky, a reddish yellow. After a few minutes, however, Anton L. realised they were moving after all. He could tell from the southern tongue, which was disappearing behind the dark silhouette of the Palace. The tongues were getting lower, but broader. It almost looked as if the luminous phenomenon produced by some mysterious event had had its zenith above the city and was now withdrawing below the horizon.

It was very bright. The deep, freshly fallen snow had a reddish-gold glow from the reflection of the tongues in the sky. Snow was lying on the ledges of the Palace, on all the

pediments over the windows, the projections and cartouches. That snow, too, was gleaming red and gold. The façade looked as if it were decorated with garlands, garlands of blood.

'It's coming back,' thought Anton L. 'It's coming back for me. Then it will have taken everybody. It was just a year ago. Was it a year ago? No, it's not been a year yet . . .'

There was not a sound to be heard, still not a sound.

The tongues kept sinking and spreading out along the horizon, the ends slowly approaching each other. Anton L. could observe this happening at one point, the point where the eastern and northern tongues would meet; for the rest the surrounding buildings were too high. The tongues of light became agitated, faded from a reddish yellow to a pale yellow, licking along the horizon towards each other. The moment they touched, the storm broke. Before that the horse jumped up. It must have been standing close up against the building all the time so that Anton L. could not see it. It was a large, light-coloured horse. It galloped along the lake, its hooves sending the snow flying up, then disappeared in the darkness and flurries of snowflakes as the gale sent the freshly fallen snow whirling up to the rooftops and swept the garlands from the Palace façade. The storm arrived with a roar like a battery of trombones. The impact was solid, physical, like a plank hitting Anton L. It would have swept him off the platform of the pavilion if there had been just the one storm, but there were four. Four planks struck Anton L. from four different directions. For a moment he felt as if he were being crushed. He felt his way backwards to the wrought-iron balustrade with the initials "A. L." and clung on tight.

Like another horse, but black and gigantic, a bank of cloud poured up into the eastern sky, wave upon wave, higher and higher, a whole herd of horses. Once the tongues of light had retreated, the sky went dark, almost black. Now the clouds were even darker, standing out against the sky. Then a flash of lightning speared out from the clouds, followed immediately by a deafening thunderclap. As if he had been struck by the lightning, a throbbing pain shot down through the left side of Anton L.'s head and stuck in the left side of his neck,

leaving a burning trail from his temple to his neck. All he could see with his left eye was bloody flames, his left ear had gone deaf.

Further flashes of lightning and claps of thunder followed in quick succession. Each one scoured the painful trail the first had drawn through his head, as if a red-hot chain were being dragged along it. He covered his left eye with his hand, felt his way to the skylight, opened it, and climbed down. He took off his hunter's jacket and his boots and got into bed. The pain intensified and localised: in his left lower jaw. It burst like a boil, leaving him with a raging ache. It was his tooth, the same one he'd had trouble with at the war memorial. During the night he hardly slept, though he still couldn't say when the gale and thunderstorm had stopped.

The morning was icy cold. The lake was frozen over. Even before the sun was up, Anton L., wrapped up in a shawl, hurried out to the chemist's across Luitpold Allee. As an ex-hypochondriac he was well acquainted with the stand-ard painkillers. Feverishly he rummaged round all the shelves. He took four aspirin, four Togal, four Thomapyrin and four Melabon capsules. He filled his game-bag with a supply of tablets. There was a large aquarium on a stand in the shop. Fish skeletons were floating in the foul water. As Anton L. came out he felt very strange. He was limping with his left leg, his stomach was boiling hot and he came out in a cold sweat on his forehead. He was sick even before he reached the Palace Gardens. He dragged himself to his pavilion and went back to bed. The pain subsided. When he woke – Anton L. had the feeling it was after a long time –, his tooth-ache had gone. His stomach was still rumbling, but that was just hunger.

Feeling washed out, Anton L. got up, went downstairs and dragged himself over to the Palace kitchen. It was light, a grey day. The snow lay thick on the paths; it had not frozen.

In the kitchen deer number seven was on the spit. Anton L. was too hungry to light a fire. He took out his hunting knife, cut off a piece, half cooked, half raw, salted it and ate it. He felt

better. He ate another slice of meat, then another. Feeling stronger, he went back to the pavilion. The hare was sitting by the door.

"So you saw it too," said Anton L.

"Of course," said the hare, "impossible not to."

"What was it?"

"The northern lights, I should think," 'said the hare.

"Have you ever seen the northern lights before?"

"No," said the hare, "never. But I imagine that's what they look like."

"But they were in the north *and* the south and the east and the west."

"As I said, impossible not to see that," said the hare.

"So it wasn't the northern lights after all?"

"I've been wondering about that."

"Come to any conclusions?"

"All sorts of conclusions."

"Perhaps it was just a winter thunderstorm," said Anton L.

"Thunderstorms are rare in winter," said the hare.

"That's why they're so eerie," said Anton L. "There's probably a perfectly natural explanation for it."

"Probably," said the hare.

"At first I was afraid. I thought, now it's coming for me."

"All that bother for just one person?" said the hare.

"Maybe they thought it was worth the effort because I'm the last."

"I don't think so," said the hare, "I'm sure there's a very simple, natural explanation."

"A very simple explanation?"

"If we could understand it, of course," said the hare. "If, for example, we were meteorologists or something like that."

"Hmm," said Anton L. "Did you see the horse too?"

"I saw everything you saw."

Anton L. walked round the pavilion. The hare hopped along with him. The hoofprints were already somewhat faint, but still clearly recognisable.

"You weren't dreaming," said the hare.

"No," said Anton L., looking at the hoofprints. "It was a

real horse. Then perhaps all the rest was too – I mean all the rest has a natural explanation too."

"As I've been saying all along," said the hare.

Anton L. went back to the door. The hare went with him.

"Want to come in?"

"No thanks," said the hare.

"See you then," said Anton L. "Watch out the wolves don't catch you."

The hare laughed and trotted off.

19

The red arrow on the globe

The real spring came late. There were a few fine, warm days at the time of the eleventh and twelfth deer, to use Anton L.'s calendar, that is around the end of March and the beginning of April, but then it turned cold again and snow fell. Only during the time of the fourteenth deer did the cold abate. Spring positively erupted. It was as if the exceptionally long cold spell had kept it dammed up and it had seethed and bubbled until it was stronger than the dam, then swept over the land with with the hot, dry *Föhn* blowing a gale. Within a few days everything was covered with fresh green growth and the blossom on the boughs burst almost audibly. As if let off the leash, the grass and weeds shot up round Anton L.'s pavilion. It was almost impossible to make out the gravel paths that had still been recognisable the previous year. A flood did its bit as well. It did not reach the Palace and the gardens, but the little lake in the park overflowed. For a few days the water washed round the trees, with clumps of them standing like islands in the lake. The flooded lake seemed playful rather than threatening or dangerous. When it subsided it left behind a thin layer of mud, which obviously had the effect of manure. Everywhere where the ground had been flooded the grass and other plants grew twice as quickly as in other places. The shops and other premises on Luitpold Allee had also been flooded. The bank and the antiques shop, the furnishings of which Anton L. had chopped up for firewood, had rear entrances into the Palace Gardens. Since Anton L. had also burnt the doors and door-frames, the water had had free access to the ground floor rooms, which were likewise left with a layer of mud. Outside the rear entrance to the bank a

thorny bush was growing rampant. Anton L. trampled it down and looked into the main hall. The combination of the large windows and the fertilising manure must have turned it into a hothouse. Green shoots were appearing in every tiny gap of the parquet floor (Anton L. had not yet chopped it up), in some places with such force that the blocks had been thrust apart.

Anton L. parked the two cars he had brought from the hotel, the two big cars belonging to Pfeivestl and the Cuypers, on one of the gravel paths beside the pavilion which at that time was still visible. After his expedition in the late autumn he had not used them again; when the snow came he had just parked them a little farther away, under a projecting roof near the rear entrance to the bank. They both still got snowed in, but that did not bother Anton L. The flood had washed round them and now they were overgrown with vegetation. That did not bother Anton L. either. He hoped that if he needed a vehicle he would be able to free them. The rust in various places was, however, all too clear to see. For the moment Anton L. had no plans to undertake expeditions by car, because of the 'rumbling' amongst other things.

When the little lake overflowed, it flooded not only the part of the park round the pavilion, but also the low-lying path between the park and the Palace which Anton L. had to cross when he wanted to get to his roasting spit in the Palace kitchen. In the area round the lake the water only came up to his ankles, but on the path it was very deep. So although Anton L. did wade around in the park a little if necessary (he had wellingtons), he was cut off from the kitchen. He had to leave the seventeenth deer on the spit and shoot his eighteenth prematurely. It was the first deer he ate raw. His supply of wood piled up outside the pavilion also got soaked, but it was so warm that he did not need any heating.

As long as the park remained inundated Anton L. stayed close to the pavilion, as he had during the snow. He was still able to observe the other flood, the dangerous flood where the river had burst its banks. Since the trees were not yet in full leaf, from the flat roof of his pavilion he could see over

one of the lower Palace annexes and through a gap in the buildings to two lower-lying streets. They were both side streets off Anakreon Strasse; the farther one ran past the side of the Three Kings Hotel. Anton L. could see one corner of the hotel with his binoculars. For days the floodwaters of the river foamed through the two streets, a murky, gurgling, seething, raging torrent, generally brown, occasionally green, which spumed up as it crashed against the corners of the buildings, sweeping along heavy beams, uprooted trees and animal carcasses. Stones clattered and crashed. Then came the first 'rumbling'.

Just as the gentle flood of the lake had left mud behind, the river flood, as Anton L. could see from his observation post, deposited boulders, stones, rubbish, sand, and gravel. He also noticed that one building in the nearer street was leaning at an angle. He had often passed it while he was still living in the hotel. He remembered seeing a sign that said the building housed the State Geological Collection and the Peruvian Consulate. The building stayed like that for four days. On the fifth day, just when Anton L. was observing it through his telescope, slates began to fall off the roof, first a few then, with increasing rapidity, more and more. Even before the last ones had fallen, the façade crumpled and sank to the ground. It was all over in a matter of seconds. As the building twisted rather than fell, the rooms inside were briefly visible. Tables, chairs, cupboards came tumbling out a fraction quicker than the building itself was collapsing, turning into a mass of bricks, sending up clouds of dust and pouring down into the street with a rumbling noise.

That was the rumbling. It came in particular from the direction of the river, now back between its banks. The cellars there had probably taken in more floodwater and the foundations been undermined. Presumably the preceding frost would also have made cracks in some of the walls. Now and then the rumbling became a loud clatter, as if a row of gigantic dominoes was falling down. By the summer the pile of bricks that had been the State Geological Collection and the Peruvian Consulate was covered in herbage.

Thus it was that Anton L. kept to the area round the Palace, which was not only more solidly built but also on higher ground, in order not to be caught, as a building collapsed, and buried alive. Even in the car he would not be any safer, quite apart from the fact that it was highly likely the streets that had been flooded would be impassable.

The plinth on which the Elector stood was also covered in vegetation and across the square, where the Elector's dagger was pointing, a tree was growing on the roof of the theatre that had not been there the previous year. The Elector himself was unchanged.

"Have you found the Book?" he asked.

"The book?" said Anton L. "Oh, the Book. I have found the Book or, to be more precise, I haven't found the Book."

"I suppose one could call that an answer."

"I mean," said Anton L., "I found a book *about* the Book, a book in which *the* Book is mentioned, but I haven't found the Book itself. Didn't I tell you?"

"No," said the Elector.

Anton L. told him the whole story, at least those bits he thought would interest the Elector.

"Oh yes," the Elector said, "that Philipp Moritz was my uncle."

"Did you know him?"

"How on earth could I have!" said the Elector. "When I was born he'd been dead eight years, almost to the day, as it happens. But one heard things."

"You knew about the Book?"

"No. Nothing was said about a book."

"I had hoped you would know where it is. It must still be in the Royal Library, if it hasn't been sold. But you don't know?"

"You ninny," said the Elector, "I don't know anything you don't. The hare told you that."

"So I have to look . . ."

"You haven't done that already?"

"Yes, I have," said Anton L., "immediately after I'd translated that old Latin tome. In the . . . in Your Royal Highness's library. Over there." He jabbed his thumb over his shoulder.

191

"Nothing?"

"No. But . . . I don't know. Even if I found it, the book's empty, it only has blank pages."

"*At that time* it had blank pages," said the Elector. "But that's not to say that writing might not have appeared in the meantime."

"You think so?"

"Have you not noticed anything, Adam L.?"

"What do you mean, *Adam* L.?"

"I beg your pardon – Anton L. Have you not noticed? It's as if a large red arrow had been stuck on the globe, and if you look closely the tip of the arrow is pointing straight at you. Do you seriously believe it's mere chance that you have been spared from the mysterious general dematerialisation of all mankind? That a group of highly intelligent people, none of whom knew you –"

"Candtler did, if only slightly."

"See how it all fits together! A group of whom you knew one without suspecting what an immense secret they concealed. That in their last year a group of highly intelligent people concentrated all their efforts on guiding you to the Book; that on the very last day before the catastrophe the ultimate or, to be more precise, the penultimate link was added to the chain? Or, to put it another way, that the catastrophe held back until the package of photocopies, without which you would have made no further progress, was delivered to the State Library? Do you think that's just chance? And that the message which put you on the track of the book was left at a candlemaker's? Not a driving school or a barber's shop or a florist's or a children's clothes shop or an insurance agency . . . There are a thousand shops the letter could have been delivered to which you would never have entered. But you need candles!"

"So Soliman Ludwig, I mean, the fact that Soliman Ludwig worked in a candle shop was all part of a plan –"

"Part of the red arrow that was stuck to the globe and points at you. And there's more. Did you not say that the owner of the candlemaker's was a cousin of Soliman Ludwig?"

"Yes."

"It's the candlemaker's to the court. Probably a firm that has been in the hands of the same family for generations. So the plan goes back even farther, back to Soliman Ludwig's candlemaking forefather, perhaps even farther, who knows. The Book is here, there's no two ways about it. It must be here, otherwise nothing makes sense."

"But *where* is it?"

"Quite near. I don't actually know, but I suspect . . . everything points to it being quite near to you. Quite near to you. Don't you feel anything? No?"

"If I didn't have this toothache all the time," said Anton L.

"You eat too many chocolates."

"Too many chocolates?" said Anton L. "Can one eat too many chocolates?"

"And not enough vitamins, or whatever the things are called. You should have a nettle salad with your venison every day. Otherwise all your teeth will fall out."

"I remember that after the war," said Anton L., "my mother sometimes made nettle salad. But how do you make it so it doesn't sting your mouth?"

"My friend," said the Elector, "I'm an elector, not a cook. But I assume you get rid of the sting if you dress it in oil and vinegar. Or you could use sorrel, that doesn't sting."

"And my toothache, will the sorrel take that away?"

"I repeat, my friend, I'm an elector, or at least the statue of an elector, and not a dentist."

Anton L.'s toothache, which had been tormenting him almost daily during the last few weeks, was immediately set off by the word "dentist". The throbbing pain shot through him – from head to toe would have been an exaggeration, but at least to the knee. The stab of pain closed the gap in the fabric of reality through which the Elector's statue was able to speak. The Elector fell silent.

The word "dentist" also set off an association.

Behind the statue of the Elector was the entrance, now blocked with rubble, to the candlemaker's. A few yards beyond it was another entrance, not blocked, as Anton L.

could see, through which he had often gone. Despite the fact that now — that is during the time, almost a year, in which he had been alone — he had often walked past this entrance, he had never thought of the importance it had once had for him. It was a few years back. Had Anton L.'s memory refused to recall it? It would have had good reason.

Anton L. went round the mute statue and over to the entrance. The nameplate was still there, an engraved brass plate:

<div style="text-align:center">

Dr Leon Klintz
Dr Barbara Klintz
Dentists
Appointments by arrangement

</div>

The practice was on the second floor, the Klintzes' flat on the third. They'd had a hole made in the ceiling and a spiral staircase installed, so they could get from the practice to their flat without having to go out onto the stairs.

With the butt of his rifle Anton L. broke down the door and went up to the second floor.

He had been treated by the dentist couple perhaps three times. Once by Herr Dr Klintz, if he remembered rightly, and twice by Frau Dr Klintz. But he had been in the Klintzes' apartment on the third floor much more often. He had got to know them in the so-called "Bundtrock Circle".

20

The Bundtrock Circle

It was around 1970, about the time he was moving from the Kühlmann Travel Agency to the Santihanser Travel Agency, that Anton L. happened to run into Jens Liefering. They had been at school together and taken their school-leaving exams, the *Abitur*, at the same time. Anton L. was not particularly good at school, but Jens Liefering was particularly bad. It was only with the greatest difficulty and the exertions of numerous private tutors that he had got over (been lifted over would be more accurate) the hurdle of the *Abitur*. As soon as he had his certificate he became, perhaps in accordance with some kind of psychological law, the kind of person who says, "I'm not talking to you. You haven't even got *Abitur*." Jens Liefering was a tall and, with a few minor qualifications, what in the 1950s was considered a handsome man. After they left school Anton L. had seen him at most twice. There had been a class reunion a year after they left and everyone had attended that. Jens Liefering sat there, tall, silent and handsome. He made it clear that he only remained silent because he considered it beneath him to show off in this group he believed he had long since left behind.

The form comedian, who had organised the reunion, had had the idea of calling his former classmates out according to the old class register in order to seat them round the table. Thus Anton L., who came immediately after Liefering in the alphabet, sat next to Jens Liefering.

He was studying architecture, said Liefering.

Wasn't that a bit oversubscribed? Anton L. had said. And he'd heard the job prospects were a bit uncertain.

The prospects for him, had been Liefering's brusque reply,

were dazzling. All he had to do was to get his friends to realise their country villas were shit. Then they'd pull them down and get him to build them new ones.

Anton L. was very impressed. He didn't even have one friend with a country villa.

Jens Liefering was not at the second class reunion. Anton L. too soon stopped attending.

"Hi!" said Jens Liefering.

"Liefering!" said Anton L.

Even now – or, perhaps, especially now – after twenty years they did not have anything more to say to each other. But you know how it is. Once you've met a casual acquaintance in the street and stopped (when it would have been better to walk past with a polite "Good morning"), you're obliged to go on talking even after you've said everything you've got to say to each other. That is true even when the other person is aware of it. There are scarcely two in a hundred thousand who are big enough to say, "Sorry, but you know as well as I do that we've got nothing to say to each other. I wish you all the best," and to reply, "Just what I was thinking. Nice meeting you." And those two would certainly have something to say to each other.

Clearly people find it embarrassing to admit to themselves that they have nothing to say to the person before them and try to put it off as long as possible. When, in such a situation, they reach a point when they can find absolutely nothing to say, they say, "Why don't we go to that café over there." That's saying something and it puts off the admission for two more minutes.

The café Anton L. and Jens Liefering went to was in the same block as the candlemaker's – with which he was at the time unacquainted, of course – but in a different street, round the corner, then round the corner again. And there, suddenly and to their mutual surprise, it turned out that they did have something to say to each other after all. That was where his involvement, his entanglement in the Bundtrock Circle began.

Jens Liefering told him he had completed his studies and taken his diploma in architecture. Anton L. could not resist asking if his friends were now pulling their country villas down.

Liefering looked somewhat put out. He had, he said, moved on to quite different things, he worked on a large-scale, a broad canvas. Town planning, for example. In the course of their conversation it turned out that Jens Liefering was one of those architects who had never built a house in his whole life. He was comfortably installed as head of planning and building control in some ministry.

From town planning Jens Liefering had got on to sociology, and from there to psychology, which, he said, had been the real focus of his interest for some time. Anton L. pricked up his ears. In the fifties anyone who wanted to be considered intellectually up-to-date had to be interested in psychology. Anton L. had missed out on that fashion. It was not until a few years ago, when psychology had long since been displaced by the fashion for sociology, that he started to take an interest in psychology. An extremely amateur interest that he pursued by reading popular books on the subject such as *You and Your Mind* or *Know Your Own Unconscious*. It was his burgeoning enthusiasm for yoga that had sent him in that direction.

Yes, said Jens Liefering, he was involved with an extremely superior group.

The circle round Professor Bundtrock, the Bundtrock Circle, he said, was extremely select. They met every Tuesday. Anyone could come along.

That was how Anton L. came to join the Bundtrock Circle.

Prof. Günther Bundtrock was an original. It has to be said – Anton L. only realised this much later, in fact only after he had left the Circle – that Prof. Bundtrock was not to blame for the intellectual frailty of the people who gathered round him, or at least only in so far as he accepted everyone who wanted to come with open arms because he supported, sometimes expressly, the theory that the negative aspects of human beings were simply an absence, a no-thing; if one negated the no-thing then what was left was the positive, the good that

was in each human being. Looked at like that, he would say, every human being was good through and through.

The fact that Bundtrock accepted anyone in his circle had another, more down-to-earth reason. He held the chair for the history of medicine at the university. It had been created specially for him after the war, to compensate him for the persecution he had suffered under the Nazis. Since, however, they had omitted to make his subject part of the degree programme in medicine, his lectures were never exactly crowded and participation in his seminars was even worse. Prof. Bundtrock felt hurt, not taken seriously, and so decided to go his own way. The material he dealt with in his lectures moved farther and farther away from the History of Medicine. Just as in the old children's spelling game NAZI could be transformed via NAZE, LAZE, LACE into LICE, over the years Prof. Bundtrock's lectures moved from the history of medicine to, for example, "Sigmund Freud and Art" or "The Plays of Frank Wedekind". Prof. Bundtrock was particularly fond of Wedekind's plays. As a very young man he had known Wedekind; he had even been an actor for a while, before he started to study medicine, and was still capable of treating his seminar to a booming one-man performance of *Earth Spirit, Pandora's Box* and *Spring Awakening.*

Reports of this maverick gradually spread among connoisseurs of the eccentric at the university and some of these connoisseurs, mostly oddball or problematic characters themselves, became attached to Bundtrock. They came from all faculties, later from outside the university as well, and thus formed the Bundtrock Circle which, like all similar groups had a solid core and fluctuated round the edges.

"How is it that anyone can go along?" Anton L. had asked Jens Liefering.

Liefering gave the condensed version of the reason for Prof. Bundtrock's openness to all, "He's glad of anyone who'll listen to him."

When Anton L. got to know him, Prof. Bundtrock was almost seventy. He was well over six foot tall and fat as a barrel, though only in the middle, a barrel with slender legs and

narrow shoulders topped by a head which, while doubtless looking distinguished, was something of mixture between Falstaff and G. K. Chesterton.

Nevertheless he impressed Anton L.

Bundtrock's actual seminars were in their last phase when Anton L. joined them. They took place every Tuesday from five to seven. Bundtrock would declaim. At seven Bundtrock and his students went to a restaurant in the city centre, not far from the place where Anton L. had been pursued by a bear, in which a private room had been reserved for them from half past seven. There Bundtrock chatted about the things he had declaimed during the seminar.

Since even some of his admirers found Prof. Bundtrock's manner of lecturing unbearable, but enjoyed the subsequent chat, more and more got into the habit of cutting the seminar but coming to the reserved room in the Green Oak afterwards. Anton L. only attended the actual seminar three times. Bundtrock was not annoyed. He negated the absence, and when eventually the only participants were W. A. Schlappner, a fanatical admirer of Bundtrock, and his girlfriend Astrid, (Jens Liefering's sister), Bundtrock abandoned the seminar and went straight to the Green Oak himself. W. A. Schlappner's Christian names were Willi Adolf, but he had no objection to people assuming he was called Wolfgang Amadeus.

Now the evenings in the Green Oak were divided in two parts. The first part consisted of Prof. Bundtrock's chats about Wedekind, Gustav Gründgens in the 1920s and so on; the second part, which only really got going when Bundtrock himself left at ten, focused on the subject that held the Bundtrock Circle together: psychology. It was not merely an unwritten law, it was an absolute condition, amounting to a taboo, of all conversations, of all communication within the circle, that they took each other's psychological hypochondria seriously. Not that they were interested in the others' imaginary and, in some cases, even genuine psychological disorders, but because listening to the others' nervous afflictions gave them the right to talk about their own.

Strangely enough, Bundtrock's own psychology – we feel

obliged to point this out, since we are talking about his Circle – was entirely free of problems. After he had withdrawn from the Circle, and especially when he heard of his death some time later, Anton L. thought a lot about Bundtrock. He still found him an impressive figure and he went to his funeral, until he heard W. A. Schlappner's croaking voice organising the funeral procession, at which he turned on his heel and placed his flowers on the grave the next day. He tried to form a clear picture of Bundtrock's character. 'Sublimated lecher' was the definition he came up with, though he immediately added a mental question mark. Sublimated lecher? Bundtrock was a sensual man, a Falstaff. He took what was ultimately a childlike pleasure in ribald jokes, foaming tankards of beer, hearty meals and naked women. The female sex was a constant source of interest. He had married (one after the other, of course) all the female research students and assistant lecturers he had been able to get his hands on, the last one, his seventh, when he was over sixty. With her he produced the final fruit of his interest in sexual intercourse: a history of sex education. But a 'sublimated lecher', even with a question mark, has no psychological problems. He wallowed contentedly in his sublime voluptuousness. But perhaps, thought Anton L., this uncomplicated personality was precisely what was needed to form the focus of a group of psychological invalids.

Psychological disorders are odd. Basically there's no such thing as an imaginary psychological disorder; if someone imagines a psychosis, then they have one, namely imagining they're ill. The only question is, do they have enough time to think about it. The majority of the core of the Bundtrock Circle were failures (was Anton L. not a failure too?), who had the good fortune – or misfortune – to have someone else to provide for them or a job that did not demand too much of the time they needed to spend thinking about themselves. Jens Liefering, the architect/civil servant, for example, or Fräulein Dr Ingeborg Schmill, a silly, girlish female with buck teeth. She was part of a large legal practice, but also had "wider" interests. She liked talking to Frau Astrid Delius about books (which neither of them had read).

Frau Dr Schmill would occasionally try, touchingly but unsuccessfully, to be "chic". She was fond of wearing a dress of imitation reptile skin that wound round her in truly labyrinthine coils, a body turban, so to speak, and she twisted her beautiful dark, thick hair round her head in braids that were presumably meant to look daemonic.

The Klintzes were genuinely hardworking. Their practice was flourishing. Frau Dr Klintz was the only one of the inner core who regarded the goings-on in the Bundtrock Circle with a certain ironic reserve. Herr Dr Klintz's problem was, as he said, that he had taken up the wrong profession. "How could anyone find it satisfying," he would occasionally exclaim, "to spend their life looking in other people's mouths?" Dr Klintz had a genuine problem. It even got to the point where he secretly went to a real psychologist for treatment. However, the psychoanalyst he consulted could not help him either. After analysing a number of dreams he concluded that it was not just dentistry to which Klintz had an aversion, but to all professions. Dr Klintz was close to despair. The psychoanalyst continued the analysis. After a further year he established that there was one profession against which there was no barrier in Dr Klintz's psyche: engine driver. But Dr Klintz could not bring himself to make the required career change.

Theoderich Lindenschmitt (he was, to put it bluntly, Anton L.'s rival for the affections of Frau Dr Klintz) was a musicologist and made a modest living from his work on an encyclopaedia of music; his thesis on Rameau had sent three professors to their grave, but he had never completed it.

Frau Astrid Delius was divorced and around forty. ("No one believes it! They simply refuse to believe it!" she would exclaim when the question of her age arose. "No one believes I'm forty." Naturally no one contradicted her.) She and her boyfriend Schlappner lived off the maintenance from her divorced husband. Schlappner too, so the rumour went, had been working on a thesis for years. Suggestions as to his subject varied from law to physics. Frau Delius once said that there was such an astonishing accord between Schlappner's

and her psychological problems that it was a rare case of complete psychological harmony.

Frau Delius was tall and thin, Herr Schlappner was short and thin. Whether Frau Delius was beautiful or not was a matter of individual taste. If you tried hard you could see that she had a certain bony, statuesque attraction. She herself, as she occasionally let slip, considered herself a beauty. Her intellectual gifts were more difficult to assess, since when the discussion demanded more complicated thought processes she would just open her eyes wide and smile an inscrutable smile. W. A. Schlappner, on the other hand, liked talking and did so often. He wore thick glasses, despite which he could only read if he held the book right in front of his eyes. He had receding hair, which was long and lank, and a nose which was almost non-existent, resulting in a face that was more or less expressionless apart from the large, thin-lipped mouth, which protruded in a frog-like pout when he spoke. His frog mouth and blinking eyes gave him a permanently indignant look. "A devious, obsequious little frog," Frau Dr Klintz once said. To the unprejudiced on first hearing him he sounded immensely erudite. He could spout philosophy till the cows came home. Nothing less than Adorno or Wittgenstein was good enough for him. But once you had heard him more often you soon realised that Schlappner had simply learnt encyclopaedia articles off by heart.

Before Anton L. joined the Circle, the second part of the Bundtrock evenings, the part without Prof. Bundtrock, had already transferred from the Green Oak to the Klintzes' apartment. That is, they went to the Klintzes at ten, after Bundtrock had left. Schlappner appreciated that because he didn't have to pay for the beer for himself and Astrid.

One must not assume that psychology for the Bundtrock Circle was merely theoretical, that they only *talked* about psychological problems. The practical exercises ("playing games," as Frau Dr Klintz put it) were a crucial element. These consisted, to put it crudely, in the members being insulted by each other in varying groups turn and turn about. Even Anton L., who was something of a truculent type,

enjoyed these exercises. Once, for example, it came out that in his younger days Schlappner had felt a long-distance erotic attraction to the Queen of England and that he still kept a drawer full of photos of her he had cut out from magazines. Frau Dr Klintz sketched one of the young Schlappner's daydreams: the Queen visits our city; she's taken round the University; Schlappner is sitting working on his doctoral thesis; all the lecturers and professors are hovering round the Queen, except Schlappner, who is bent over his books; suddenly – an attempt on the Queen's life, all those who were hovering round her flee, only Schlappner steps in and saves Elisabeth, who is so grateful she immediately falls in love with him . . .

"But we all know," said Frau Dr Klintz, "that our friend Schlappner is just a wimp."

Schlappner was, of course, insulted and left the apartment with Frau Delius.

The rules of the "game", however, forbade any final break, however deeply hurt a member felt. During the following weeks Schlappner circled, so to speak, round the group he was aggrieved with, gradually pulling other members out into his orbit, according to the centrifugal force inherent in the "game" they were playing, until his position became static and it was the others who were circling. After a while the centripetal force started operating on those who were now on the periphery, and the group came back together again. The "game" could begin again with the roles reallocated. *One* line, however, was never crossed: psychological problems were never called into question. To say, "Basically you're perfectly normal," would have been unforgivable, outside the rules, and would have cut the bond tying them together.

One "game" that came close to this line, perhaps even crossed it, and resulted in a temporary stagnation of the Bundtrock Circle (and Anton L.'s leaving it) was connected with playing in another sense. The idea came from Bundtrock himself; the professor proposed they should perform a play. Naturally the plan was taken up with enthusiasm. Even before a single practical step had been taken to put it into effect, it

engaged the energies of every member of the group, the allocation of roles alone offering the basis for countless "games". Eventually, however, they did get down to it. Prof. Bundtrock had suggested one of Lessing's short, early comedies, *The Young Scholar*.

The young scholar in Lessing's comedy is a conceited ass who thinks himself cleverer than anyone else and at the end gets the comeuppance his arrogance deserves.

It was plain to see that Nature, in producing A. W. Schlappner, had plagiarised the character from Lessing's comedy, even down to individual words and phrases. Schlappner, it was agreed, should play the title role.

Initially Schlappner was flattered to be allocated the main role. He was also suited to it because his habit of memorising encyclopaedia articles meant he had had practice in learning a part. But as the rehearsals proceeded it became apparent that Schlappner was not so suited to it after all because he *acted* the character. He was meant to *be* the character. Frau Dr Klintz told him this about a week before the performance. This was the spark that set off the explosion, but it was a delayed explosion. At first Schlappner did not feel insulted. After the rehearsal he went to see Frau Delius, who had not been there, and since it was late he had to take a taxi. It so happened that the previous day the taxi-drivers' trade association had agreed an increase in fares. Since the meters in the cars could not be set to the new rates immediately, the drivers were permitted to demand a higher price than indicated on the meter. The association had given out stickers explaining this to be placed next to the meters in the taxis. Consequently the taxi-driver who drove Schlappner to Frau Delius asked for more than was shown on the meter. Schlappner refused to pay the excess. The driver pointed to the explanation beside the meter.

Schlappner replied that that was no affair of his, giving reasons he thought were legally valid. Eventually Schlappner had to pay the excess. But what made him incandescent with rage was not that the driver threatened to "thump him one," but that he clearly did not take him seriously, either as

a person or as an expert on the law, despite Schlappner's repeated assurances as to his own importance.

Furious, Schlappner stormed up to Frau Delius's flat. And his fury at the taxi-driver set off the bomb Frau Dr Klintz had laid with her remark that, "You're not supposed to *play* the young scholar, you *are* him."

Schlappner picked up the telephone, called Prof. Bundtrock – in the middle of the night – and said he wasn't taking part any more.

Coming just one week before the performance, it led to a whole host of complications. That, though, would have been within the bounds of the "game". What went beyond them was what Schlappner regarded as a primitive and underhand recourse to the norms of the outside world: they simply found someone else for the role. This was possible because a young music teacher, who had joined the Circle a few days previously, had turned out to be an excellent actor and took on the part of the young scholar.

The play was performed. Afterwards a feeling of unease crept into the group, not because Schlappner and Frau Delius were missing, but because the violation of the "rules of the game" with regard to Schlappner had upset the delicate balance of the group. On top of that Prof. Bundtrock was away for six months because he had to go to Japan to pursue his research into erotic woodcuts. The Circle disintegrated. It did come back together again some time later, but Anton L. missed that. That was not entirely unintentional. It was connected with Frau Dr Klintz.

Anton L. had fallen in love with Frau Dr Klintz very soon after he joined the Bundtrock Circle. Flirtations were part of the "game", but Anton L. did not quite stick to the rules. One day, when Herr Dr Klintz was absent and his wife alone hosted the second part of the Tuesday evening, Anton L. managed to arrange things so that he was the last to leave. That was not a simple matter, since he had a rival, as already mentioned, in Herr Lindenschmitt. Lindenschmitt stayed on too. There followed a long duel in staying put. Anton L. eventually won because Lindenschmitt lived a long way out, on the edge of

the city, and lacked both a car and the money for a taxi. Anton L.'s bedsitter was within easy reach of the Klintzes' apartment on foot. Shortly before the last tram left, Lindenschmitt threw in the towel and disappeared.

Anton L. tried to kiss Frau Dr Klintz. Gently and calmly she repulsed him, reminding him of the "rules of the game".

"I'm not playing a game, Barbara," he said.

"Everything's a game we play," she said.

"Then let's play at playing a game," he said.

"At best we can play at playing at playing a game," she said. "No, take your hand off my knee, Anton."

The bell rang. Lindenschmitt was back; he'd missed the tram. Frau Dr Klintz said, "Oh, it's you, Theoderich," adding, before Theoderich could take his coat off, "Anton's just about to leave. You can go together."

So Lindenschmitt accompanied Anton L. It was the end of Anton L.'s passion for Frau Dr Klintz. Lindenschmitt's walk home lasted a further two hours.

All that had happened before the performance of *The Young Scholar*, in which Anton L. was only involved in a very minor way (he did not have a part). When the Bundtrock Circle disintegrated Anton L. noticed that he did not miss the Tuesday evenings and took the opportunity to eschew the renewed meetings of the group.

21

The instrument with the blob on the end

As Anton L. went up the two flights of stairs to the Klintzes' practice his toothache was no longer a simple toothache. The pain was pumping through the whole left part of his body. All he could see with his left eye was bloody squiggles, his left ear had gone deaf. He felt as if his left side was swollen and pulsating.

The practice door was open, but Anton L. was so enveloped in his pain that he did not notice this odd circumstance. The waiting room was straight ahead. The three times he had been treated by Herr or Frau Dr Klintz he had, as a friend, not had to wait. (The bill had been a "friendly" one too, a ridiculously low, almost symbolic amount; otherwise the Klintzes' bills were pretty stiff. Their clientele came from the better-off classes.) Herr Dr Klintz's surgery was on the left, Frau Dr Klintz's on the right. Anton L. went to the right. That door too, though this was not so surprising, given that the practice as a whole was closed, stood wide open.

Everything was covered in a thick layer of dust. There were cobwebs stretching from the swivel arm with the drill to the well-known dentist's torture chair, and everywhere else in the room. Anton L. brushed the cobwebs off the chair with his sleeve and flopped down in it. A cloud of dust flew up, almost choking him. He jumped back onto his feet; even more dust billowed up. He flung open the window. The window gave onto the square. He was looking down on the Elector's rear view.

Anton L. dragged himself back to the dentist's chair. Although he sat down more cautiously, dust still swirled up, but much less.

What was he doing here? Trying to treat himself, pull out the tooth or something like that? What a pointless idea.

He fiddled with the knobs on the fully automatic chair. Suddenly the back tilted down and the footrest went up, almost making it into a bed. Anton L. remembered the mechanism, it didn't startle him, but the pain in his left side surged up his body like a hot liquid, almost bursting his skull, broke into eddies, then poured back down, branching out into his right side as well in streams of fire. In the left side of his mouth was a white-hot cube of stone-hard pain sending out signals in waves that drove him to the brink of madness. He tilted the chair back upright and grabbed the drill.

A pointless idea. It was an electric drill. It wasn't working.

Was it the hare who had told him that some dentist's equipment had a mechanical drive as well as an electrical one? Or was it the Elector?

Anton L. sat up. Holding his hand over his left eye, he examined the mechanism of the drill. Yes, there were some pedals at the bottom. He pressed one with his foot. A jet of foul, brownish water spurted up. He stepped on another. Nothing happened. The third set the drill whirring into life and kept it turning as long as he pushed the pedal up and down. The pain vanished immediately, as if it had been blown out, like a candle. The pain had been on his left and Anton L. swayed a little, as if a weight had been lifted from his left side.

But the pain had only been frightened, not driven away. Two or three seconds later it was back, like a whiplash from head to toe. The hot cube in his left jaw was bigger than ever.

Anton L. set the drill whirring again. It was no use. The pain stayed put.

Once again he covered up his left eye and with the right examined the late Frau Dr Klintz's instruments, which were in a tray which swivelled out at the bottom of the arm with the drills. He seemed to remember that she had given his teeth a light tap with an instrument with a blob of metal on the end. That was one of the ways of establishing which tooth was the problem. The instrument with the blob on the end was, like everything else, covered in a layer of dust and cobwebs. He

stepped on the pedal which produced the jet of water and kept pushing it down until the water ran clear. Then he cleaned the blob-ended instrument.

Cautiously he opened his mouth wide and put his left thumb and index finger in to hold the inside of his cheek away from his teeth. As far as he could without being able to see them, he gave each of his teeth a gentle tap with the instrument, first the top ones, then the bottom.

The top teeth did not hurt. At first all his bottom teeth after the incisors hurt the same. When, however, he tapped one farther back, the fifth or sixth, his whole being was hit by a hammer of pain, a pain bell sounded in his head, a tornado of pain swept everything visible into a vortex round the chair. For a few moments the equipment, the windows, the doors went spinning like a merry-go-round, all Anton L. could see were coloured or black and white stripes. He dropped the blob-ended instrument.

'So that's the one,' thought Anton L., or whatever it was at the eye of the cyclone of pain thought; at that moment Anton L. was incapable of thought. The instrument hit the floor with a clinking noise. The clinking set off a silvery electric flash, which shot up through the furious spinning motion from bottom right to top left, disturbing its axis. Now Anton L. was sitting at an angle in the chair. He held on with both hands. He could feel the sweat pouring off him. The spinning motion was contracting. Soon there was a dark, red-striped cylinder right round Anton L.'s head. He was gasping for breath. The axis of the cylinder straightened up again, the revolutions slowed down, stopped. For a moment everything went black, then the blackness broke up and daylight reappeared.

The tooth was still hurting, but the pain was innocuous, trifling compared with what had gone before.

He breathed in deeply and wiped off the sweat with one of the clinical tissues on the instrument tray. He could still hear the pain rumbling in the distance, as if far-off doors in deep passageways were being slammed shut.

'So that's the one,' thought Anton L.

209

Very carefully he felt the tooth with his finger. Naturally there was no sign of anything wrong on the outside.

There was the drill that could be operated with the pedal.

'Nonsense,' thought Anton L. 'A really stupid idea. What am I going to drill? How am I going to drill? The tooth probably has to come out.'

The late Frau Dr Barbara Klintz's forceps were also on the instrument tray.

He picked them up. Immediately the far-off doors opened with a rumble of thunder and the pounding feet of the red horde of pain could be heard once more, approaching rapidly. He quickly dropped the forceps back on the tray. For a moment the horde paused, ears pricked, then retreated.

Anton L. was well aware that there were injections. Frau Klintz had given him one when she treated him. But giving an injection was also a matter of practice. And how! Anyway, which injection? There were a few syringes and needles lying around, cartridges of anaesthetic too.

'No,' thought Anton L.

He got down out of the chair and staggered out of the practice.

"All sorted out?" said the Elector as Anton L. walked, no, crept past him in the square.

"No," said Anton L.

"I thought so all along," said the Elector.

"It just wasn't possible," said Anton L.

"Extracting one of your own teeth," said the Elector, "not even an experienced dentist can do that."

"An experienced dentist could, perhaps," said Anton L. He sat down on one of the dozen low, round stone bollards that held the low-hanging, heavy iron chain enclosing the statue.

"Perhaps," said the Elector. "A *very* experienced dentist perhaps."

Anton L. placed his foot on the chain and swung on it.

"If . . ." said the Elector.

"If what?" said Anton L.

"If Providence, or God, or whatever, chose you, you of all

people, Adam L., to be the sole survivor of the catastrophe, then . . ."

"Then what?" said Anton L.

"Then Providence, or God, or whatever has an obligation to get rid of your toothache. Otherwise it wouldn't make sense."

"Hmm," said Anton L.

"It would be absolutely unsatisfactory if this catastrophe, that is this end of the human race, were not also somehow a new beginning."

"That occurred to me too,"

"If it wasn't intended as a new beginning, then one person – that is you – wouldn't have been left over."

"It can't be mere chance," said Anton L.

"Correct," said the Elector. "But in that case, whoever or whatever it is has an obligation to get rid of your toothache,"

"A conclusion that makes perfect sense to me," said Anton L.

"Has it gone?"

"My toothache?"

"Yes."

"No."

"Hmm," said the Elector.

For a while both were silent. His previous pain now locked up behind the far-off doors, something akin to a feeling of peace spread through Anton L. although, looked at objectively, his toothache was still raging.

"You called me 'Adam' again," said Anton L.

"Do forgive me," said the Elector.

"No, no," said Anton L. "Adam's right. I am Adam."

"You could argue that," said the Elector, "in a way."

"Not just in a way. I will take possession of the earth."

"Not bad, not bad at all."

"I will use the summer to go to Italy. If one of the cars is still working, I'll drive as far as I can. Then I'll continue on foot. I'll miss you."

"No," said the Elector, "you won't miss me. In Italy especially there are so many of my colleagues."

"Yes," said Anton L. "And now you don't need to speak Italian when you go to Italy. German is the sole world language."

"And the Book?" asked the Elector.

"Perhaps I'll find it first."

"It could be somewhere quite close."

"How do you mean?"

"Have you really searched the Chinese pavilion? Really searched it from top to bottom?"

"No."

"I'd do it," said the Elector.

"I have to lie down for a while," said Anton L. "I'm quite shattered."

"I'm not surprised," said the Elector.

The toothache lasted a few more days. Anton L. felt as if his head were a pear lying on its side, the heavy side on the left. He took more painkillers, but the best way of making his current pain seem relatively mild was the memory of the few seconds of pain after he had tapped the tooth with the blob-ended instrument.

One day the toothache was gone – gone as the result of an astonishing development, an astonishing but logical development, so logical that it hardly needs to be told.

22

The beheaded executioner

If Anton L., lying in his bed, had reached out to his left just once and felt the panelling of his bedroom in the pavilion – he would not even have had to raise himself from the pillows, just stretch out his arm – he would have discovered a small protuberance with which part of the panelling could be slid back. If Anton L. had discovered this protuberance months ago, when he first moved in – it wasn't even concealed or disguised, it was a fairly obvious knob or handle, though to a superficial glance it could be the tail of one of the birds of prey that formed a regular motif in the decorative carving, none, though with such a prominent tail; in that respect the disguise, if that was what it was meant to be, was almost a pointer – if, then, Anton L. had pulled the handle or knob when he first moved in he would have saved himself a long search. The Book was behind the panel.

There were other books there too, some twenty or thirty, though far fewer than the shelf behind the panelling could take. But it was there in the middle, unmistakable: bound in fine leather with red and gold stars, and on the spine a golden snake, which had split and formed a figure of eight.

Anton L. took the Book out and went over to the window. When he had come back 'from the dentist', or from talking to the Elector, he had not, as he had originally intended, simply gone to bed; he had started to search the pavilion from top to bottom, or rather from bottom to top, beginning with Sonja's room. That was why it was already evening by the time he found the handle or knob on the bird's tail.

But it was a mild, sunny evening. It was one of the longest days of the year. (Was it 26 June? The anniversary?) The sun

was sinking behind the bushes growing among the rafters of the collapsed roofs of the houses along the west side of the Palace Gardens, its beams shining red and gold in evening air that had long since become pure and clear again. The pattern of the window panes, drawn out in a delicate filigree, stretched across the floor.

A lame horse, a grey-brown one he had never seen before, was grazing in the park.

Anton L. held the Book up to the light. He opened it. He did not open it somewhere in the middle, the way you open a book you're just casually looking at. He opened the front cover, turned the endpaper. He was not startled to see writing appear on the initially blank title page almost as soon as the sun touched it.

He read the title.

He turned the page, carefully running his thumbnail down the fold to keep it flat, and slowly glanced through the list of contents, which covered three pages. Then he began to read the first chapter. It was about the origin of the universe. It also dealt with events and conditions outside the universe. There were four footnotes and a fold-out diagram to make these complex interrelationships more accessible.

The book was written in German.

Anton L. kept on reading until the sun had disappeared behind the buildings to the west. Then he lit some candles, but the candlelight did not bring out the writing on the blank pages, so he put the Book back on the shelf and closed the panel.

It was still too early for him to go to bed. He took his rifle, put on his faded deerstalker and went out. A flock of birds flew low over the Palace Gardens. Only one of the four fountains was still working. They had frozen up in the winter and all but one had burst. The water from them seeped up round the broken basins, turning the whole area into a morass. The fountain that was still working was festooned with moss.

Anton L. walked slowly across to Luitpold Allee. Another flock of birds, smaller birds, probably sparrows, swept in a curve low across the park, banked and settled on the roof of

the pavilion. The statue of Diana, that had been on the top, had fallen down; it was lying, face stuck in the ground, across one of the now almost invisible gravel paths. The lower halves of the pavilion columns were covered in moss. The sparrows did not stay on the roof for long. One (do sparrows have leaders? The Book would deal with that in the appropriate chapter) flew off and fluttered around; the others followed, formed a flock and shot off straight as an arrow through the branches and foliage of a tree.

'How do they manage not to bash their heads?' Anton L. wondered. The sparrows had flown through the tree like water going through a sieve.

It was already getting dark in Luitpold Allee.

"Where're you off to?" asked Jacob the hare.

"Oh, you're here, are you?" said Anton L.

"I'll have to make myself scarce soon, before those great big hairy monsters with the long teeth wake up. Can't see the point of them, can't see why they exist at all."

"Everything has a meaning."

"Oh, listen to the man with the Book," said the hare. "And you've only got to page three."

"Fourteen," said Anton L.

"Is there anything about me in it?"

"I haven't got that far yet."

"I wonder if it's any use," said the hare.

"If what's any use?"

"I mean I wonder if it's any use you reading that book."

"How do you mean, use?"

"Once you've read the book, you'll know everything," said the hare.

"Yes."

"But what use is it, knowing everything? In the old days, when there were still other people around, you could have made a big splash with your book. But now you can't tell anyone all the things you know."

"What about you?"

"Rubbish. You know I'm not really talking and listening. We've spoken about that already."

215

"Well of course I can't explain to anyone —"

"Then all that stuff's pointless," said the hare.

"Knowledge is never pointless," said Anton L.

"The question is whether knowledge, isolated knowledge just one person has, is knowledge at all."

"*I* know that I know," said Anton L.

"Ooh, listen to him!" said the hare. "Bully for you. *I know that I know*. Soon you'll be saying, *I am that I am*."

"What do you mean?"

"You'll see soon enough."

"You're coming out with some stupid things today. And I don't think I like your tone. 'Ooh, listen to him. Bully for you.' I find that a bit cheeky for this kind of conversation."

"Yes, yes," said the hare. "It won't be long before you're saying, I'm not talking to someone who hasn't read the Book."

Anton L. gave the hare a bewildered look.

"Should I not read the book? When everything in the world, perhaps even from the very beginning, has been directed towards —"

"I know, I know. The red arrow on the globe. Pointing straight at you: look, there's Anton L. But who is there to look?"

"I don't care."

"You don't need to read the book. You're the cleverest person there is anyway. The undisputed intellectual champion of the world."

"So you wouldn't read the book?"

The hare folded one of his ears down and sniffed. "I wouldn't necessarily say that."

"There you are, then." said Anton L.

"Although that would be a possibility, of course," said the hare. "*One* possibility . . ."

"Not to read the Book?"

"We're wasting our time. All this theoretical stuff's getting us nowhere. The fact is, you simply *have* to read a book like that, once you've got it. Come what may. I can go along with that."

"Every end is a new beginning."

"Who says so?" said the hare.

"The Elector."

"With all due respect to His Electoral Majesty," said the hare, "that statement is totally without foundation. A load of bullshit, not to put too fine a point on it."

"But each thing that withers away bears within it the seed of –"

"Stick to the facts," said the hare. "None of the fancy stuff. That's all this old-fashioned pantheistic nonsense. There are ends that contain a beginning, yes; and there are ends that contain no beginning."

"But I wouldn't see any meaning in that –"

"There are things that have a meaning, and there are things that don't have a meaning. 'Everything has a meaning.' All this cosmic mumbo-jumbo! Just hearing it makes my –"

"Why are you getting all worked up?"

"It's like a drug, it befuddles the brain. 'Everything has a meaning!' I can just as well say, 'Nothing has a meaning.' "

"You're unbearably pessimistic."

"Optimism is the reason of idiots. Anyway, I'm neither an optimist nor a pessimist. If you have to classify me, I'm a positivist. But you'll soon be one too, when you've read your book."

"We're wasting our time with theory again. Whether every end bears within it the seed of a beginning – let me finish – or not, you yourself said that some ends contain a beginning. Therefore it is conceivable that within me, the last of the Old Humans, there is the first of the New –"

"Cosmic," said the hare, "very cosmic indeed."

"I asked you not to interrupt."

"Sorry."

"Therefore within me . . . What was I going to say?"

"How should I know?"

"Now I've forgotten what I was going to say."

"That within the last of the Old Humans there is the first of the New Humans. And there's a New Hare inside me, too."

"I had such a beautiful sentence worked out in my head, and now it's gone because you interrupted me."

"In that case it'll have been more beautiful than true," said the hare.

"Anyway," said Anton L., "to cut a long story short, I want to be a new beginning."

"And how, if I might ask, are you going to go about that?"

"What do you mean?"

"I don't mean anything, I'm just asking. How are you going to go about it? How are you going to make this new beginning? Mate with a cow? Or what?"

"I haven't worked out the details yet."

"Of course. You don't work out details when you're on a cosmic trip."

"I have no intention of mating, not with a cow, nor with anyone else. Perhaps . . ."

"Perhaps?"

"Perhaps," said Anton L., "I'm immortal."

"You don't say!"

"I don't know what's got into you. That would be the simplest explanation why I, I of all people, am the only one left."

"Because you're immortal?" said the hare.

"I'm not saying I'm immortal –"

"Of course."

"I'm just saying that there is the possibility that I might be immortal. There is some evidence to suggest it."

"Why're you reading the book, then?"

"What's that got to do with it?"

"Now as you know, I'm not a human being, just a creature without a soul, but I do think about the things that go on in the world. Correct me if I'm wrong, but what you humans always wanted above all was to be saved, that's what your religions promised you. Since, basically, humans had no idea what the meaning or the purpose of the world was, that gave them the opportunity to *believe*. You're with me so far?"

"I think I'm capable of following a hare."

"Just depends where to. But OK. Belief – or faith – was

counted as a merit which gave them the right to be saved after death. To enjoy eternal life, for example. To put it another way: if God, assuming he exists, had revealed himself physically, so you could see him or touch him, rather than just giving the kind of hint you get in the New Testament –"

"Have you a degree in theology?"

"Don't interrupt. The New Testament's not a revelation, the New Testament's an aid to faith. It doesn't provide knowledge. An encouragement to faith, you could say. But that's not the point I want to make. What I'm saying is that if God had revealed himself physically, then you human beings would have *known*. Knowing isn't difficult, there's no merit in knowing, it's *believing* that's difficult. So what about you? Once you've read your book, you'll know everything. The book – I haven't read it, of course, but it has to be the physical revelation of God, so once you've read it, you won't need to believe, you won't be *able* to believe, you'll *know*."

"So faith is a grace?"

"And since you can't believe any more, you can't be saved."

"Perhaps there are other merits that count?"

"Such as?" said the hare.

"Well," said Anton L., "finding the Book, for example."

"Huh! Finding the book. You said yourself that everything in the world was directed towards *you* finding the book. The red arrow on the globe with the tip pointing at Anton L. Huh! And under *those* conditions it counts as a merit if you find the book? Not finding it would have been more of a merit. No, no, the fact that you are denied the merit of faith suggests you're an end with no beginning in it. The end of the human race. The last one is allowed knowledge."

"So it's my task to give back the fruit of the tree of knowledge?"

"Yes. Very nicely put. You can burn the book under the apple tree. At the back there, where you send your whatsits, your faeces. All the plants there are thriving because it's so well manured and a few weeks ago an apple seedling appeared. In a few years it'll be an apple tree."

"You're impossible."

"Imaginary, maybe," said the hare, "but perfectly possible."

"And what if the book says there is no God?"

"You've read the first few pages, doesn't it say anything about that there?"

"The book is in three parts, each with twelve chapters. I've glanced through the list of contents. It's the twelfth chapter of the third part that deals with God."

"And what if it turns out there is no God?"

"Is salvation *without* God possible?"

"Aha," said the hare, "a kind of democratic hereafter. The souls organise eternal life themselves. Not a bad idea. Any evidence for that?"

"You and your evidence."

"I'm sorry, but it's getting dark. It won't be long before those nasty wolves turn up. I'm sure you'll understand my physical safety is more important to me than the salvation of your soul. I have to say I'm afraid you're not going to be a new beginning. Not unless you mate with a cow, that is. Good night."

"There is another −" Anton L. had been saving what he believed was his trump card for the end. But the hare had gone. Luitpold Allee was dark.

Anton L. walked along the avenue in the direction of the National Library. The noises of the night had long become familiar and keeping a watchful eye and ear open was such a matter of course that he could abandon himself to his thoughts.

Things change quickly. Even concrete must contain some life forms. One year and one flood were sufficient for even the concrete slabs of the wide pavement to sprout patches of primitive green lichens. Not just between the joins – there the grass wasn't just *sprouting*, it was *growing* in clumps, and so vigorously that quite a lot of the slabs had already been pushed up and wobbled when he stepped on them; another flood and they'd be swept away −, lichens were growing *on* the slabs, eating their way across the surface in a sprawl of different shapes. For a year nature, kept in an asphalt straitjacket for centuries, had only reached out a tentative hand to take hold

of the stone city. Now, however, after the flood and the over-long spring followed by a somewhat damp summer, she had delivered a hammer blow.

In the main the large, neoclassical National Library building was undamaged. Its huge, dark bulk loomed up along Luitpold Allee. There was a half moon. The moonlight, too, was brighter, Anton L. thought, perhaps because of the clean air. The moonlight was playing round the shapes and forms of the library. Every marble projection cast long shadows down the façade. In some places, though, the stucco had peeled off, revealing the brickwork, dull red amid the brighter plaster which now, where it was not in deep shadow, shimmered a pale greenish colour in the moonlight. Many of the windows were broken, some of them had plants growing in them, either hanging down or pushing their way upwards along projections or gaping cracks.

A little farther along Luitpold Allee, beyond the National Library, was St Serapion's, a neoclassical church. A double pillared arcade with a garden behind it had connected the church to the National Library. At this point both the arcade and the road had been swept away. A huge mass of water must have burst through during the flood. Three quarters of the arcade had been washed away; only a few pillars had been left standing, some beside the church and others by the library. The rest were smashed and scattered higgledy-piggledy across the road. The mud left among the broken pieces by the flood had encouraged vigorous growth. Bushes had sprung up round the rotting trunks of trees uprooted from the garden behind the arcade, or washed down from even farther away by the flood waters; ivy wound round the broken stumps of the pillars.

On the other side of the road, where the torrent had continued on its path of destruction, there was a yawning gap in the row of buildings, which lay in deep shadow. St Serapion's was still standing, just its façade was missing, as if it had been sliced off. The interior of the church was like a gaping wound, too large ever to heal. From here and there inside came the glint of the gold tiles of the, as Anton L.

remembered, Romantic and rather mawkish, excessively monumental mosaics. Now that the façade was missing, a group of statues round a side altar were more or less out in the open. They, too, were in the full light of the moon, which turned the marble pale green. A gigantic executioner was brandishing his sword prior to beheading a praying bishop. The bishop had kept his head, the executioner's had rolled onto the floor.

Outside the National Library was a double flight of steps leading up to the entrance. These, too, had weeds growing on them. Four stone blocks on the steps, two on one side, two on the other, had supported statues of seated thinkers in classical garments. Anton L. remembered that when the library had been rebuilt after the war there had been an argument as to which statue belonged where. (They had been removed for safe storage, as they were the work of a fairly important sculptor.) The argument also rather unexpectedly brought up the question as to whom the figures were meant to represent. In the case of three of the statues that question had never been conclusively resolved. Only for one was it clear whom the sculptor intended to portray, since he had carved the name "Plato" in Greek letters on the back of the stool on which the stone philosopher was sitting. He had omitted to do that for the others; perhaps he didn't even know himself who they were meant to be.

The three nameless philosophers had fallen down the steps with part of the balustrade, probably swept away by a sidearm of the torrent that had broken through between the library and the church. Two statues, one broken in the middle, lay at the foot of the steps, the third had disappeared somewhere beneath the mud and scrub. Only Plato remained at his post, not because he was Plato, but because he had been farthest away from where the water had broken through.

Anton L. felt hungry. He had eaten very little during the last few days, because of his toothache, and nothing at all on this day.

At home, that is in the Palace kitchen, the remains of the twentieth deer were on the spit. Anton L. was thinking of

turning back when he heard a rustling in the undergrowth at the foot of the statue of Plato. A fat black hen came waddling drowsily towards him. Its fright when it realised Anton L. wanted to catch it, woke it up; it fluttered up in the air, but too late. He caught it with his bare hands, wrung its neck and ate it on the spot, spitting out the bones and feathers.

"*Bon appétit*," said Plato.

"Sorry?" said Anton L. Since Plato did not say anything else, he went on eating.

23

A boneless pheasant

Drastic changes took place during the following months, while Anton L. was reading the Book. As he had told the hare, it had three parts, each with twelve chapters. In the first few chapters it occasionally referred to itself as the *summa summarum*. Later it went on to deal with other, more profound matters.

Anton L. read it slowly and carefully. The summer passed. The journey to Italy, about which he had spoken to the Elector, never took place. A person reading a book like that does not need to go to Italy, he does not need to go anywhere, as we will see shortly.

Although it dealt with very complex matters, the Book was easy to read and comprehensible. There was nothing that was actually difficult to understand, especially as he got farther into the book. Several times his reaction was the familiar, 'That's just the way I would have put it. – I don't know why I didn't think of that before. – When you think about it, that's the way it has to be.' Despite that, he read slowly and carefully. He didn't want to miss a single word.

It is doubtful whether Anton L. even noticed the changes, which will be described later. True, he did notice the angel, it was impossible not to, but the small changes? He would often read a chapter two or three times in succession. Often he would spend days over a single sentence, even half a sentence. He pored over the explanatory diagrams. It was not surprising, then, that the weeks and months flew by unnoticed as he read the Book, especially since in the first few weeks, until he got to the end of the twelfth chapter, he was restricted to the normal daytime, that is between sunrise and sunset.

After he had started to read the Book he did not go back to the Palace kitchen. Untouched by Anton L., the twentieth and last deer remained on the spit, a prey to worms and maggots. At the beginning he still felt hunger and thirst, but once, when he opened the window, a pheasant flew in. The pheasant plucked itself, all Anton L. needed to do was eat it. He wrung the first pheasant's neck, but with the subsequent ones – at most there were three – he didn't bother. The pheasants didn't seem to mind. The last pheasant had no bones. His bodily needs grew less and less. After the last pheasant he did not feel hungry any more, just occasionally thirsty. As usual he quenched his thirst with champagne, half a bottle a week; after a while he forgot even that and did not notice. The corresponding bodily functions, too, began to shut down. Eventually the secret compartment behind the panelling remained unused.

One late summer's evening, it was probably the beginning of September, Anton L. stood at the window of his room on the upper floor of the pavilion. He had finished the first twelve chapters and was eager to start reading the second part, the thirteenth chapter. But the sun was going down. Small, dark, thin strips of cloud were floating across the western sky, the head-high grass that covered the whole of the park began to stir in a gentle breeze. (Only where the water from the burst fountains was overflowing and seeping up was the vegetation different. There tall, pale plants with thick, hairy leaves had shot up.) The bushes on the roofs of the buildings to the west threw long shadows over the miniature prairie. The sun was turning red.

Anton L. had already noticed that he could part clouds by staring at them. Now he directed his stare at the sun. Initially the sun dazzled him, making him see rings and squiggles of fire, just as when he had had toothache (which, of course, had not come back), but he persisted, making his stare more forceful, until the sun yielded and turned into a harmless glass sphere which bowed before the solar intensity of Anton L.'s gaze. To be specific: the sun rose back a little above the horizon and stayed there until Anton L. had finished the

thirteenth and fourteenth chapters and dismissed it. With relief, but without protest, the glass sphere sank below the horizon. Anton L. went to bed.

Controlling the sun like that was not simple. Once he forgot to dismiss it before he went to bed. When he got up he found that all the trees round the pavilion were burnt on one side. He found it irksome to have to concern himself with things which previously had been, quite rightly, self-regulating. But that was merely a transitional period. In the middle of October, just as he was starting on the third part, the twenty-fifth chapter, (every page now was an ocean of knowledge into which he plunged), the angel came.

The angel was very tall, had a bird's head, though with scales not feathers, was female – not of the female sex, but female in appearance – and wore a fiery red robe of ineffable, flamed material, something like a cross between feathers and stone. When the angel moved, its robe parted, revealing a woman's body of radiant perfection: white skin with a shimmer of gold, breasts of such proud and confident firmness their ruby tips were almost pointing in different – upwards – directions, and a belly with a flawless curve down to the ornament in the from of a rose at the point where, in human women, the sexual organs begin. Whether the angel possessed such organs – if it did, they were presumably as perfect as everything else – Anton L. could not see. Nor did he make any effort to do so.

"I am Sonja," said the angel.

"Oh yes," said Anton L.

Sonja carried out the irksome tasks resulting from his advancing knowledge.

The last sentence of the third part, the last sentence of the thirty-sixth chapter, the last sentence of the book was, "Thou art God."

24

God cannot say, "I dissolve myself"

"It's very good of you," said the hare, "still speaking to me, now that you're God. Do I have to *Thee* and *Thou* you?"

"Leave that to the Book. As long as you don't keep interrupting."

Anton L. was sitting outside the expensive antiques shop, the contents of which he had chopped up for firewood during the winter. A stone Rococo garden seat – probably not entirely genuine – had naturally not gone on the fire. Sonja, the angel, had carried it out of the shop and placed it in front of the window, so that Anton L. could sit on it. He was sitting on the bench, legs crossed. The angel was standing behind him and had unfolded a purple nimbus.

"Now that I am God," said Anton L., "or rather, now that I know I'm God, I always was, of course, I will create a new mankind."

"I should think about that very carefully," said the hare. "Anyway, when? Right away?"

"I have thought it over –"

"Excuse me if I do interrupt you, God," said the hare. "A new mankind? You think the world can't manage without mankind? You're still pretty anthropocentric, aren't you? It's obvious you were only promoted a short while ago."

"What have you got against man? I loved – no, I didn't love my fellow men. I even hated them, but I loved man*kind* deeply, with all my heart."

"Why only humankind?"

"I don't understand," said Anton L.

"Humankind's a pretty pathetic object for such a deep love. Life, life as such, now that I could understand: humankind and

harekind and rhinoceroskind and birdkind, fishkind, worm-
kind, antkind, infusoriakind, treekind, grasskind, fernkind,
mosskind – to love all those, now that I could understand. But
humankind? Was that depraved lot worth it?"

"I'm afraid you just don't understand?"

"No," said the hare, "I don't understand. I never did under-
stand why so much fuss was made about the salvation of a
few fools."

"You forget the great deeds of mankind."

"Great deeds?" said the hare. "Shooting us, mainly."

"End of argument," said Anton L. "God does not argue. I
have resolved to create mankind anew. Anew! That's the
important bit."

"Best of luck," said the hare.

"I will make a new beginning. Tomorrow, at the hour when
I command the sun to rise, I will rematerialise mankind."

"They are in for a big surprise."

"With the help of the Book, that is by my own power, be it
noted, I will carry out this act. Despite their abominable past, I
will give them, mankind that is, the opportunity I have
had myself and which, as you must agree, I have made use of.
I remember 1945. Then one part of mankind was faced with a
similar situation. Much had been destroyed. For a while –
at that time only for a while! – they became peace-loving,
more spiritually inclined. Now they will find a world that has
been completely destroyed. Their peace-loving and spiritual
tendencies will endure, especially since I will deprive man-
kind of certain characteristics which have turned out to be
unfavourable."

"Don't let them have guns."

"Not only no guns, they will be denied access to all the
forces of nature that were harmful."

"A splendid idea, in theory."

"Why in theory?"

"It seems to me," said the hare, "that what you have in
mind is a bunch of vegetarians going round in hand-woven
sandals reading uplifting tracts –"

"They won't do *you* any harm."

"They will tell *you* to get stuffed. They had another God before who had their best interests at heart and they told him to get stuffed."

"I've thought of that too. What I will rematerialise will be mankind perfected. I'll spare them the pain of all the different stages of development they should go through, I'll let them off the hard school of the mistakes they really ought to make. I will awaken mankind in its final, purified state."

"May I make a suggestion?"

"Yes?"

"I'd have a look at a few samples first. Not bring them all back at once."

"That is perhaps not a bad idea."

"If I were you," said the hare, "before I scattered the whole of mankind over this unfortunate planet, I'd have a few appear this evening, here, before your throne."

"This evening?"

"Then you could still change your mind."

Uncertain, Anton L. looked round at Sonja, the angel, but it, holding on to the nimbus, just turned its head to one side; its resplendent body shone out from the wide-open robe.

"All right then," said Anton L.

A tremor shook Luitpold Allee. The building in front of which Anton L. was sitting billowed out, the façade burst, and bricks and tiles rained down. However the angel held its nimbus like a tent over Anton L. and the hare, and the bricks and tiles bounced off it.

The earth opened up. Out of a fissure that ran along the middle of the street rose a human being with its feet attached directly to its knees; to make up for that, it had arms as long as a boa constrictor. It felt around with its hands and staggered straight back into the fissure. Clearly it was blind.

"Just a minute, it's falling back in," said Anton L.

But it didn't fall back in. Another was coming out of the crack and pushed it out of the way. The second was transparent, had no hair and a head the size of a water butt in which a brownish brain could be seen pulsating. The brain was constantly secreting a fluid which dripped down

inside its body and was excreted through the feet. The second human grabbed the first by the arm and started to suck at it.

A third human emerged from the fissure. It was large and powerful and moved on hairs, like a caterpillar; when it turned round, they could see that it was as thin as a sheet of paper. The fourth was a dwarf, but had a male member the size of a cannon, three times bigger that it was. It had difficulty getting its arms round its penis and it could only keep its balance by leaning back. When the dwarf saw Sonja's resplendent body, its penis shot straight up in the air, high as a tree. The dwarf fell flat on its face. The penis went right through the middle of the paper-thin one that went on hairs. By now the one with the long arms had sensed that someone was sucking at its arm, but could not see who it was. It started to swing its arms round and round. The transparent one hung on and went round and round in the air too.

A fifth came out. It had such a voluminous fold of flesh on its neck it could wrap itself in it like a cloak. A sixth had a body covered in fungi, a seventh a mouth like a leech. The eighth had no skin and no bones; it moved by dissolving into a puddle, trickling a bit this way or that then building up again into a kind of soft, red cheese. The one with the leech-mouth slurped it up, then burst. The bits formed new leech-men.

The next ones looked as if they had been made out of wire. Then shadows fluttered out of the crack, like smoke, some light-coloured, some dark. They mingled and spun round in long swirls over the ground. Then came a red maw with white teeth.

The maw stuck out a tongue, big as a flag, and some of the shadows got stuck to it. A long, white grub made of fat, the size of a small airship, came out of the fissure and regarded the scene with fourteen impudent eyes.

"Some . . ." said Anton L.

"Some what?" asked the hare, who was hiding under the seat and looking out through Anton L.'s legs.

"Some error must have crept into my calculations," said Anton L.

"On the contrary, your calculations are perfectly correct.

You just didn't really know what the result of your cosmic multiplication would be."

Anton L. gave the angel a signal. The angel unfolded another nimbus and threw it over the pack that had poured out of the fissure. The nimbus inflated to a sphere, sucking everything up inside it, then reduced to the size of a goldfish bowl in which the wriggling and shoving, coupling and slurping went on in shrunken format, but clear and distinct, as if under a magnifying glass. The angel handed the sphere to Anton L., who held it in front of him in the palm of his hand and looked at it.

The hare came out from under the seat.

"I almost feel sorry for you," said the hare. "Even I didn't think it would be that awful."

Anton L. said nothing. He glanced at the angel, but it was holding the nimbus again and turned its head slightly to one side. It was looking along a precise tangent to Anton L.'s head.

Anton L. stood up and threw the sphere back into the crack in the road.

"What now?" said the hare.

"Can God dissolve himself?" asked Anton L.

"I don't think so," said the hare.

"I don't really think so, either," said Anton L. "God can't say, 'I dissolve myself.' What would happen if God were to say:

'I – dis – solve – my – self –' "

It was the first cold night. When the sun rose the next morning the first leaves on the trees had turned brown.

The tremor had destroyed the foundations of the statue of the Elector. The heavy bronze figure had tilted to the side and fallen to the ground. It had broken in two places, at the hip and at the neck. The legs and stomach were close to the cracked pediment, the torso farther away, the sword was stuck in the ground. The head had rolled even farther. It was looking up into a clear autumn sky across which a flock of starlings was flying south.

Recommended Reading

If you enjoyed reading *Grand Solo for Anton* and would like to read another novel by Herbert Rosendorfer we have published another three:

The Architect of Ruins
Letters Back to Ancient China
Stephanie

There are also other books on our list which should appeal to you if you like the novels of Herbert Rosendorfer:

D'Alembert's Principle – Andrew Crumey
Pfitz – Andrew Crumey
Androids from Milk – Eugen Egner
The Great Bagarozy – Helmut Krausser
The Others – Javier Garcia Sanchez
The Limits of Vision – Robert Irwin
Lucio's Confession – Mario de Sa-Carneiro
The Other Side – Alfred Kubin
The Golem – Gustav Meyrink
The Angel of the West Window – Gustav Meyrink
The Green Face – Gustav Meyrink

These can be bought from your local bookshop or online from amazon.co.uk or amazon.com or direct from Dedalus. Please write to **Cash Sales, Dedalus Limited, Langford Lodge, St Judith's Lane, Sawtry, Cambs, PE28 5XE**. For further details of the Dedalus list please go to our website www.dedalusbooks.com or write to us for a catalogue.

Letters Back to Ancient China – **Herbert Rosendorfer**

Letters Back to Ancient China is one of the most successful German novels of the 20th-century with well over two million copies sold. It combines comedy, fantasy and satire in a moving personal odyssey.

'A 10th-century Chinese mandarin travels forward in time, and writes letters home reporting on the strange land of "Zha-ma-ni" in which he is surrounded by giants with big noses, and frightened by the iron carriages called "mo-tao-ka". We gradually realise that he is in present-day Munich, and the hapless voyager's encounters with modern life and love, make delightful reading.'
Andrew Crumey in Scotland on Sunday

'witty, lively and idiosyncratic.'
Meren Meinhardt in The Times Literary Supplement

Mike Mitchell's translation won The Schlegel-Tieck German Translation Prize.

£6.99 **ISBN 1 903517 39 7** **276p** **B. Format**

Stephanie – Herbert Rosendorfer

'An elegant, elegiac novel, its titular character goes back to a past life in which she is a Spanish duchess who has murdered her husband. The book's first half, narrated by her brother, tells of the start of Stephanie's strange experience and her eventual disappearance from the present, to which she returns only to die of cancer. The second is composed of letters written by Stephanie, in 1761, to her brother. The conceit sounds trite, yet it works well. Characters are evoked economically, and the claustrophobic world to which Stephanie regresses is detailed deftly and dispassionately.'

Scotland on Sunday

'Her story is interwoven most skilfully with her 20th-century life, which holds strange parallels and reflections and allows Rosendorfer some acute and occasionally darkly comic, social comment. This is a quality book from a first-rate mind of considerable sophistication. Dedalus is to be thanked for introducing us to Herbert Rosendorfer.'

Elizabeth Hawksley in The Historical Novel Review

Mike Mitchell's translation was shortlisted for The Schlegel-Tieck German Translation Prize.

£7.99 ISBN 1 873982 17 8 153 p B.Format

Androids from Milk – **Eugen Egner**

An anarchic, surreal and zany novel which reads like Kafka rewritten by Monty Python.

Reuben Hecht has been stuck at the age of 17 since he ran away to the Ivory Coast twenty years ago. His mother regularly beats him with a wooden spoon to make him complete his pictorial assignments for the Holy German Paintbrush Distance Learning Academy; his father has taken to his bed to hatch out a dwarf.

After attending a concert by the rock group, 'The Flesh-eating Fetish Bitches', Reuben decides not to return home, as he has heard reports that his parents are dead and the family GP and the parish priest are pursuing him to put him in a children's home for good, since he will never come of age.

This starts him off on a surreal odyssey in which the owner of a freak show sends him, together with Edwina, who can switch age at will, to the mysterious Colony to bring back some of the androids developed from UHT milk that have been reported there.

£7.99 **ISBN 1 903517 02 8** **202p** **B. Format**

The Great Bagarozy – **Helmut Krausser**

'Psychiatrist Cora has a new patient who is obsessed with opera diva Maria Callas. Cora's life is at a crisis point: bored of her tax consultant husband and struggling with professional failure, she finds her new patient fascinating – and also dangerously attractive. She falls in love with him, but he refuses to have an affair. He claims to be the Devil and to have inhabited Callas's black poodle – is he quite simply mad? Then he disappears but Cora rediscovers him performing in variety as The Great Bagarozy. An exhilarating blend of reality and the supernatural, this is one of the most acclaimed German novels of recent years.'

> *The Good Book Guide*

'The cultures of psychiatry and celebrity worship are memorably skewered in this ingenious fantasy of satanic possession and perhaps delusion, a novel by a prize-winning and critically acclaimed German writer now making his American debut. A brilliant work. Let's have more of Krausser's fiction please.'

> *Kirkus Reviews*

'. . . a vivid and mischevious fantasy, fast-paced and often wickedly funny.'

> *Ian Brunskill in The Times*

£7.99 ISBN 1 873982 04 6 153p B. Format

Pfitz – **Andrew Crumey**

'Rreinnstadt is a place which exists nowhere – the conception of a 18th-century prince who devotes his time, and that of his subjects, to laying down on paper the architecture and street-plans of this great, yet illusory city. Its inhabitants must also be devised: artists and authors, their fictional lives and works, all concocted by different departments. When Schenck, a worker in the Cartography Office, discovers the "existence" of Pfitz, a manservant visiting Rreinnstadt, he sets about illicitly recreating Pfitz's life. Crumey is a daring writer: using the stuff of fairy tales, he ponders the difference between fact and fiction, weaving together philosophy and fantasy to create a magical, witty novel.'

The Sunday Times

'elegant variations on the postmodern vogue for 18th-century philosophical fiction'

Boyd Tonkin in New Statesman & Society

'Built out of fantasy, Andrew Crumey's novel stands, like the monumental museum at the centre of its imaginary city, as an edifice of erudition.'

Andrea Ashworth in The Times Literary Supplement

£7.99 **ISBN 1 873982 81 X** **164p** **B.Format**